MW00534446

MONTANA
unforgettable

PHOTOGRAPHY BY
CHUCK HANEY & JOHN LAMBING

FARCOUNTRY
PRESS

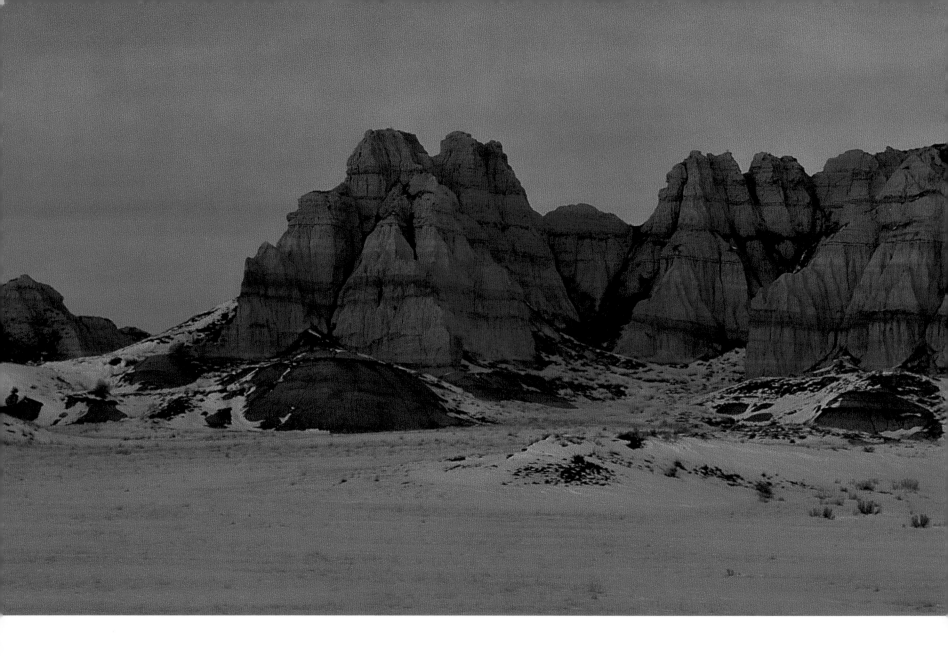

ISBN 10: 1-56037-448-9
ISBN 13: 978-1-56037-448-0

© 2008 by Farcountry Press
Photography © 2008 by Chuck Haney & John Lambing

All rights reserved. This book may not be reproduced in whole or in part by any means (with the
exception of short quotes for the purpose of review) without the permission of the publisher.

For more information about our books, write Farcountry Press, P.O. Box 5630,
Helena, MT 59604; call (800) 821-3874; or visit www.farcountrypress.com.

Created, produced, and designed in the United States.
Printed in China.

13 12 11 10 09 08 1 2 3 4 5 6

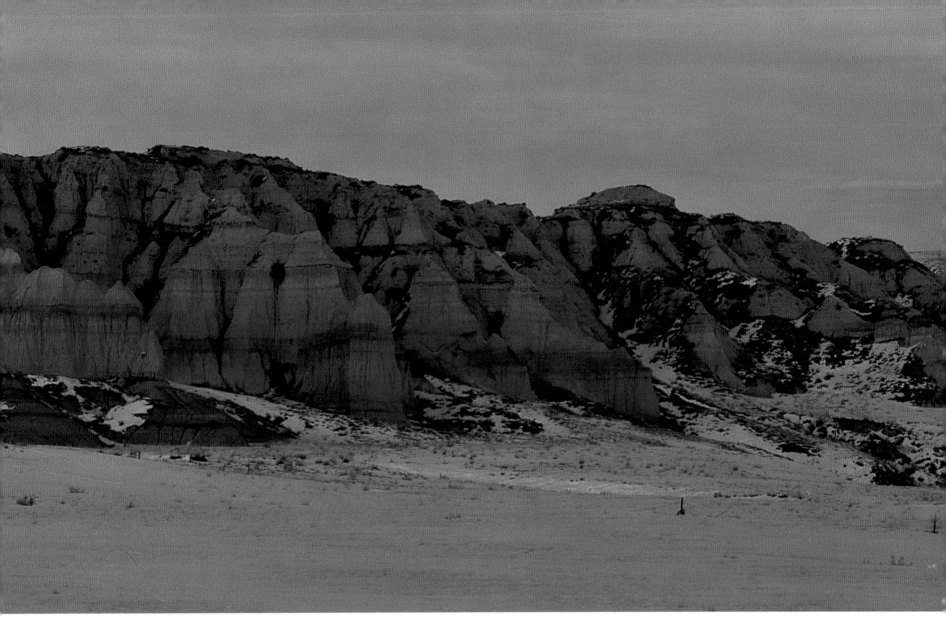

Above: Sandstone badlands near Plentywood pick up the violet tones of dusk. CHUCK HANEY

Right: The low rays of a rising sun bring brilliant hues to the sky over the Missouri River a few miles south of Canyon Ferry Reservoir. JOHN LAMBING

Title page: Winter light on the landscape is unparalleled, as seen here on Jerusalem Rocks in Buckley Coulee, near the international border. CHUCK HANEY

Cover: Wildflowers blanket a meadow above Lake Sherburne, on the east side of Glacier National Park.
CHUCK HANEY

Back cover: Snowmelt from Little Rainbow Mountain feeds Storm Lake, in the 158,416-acre Anaconda-Pintler Wilderness. JOHN LAMBING

Flap: The soft sandstone near Broadus erodes easily, creating these rugged badlands near the Powder River.
JOHN LAMBING

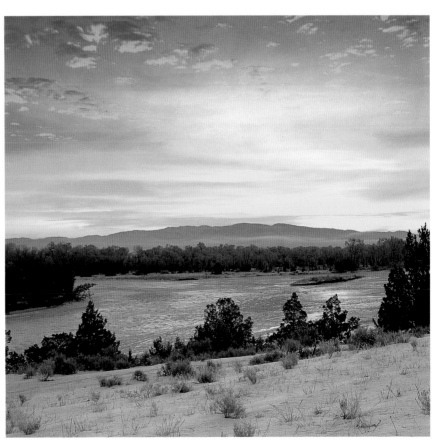

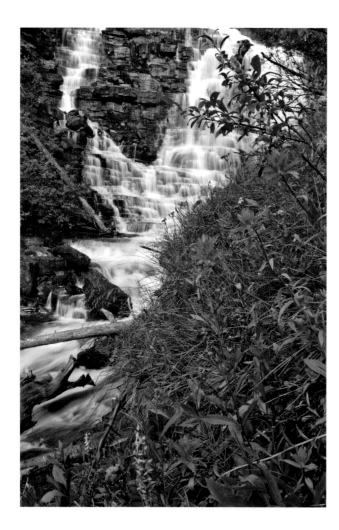

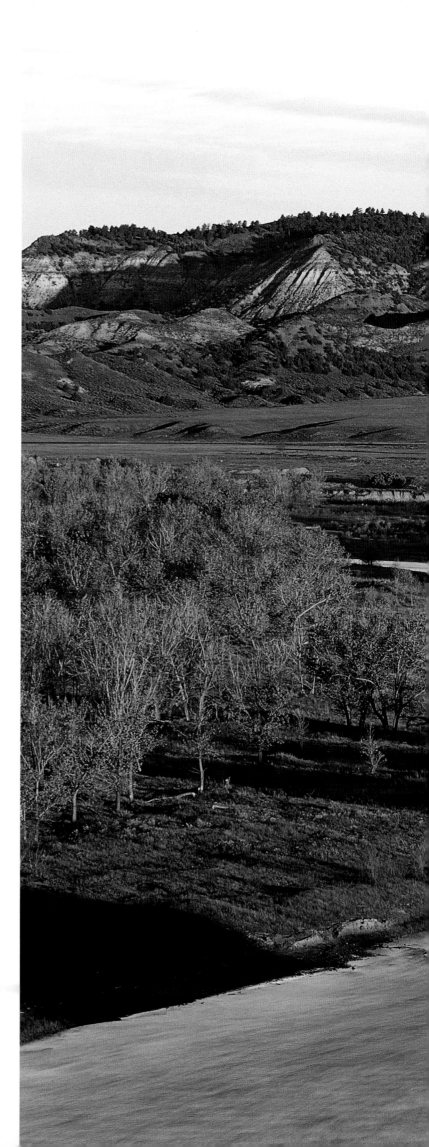

Above, top: Native paintbrush flowers dab tones of pink and red among the nonnative oxeye daisies. CHUCK HANEY

Above, bottom: Florence Falls careens down a lush slope in Glacier National Park. CHUCK HANEY

Right: Beneath the inhospitable badlands near Broadus, the Powder River has created rich bottomlands perfect for grazing and hay production. JOHN LAMBING

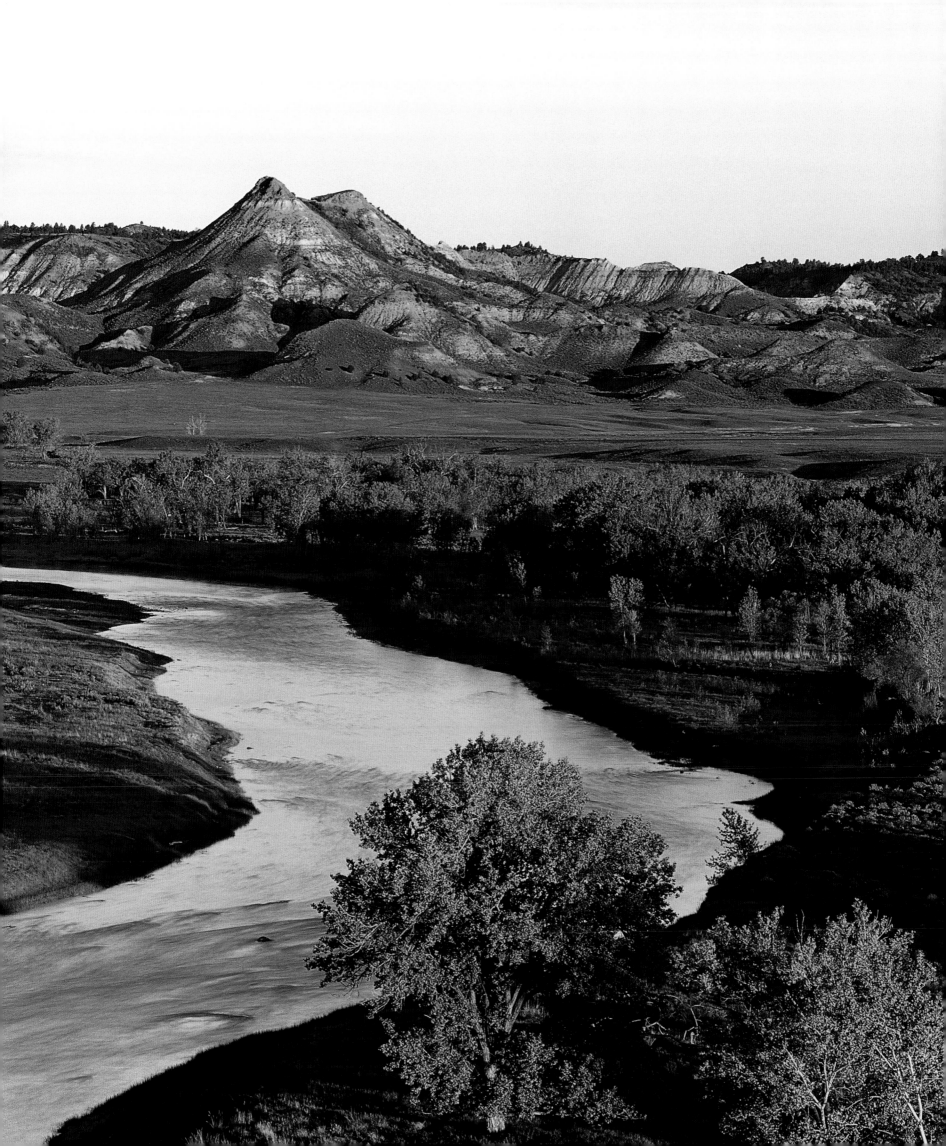

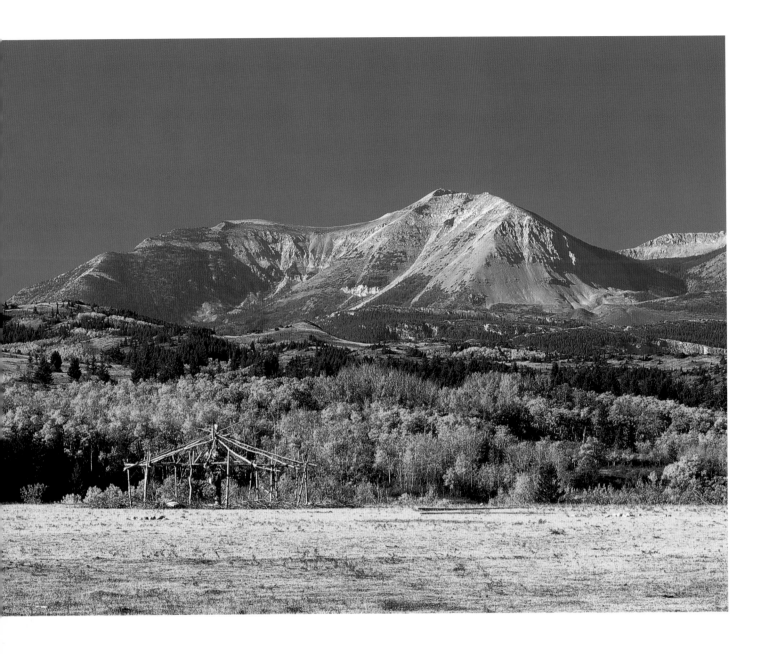

Above: The framework of a sun dance lodge awaits the next ceremony on the Blackfeet Reservation. The reservation encompasses prairie lands that sit at about 3,400 feet elevation as well as mountain peaks that soar above 9,000 feet. JOHN LAMBING

Right: Foliage on quaking aspen trees provides unequaled brilliance in autumn. In the background, the Lima Peaks rise to nearly 11,000 feet, too rugged and severe to sustain any but the most tenacious low-growing vegetation. JOHN LAMBING

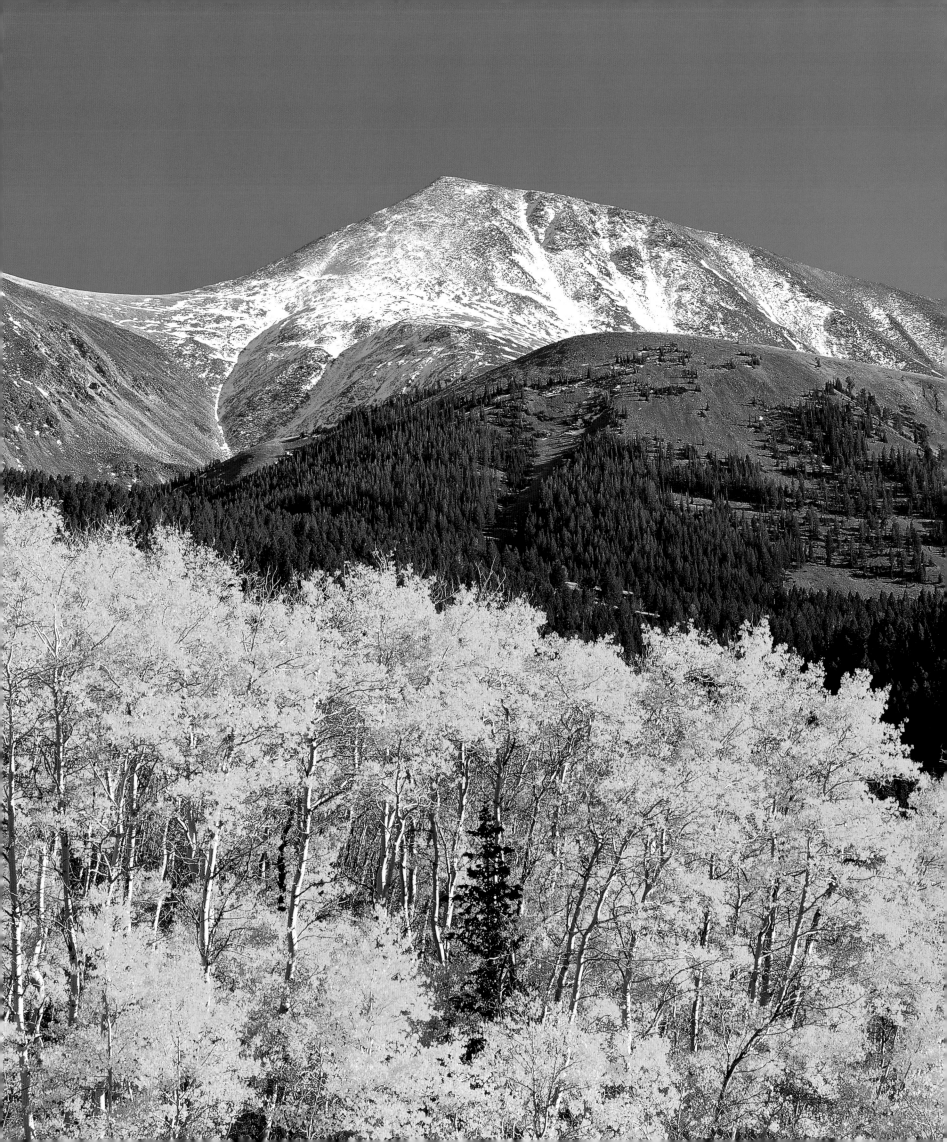

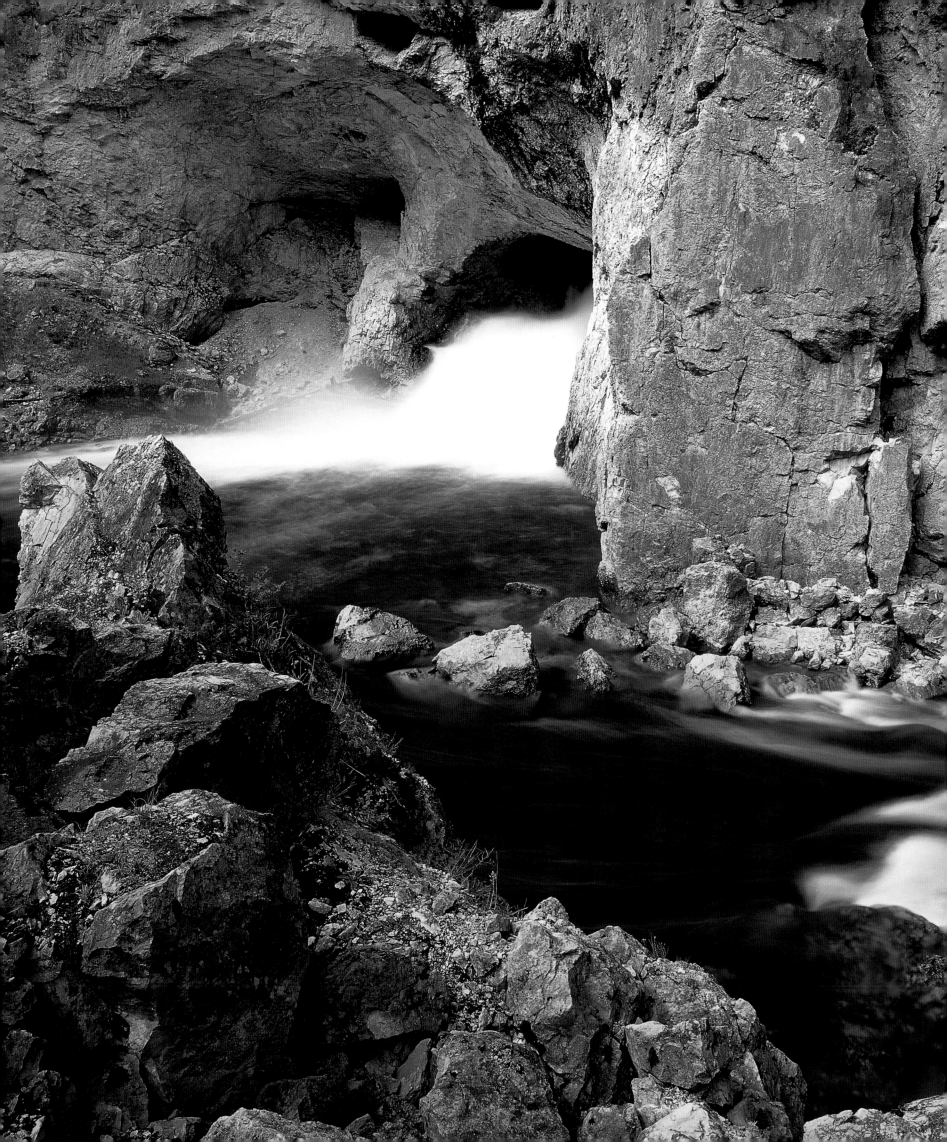

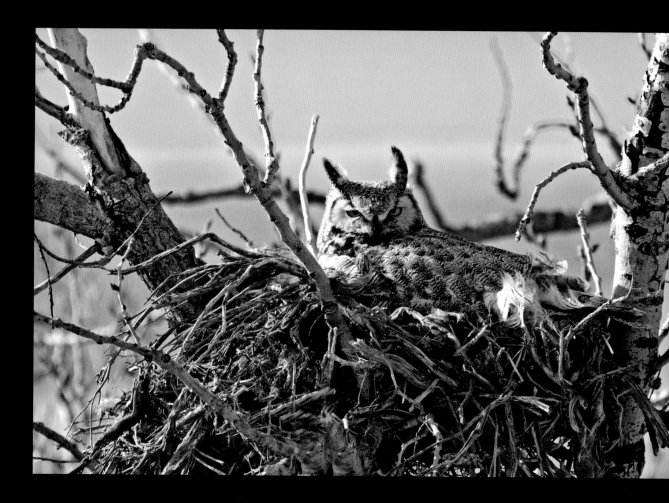

Above: A female great horned owl in her nest near Shelby. Great horned owls are easily recognized by their prominent tufts, yellow eyes, and black beak. CHUCK HANEY

Left: The Boulder River flows through Natural Bridge Monument, disappearing into a large mass of rocks and reappearing 100 feet later. The Boulder River originates high in the Absaroka-Beartooth Wilderness and flows north, joining the Yellowstone River near Big Timber. JOHN LAMBING

Right: Often called prairie dogs, Columbian ground squirrels dig out and inhabit vast underground networks of interconnected dens and runways. CHUCK HANEY

Far right: Canola blooms brighten a field near the Moccasin Mountains, about fifteen miles from Lewistown. Canola seed is processed to make cooking oil, livestock feed, and biodiesel. Canola crops fill more than a million acres of land in Montana. JOHN LAMBING

Below: Montana's official state bird is the meadowlark. The male seen here is singing its melodic, distinctive, descending trill. CHUCK HANEY

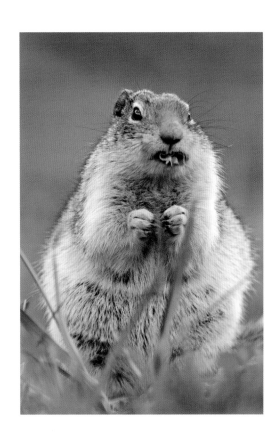

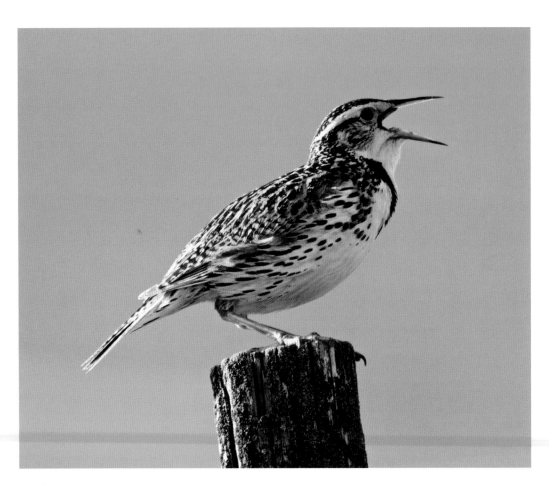

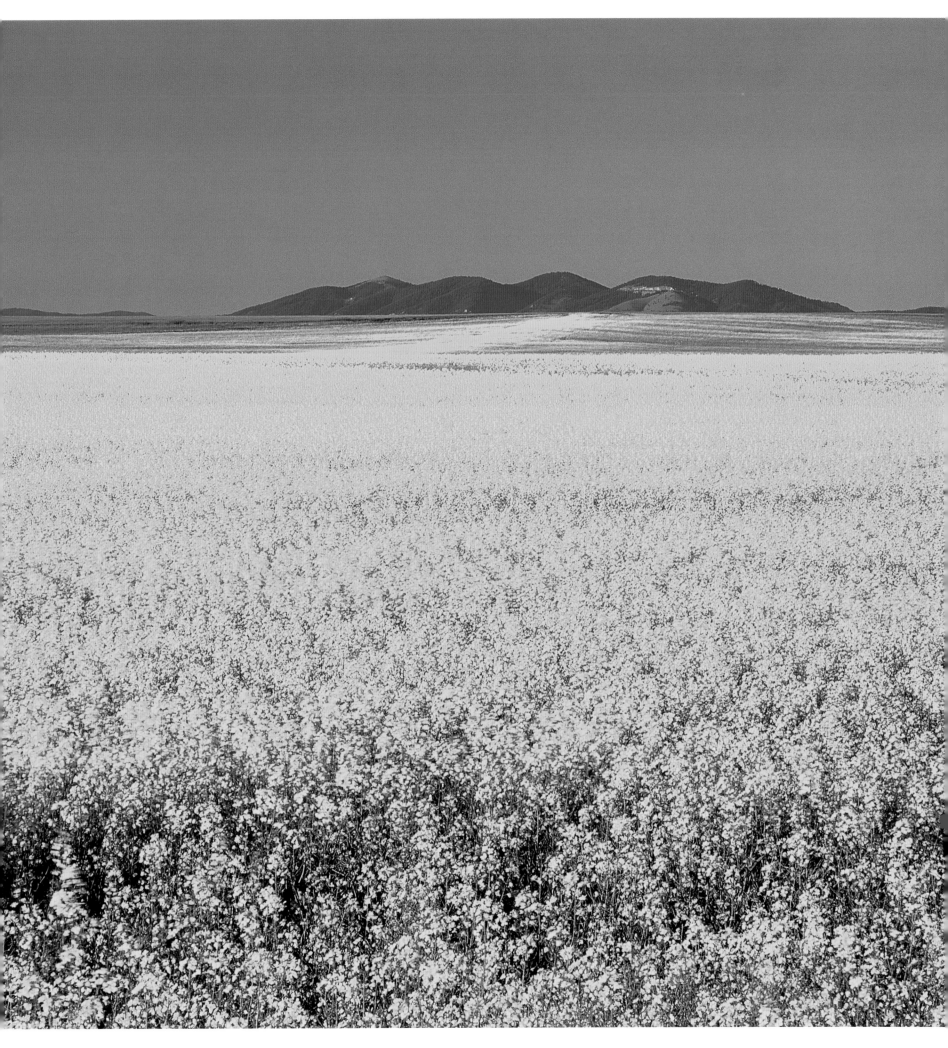

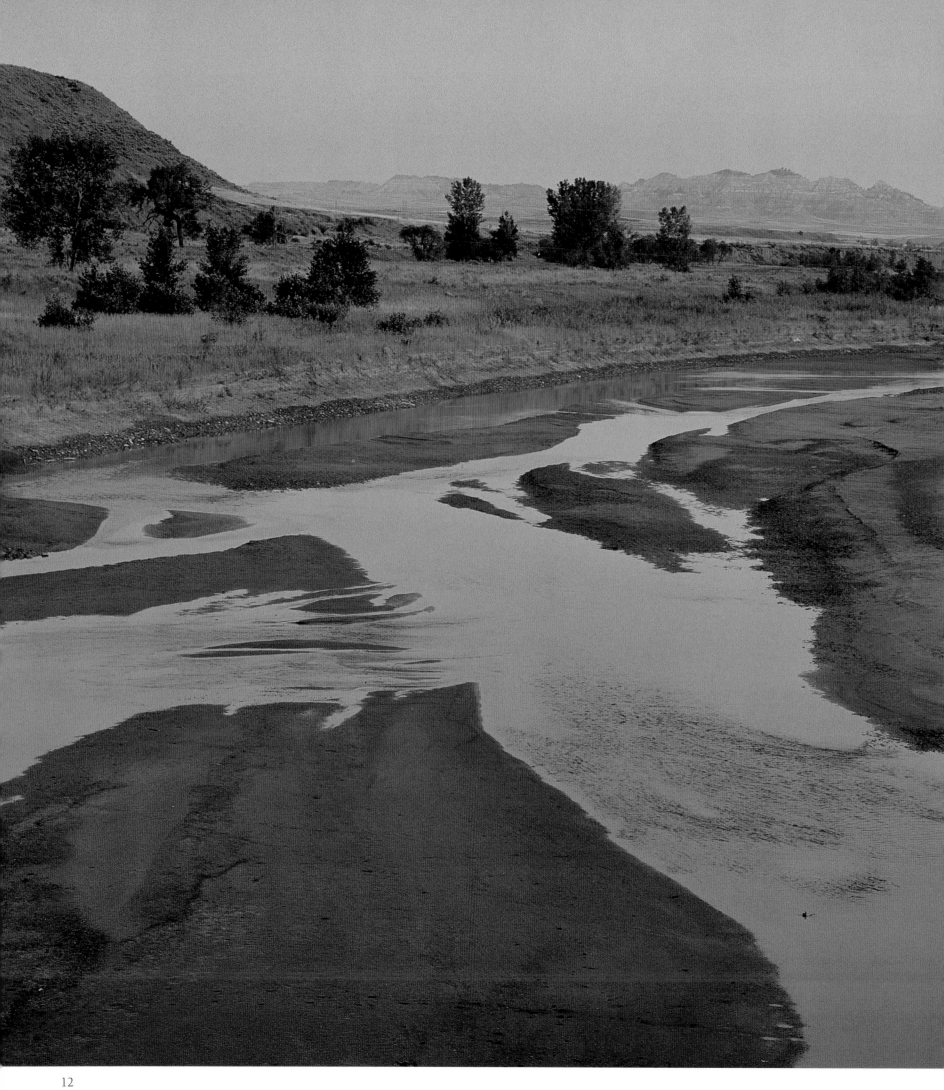

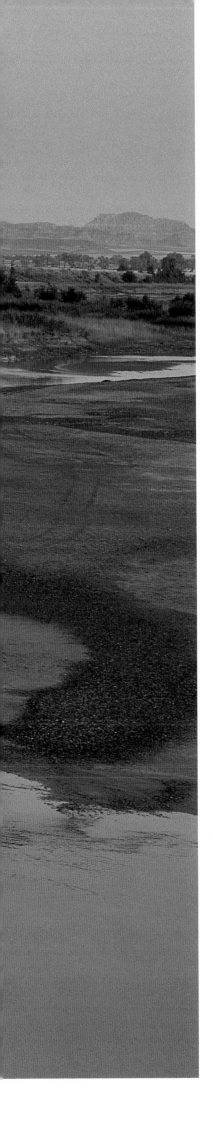

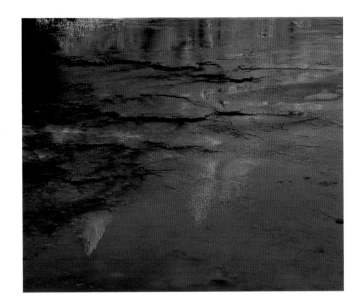

Left: Newly formed ice in Lost Creek reflects autumn colors in the Swan Valley. CHUCK HANEY

Far left: The Powder River slows to a trickle in summer, much of its flow diverted to irrigate hayfields on adjacent benchlands. CHUCK HANEY

Below: Early winter brings freezing nights and sunny days to the Yellowstone River. Ice always forms first along the banks or over shallow gravel bars, where the current is slow. CHUCK HANEY

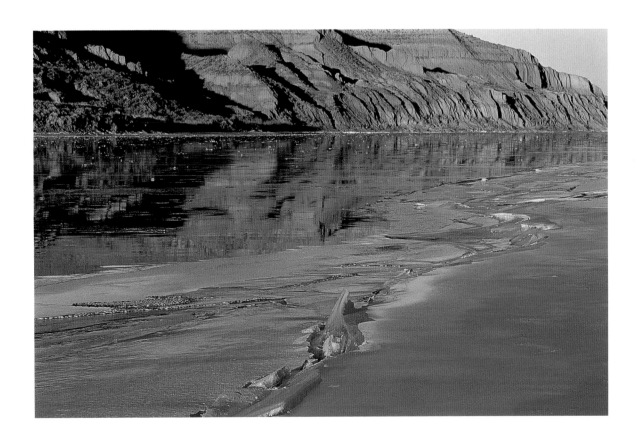

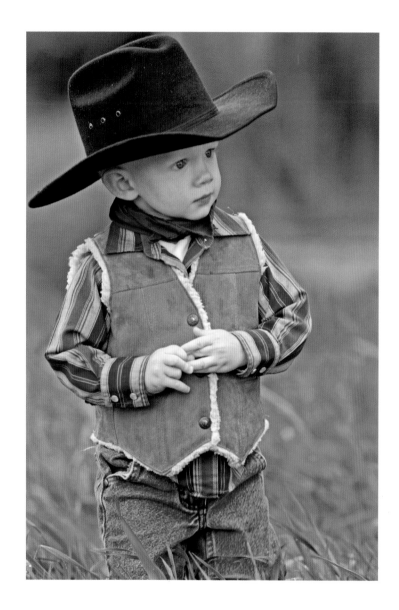

These pages: A cowboy in the making, young Jim Perry
intently watches the herding action at the Lee Ranch
in Judith Gap country. CHUCK HANEY

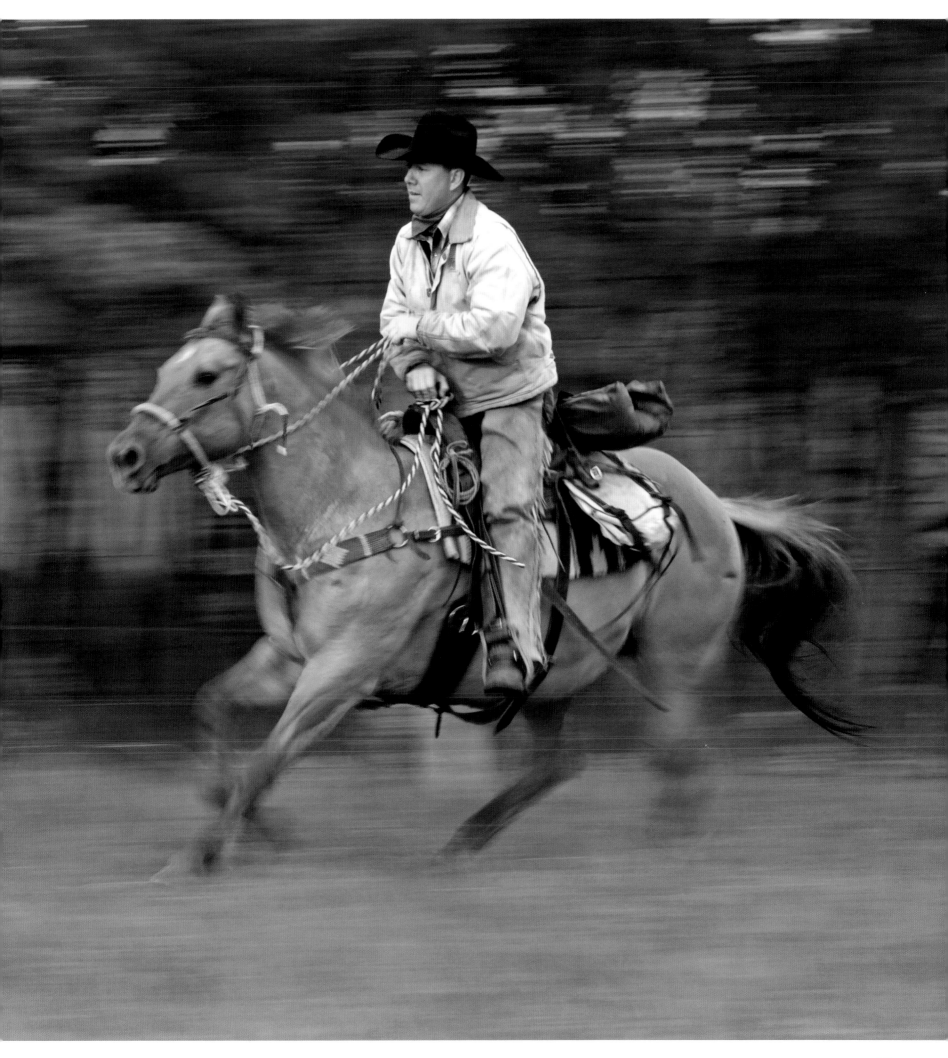

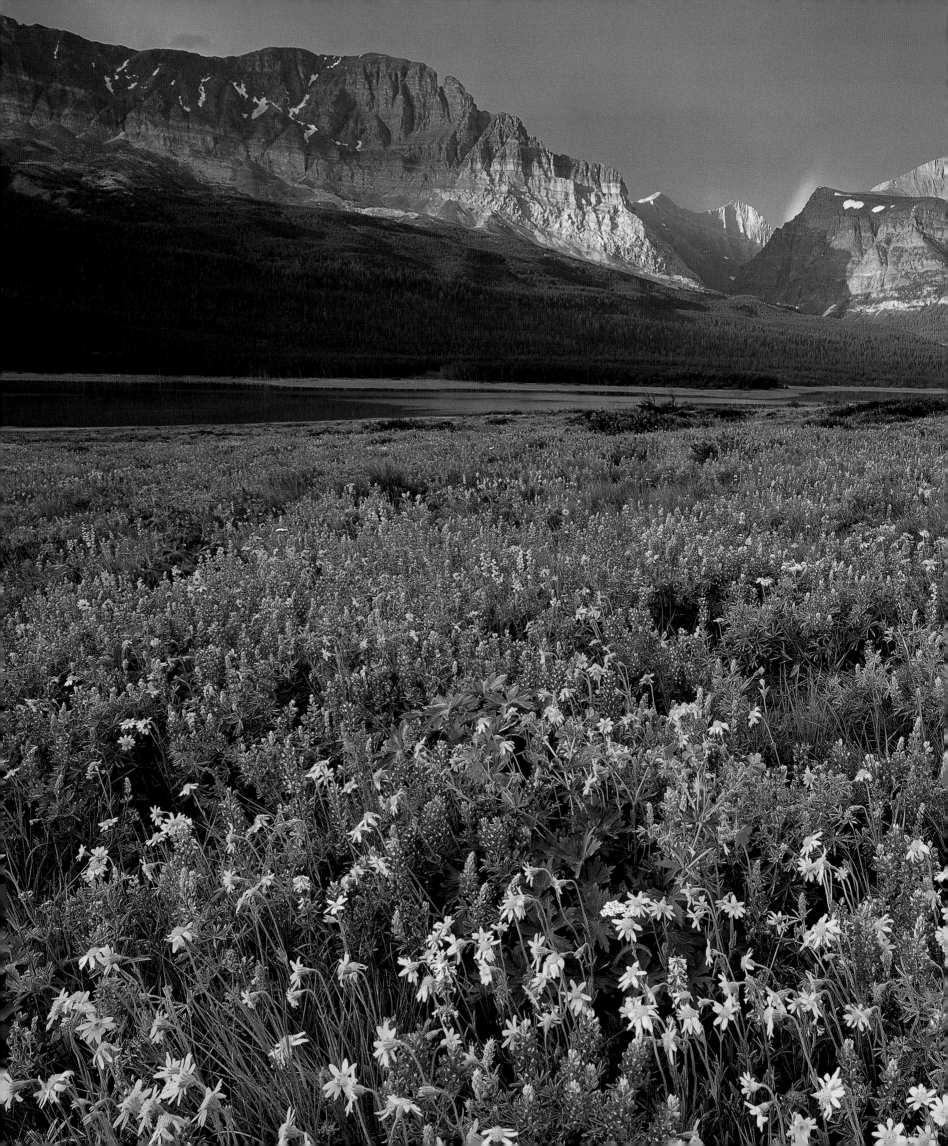

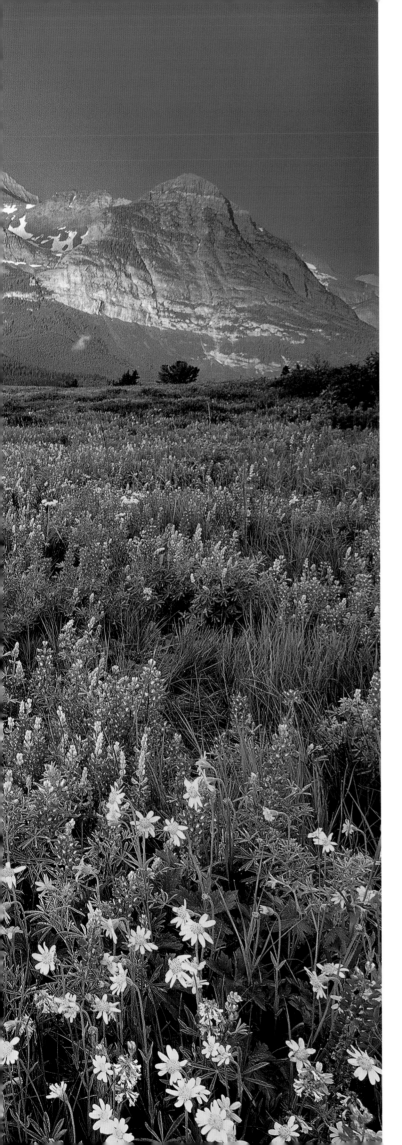

Left: Lupine, mule's ear, and sticky geranium create a multicolored mosaic of wildflowers in a meadow next to Lake Sherburne, rivaling the colorful rainbow peeking from between the rugged peaks at Many Glacier. CHUCK HANEY

Below, top: Sticky geranium was named for the fine hairs on its stem and leaves that make the plant feel sticky. CHUCK HANEY

Below, bottom: Look closely to see why this penstemon got the common name fuzzy-tongue. JOHN LAMBING

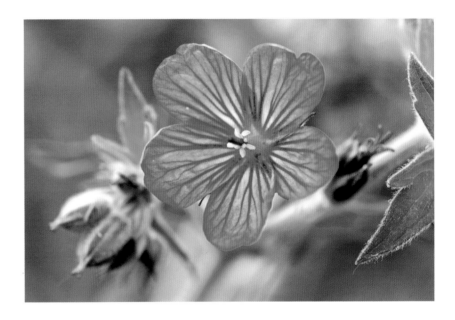

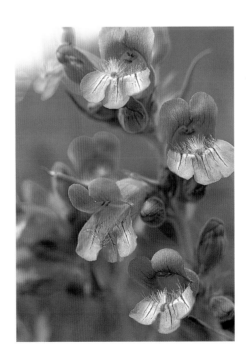

17

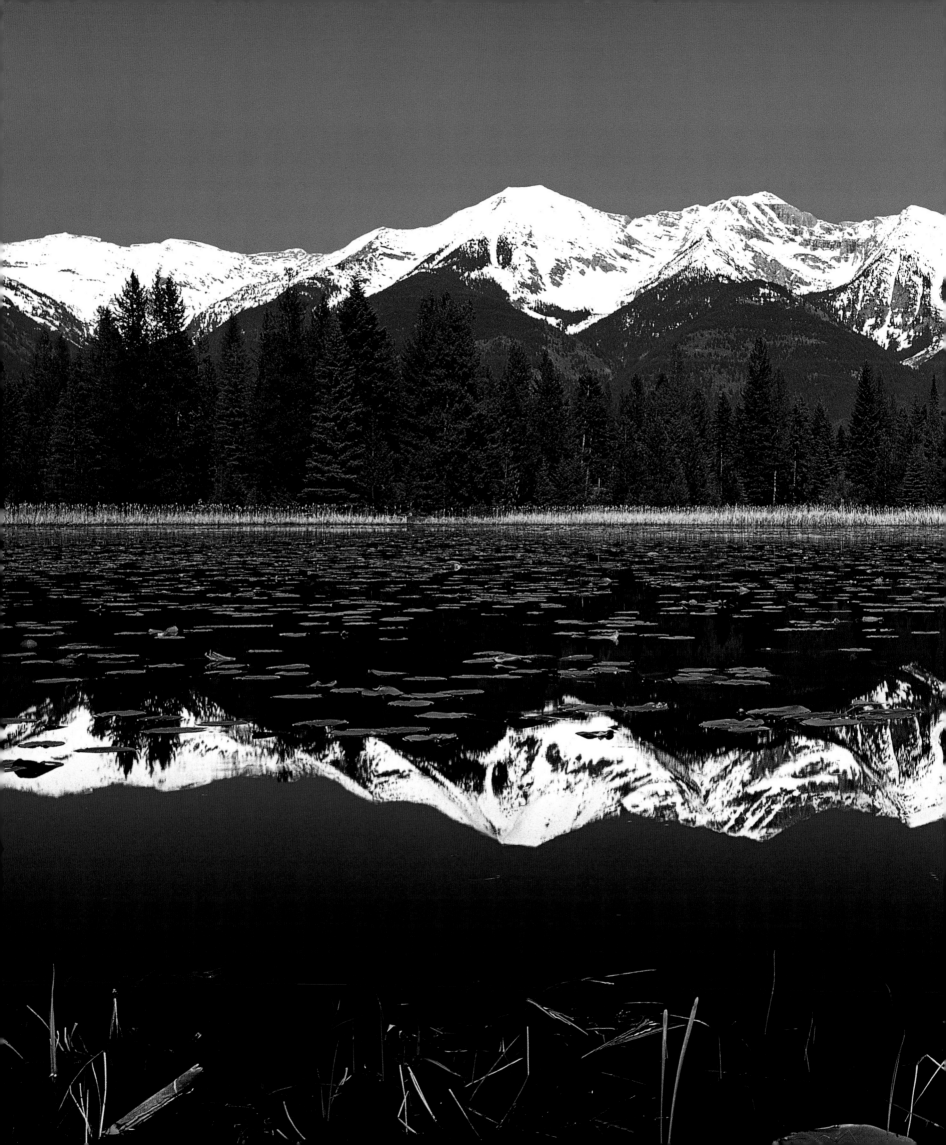

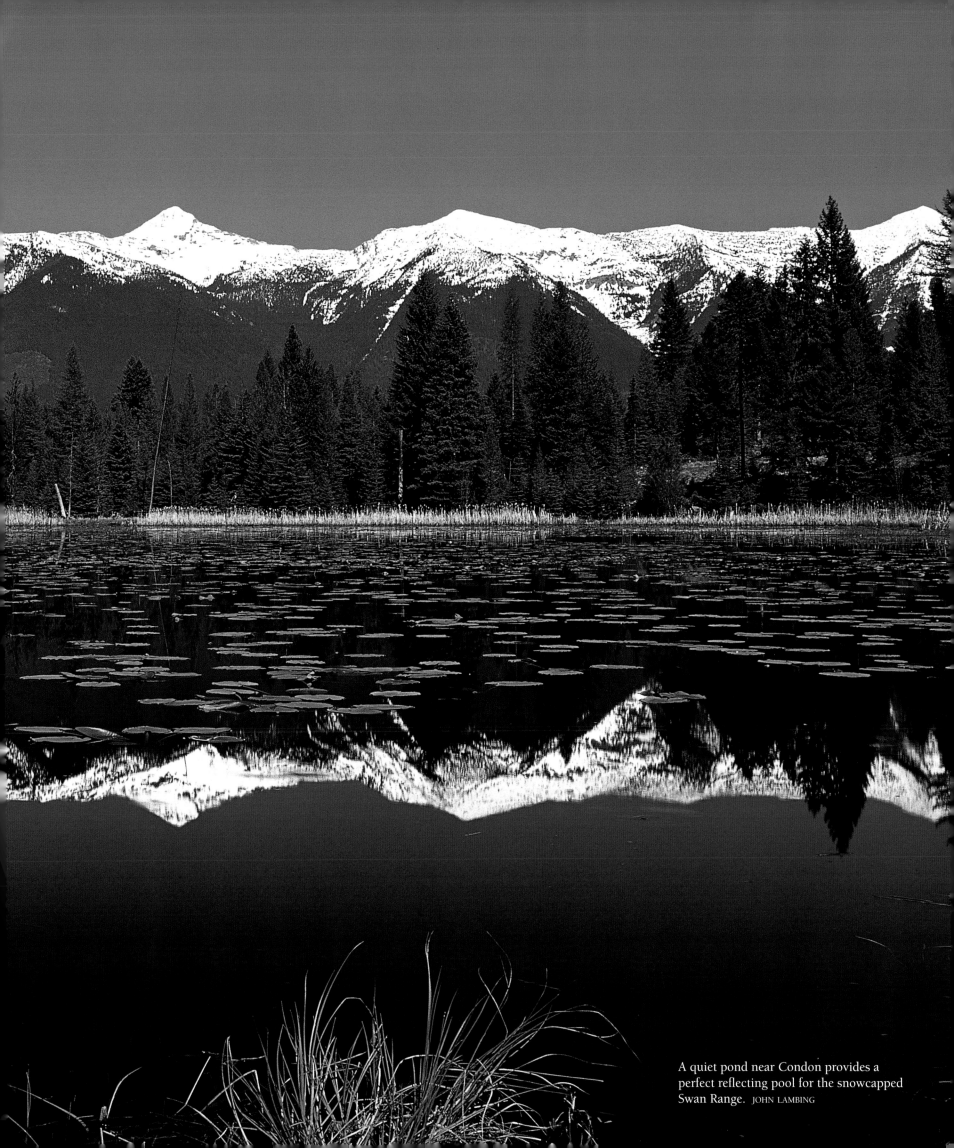

A quiet pond near Condon provides a perfect reflecting pool for the snowcapped Swan Range. JOHN LAMBING

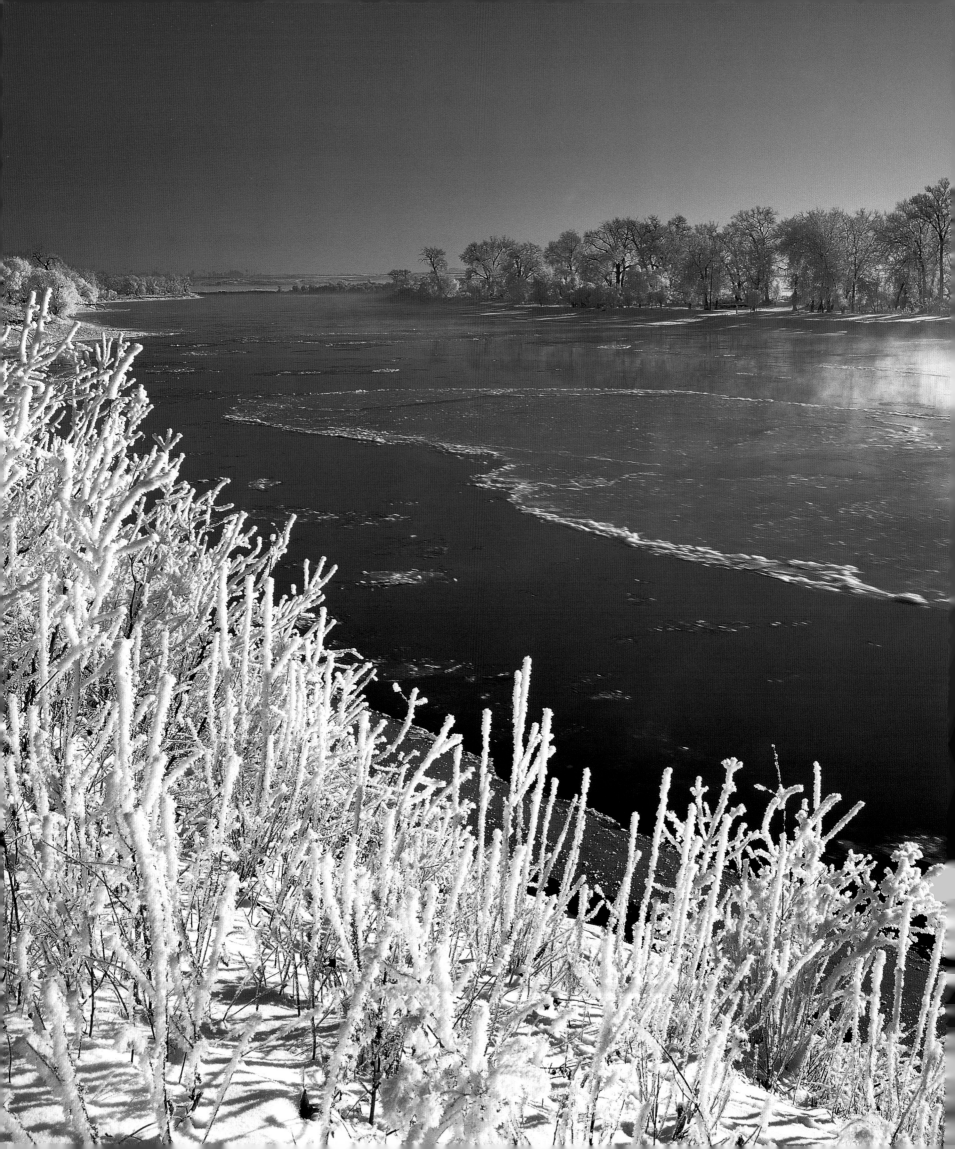

Left: The river water is warmer than the frosty air, causing a lovely mist to form over the open water on the Missouri River near Ulm. JOHN LAMBING

Below: Eons of wind erosion created the bright-white sandstone hoodoos in the hills south of Dillon. JOHN LAMBING

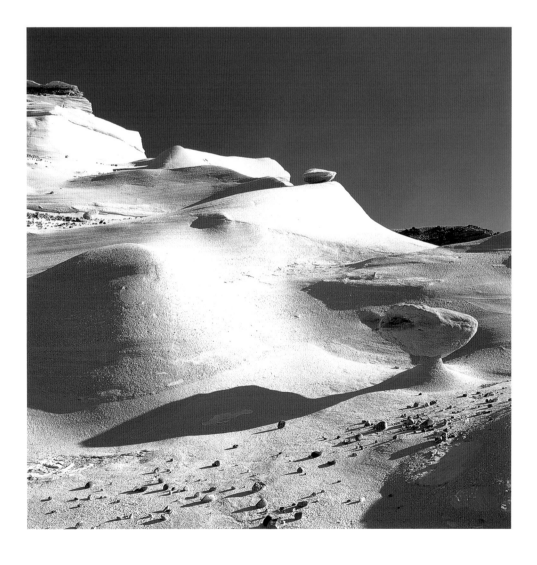

Right: A field of ripe grain waves in the breeze near Valier, in Montana's fertile "Golden Triangle," so named for the extensive fields of barley, wheat, and other grains that turn gold when ready for harvest. JOHN LAMBING

Below: Grain elevators, this one near Choteau, dot the Montana landscape, evidence of the state's long tradition of agriculture. JOHN LAMBING

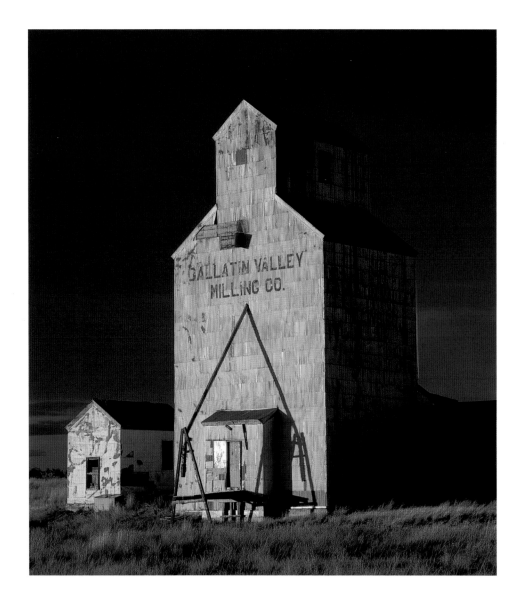

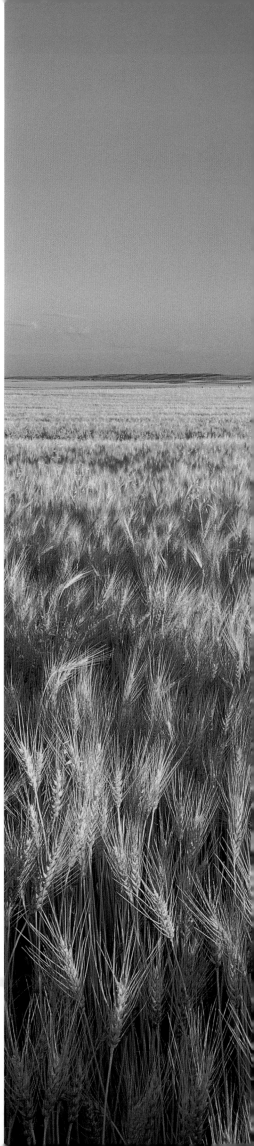

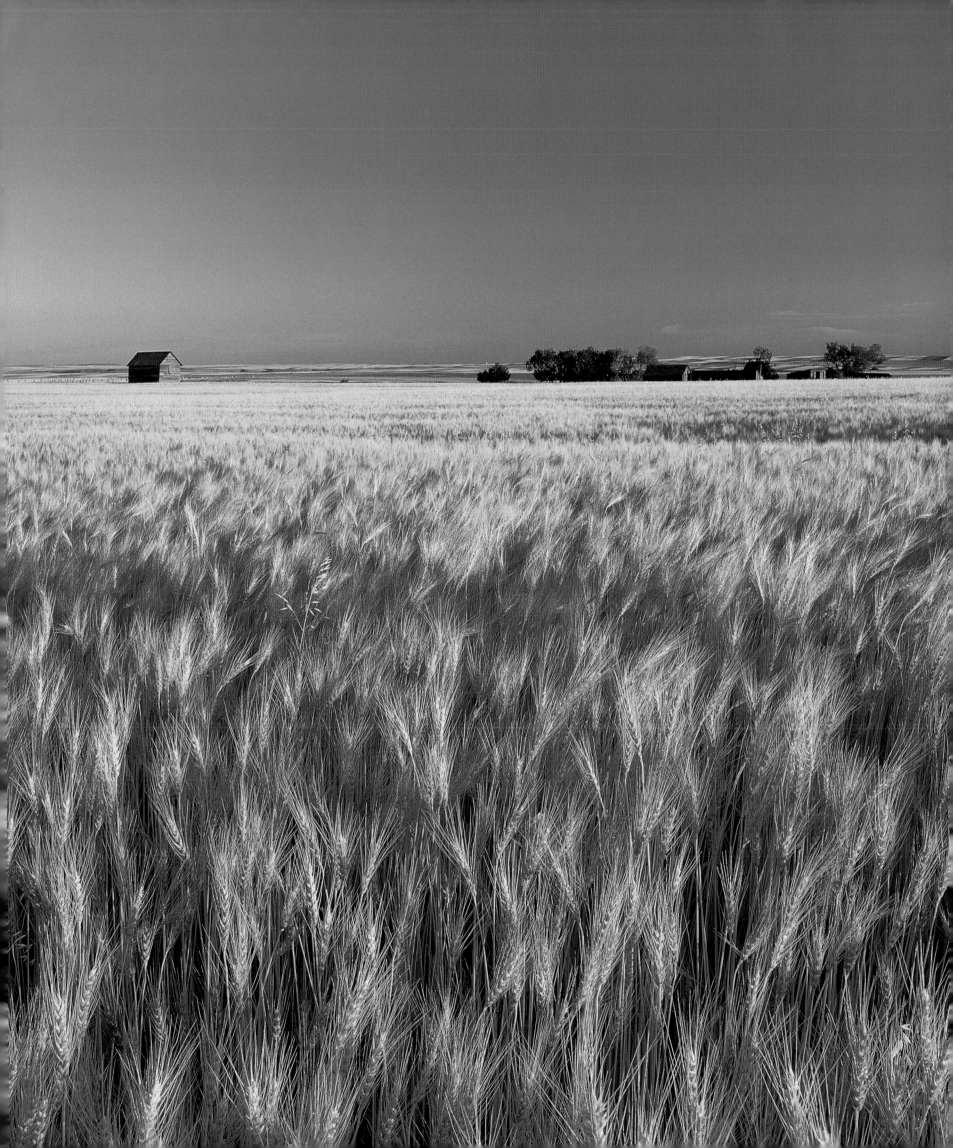

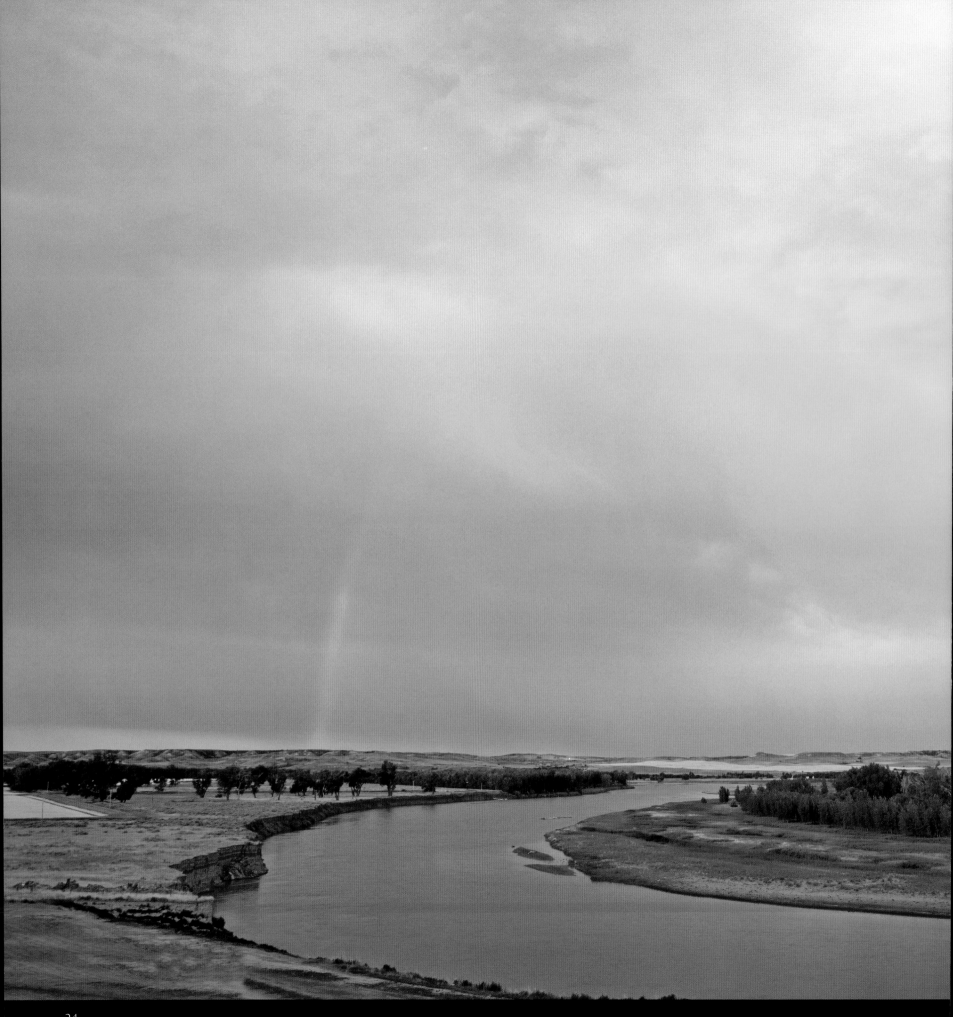

Left: Beneath a pastel sky graced with a rainbow, the Missouri River flows gently from near Bainville, Montana, across the state line to North Dakota. CHUCK HANEY

Below: A misty dawn adorns the Yellowstone River near Forsyth. CHUCK HANEY

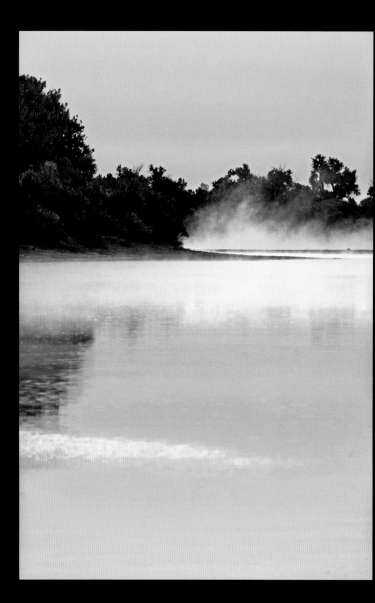

Right: Canoeing through the White Cliffs section of the Upper Missouri River Breaks National Monument. The pleasant and scenic float through the Breaks is a favorite multi-day trip for canoeists and rafters. CHUCK HANEY

Below: A kayaker paddles at sunset on Whitefish Lake. CHUCK HANEY

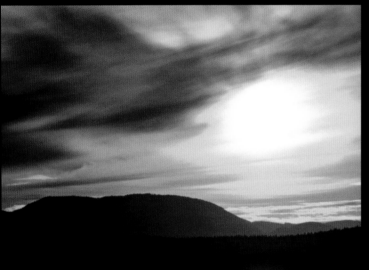

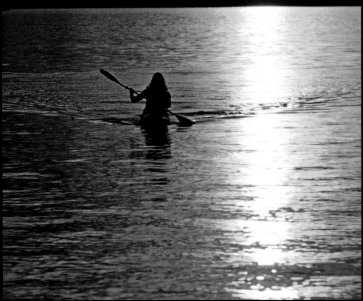

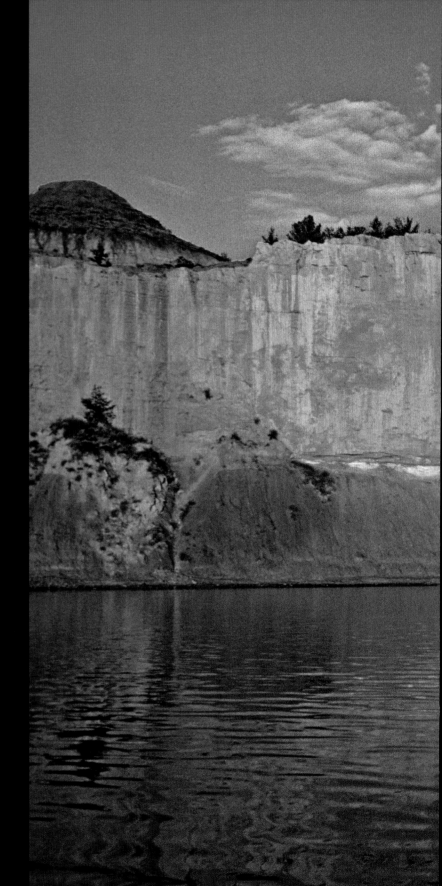

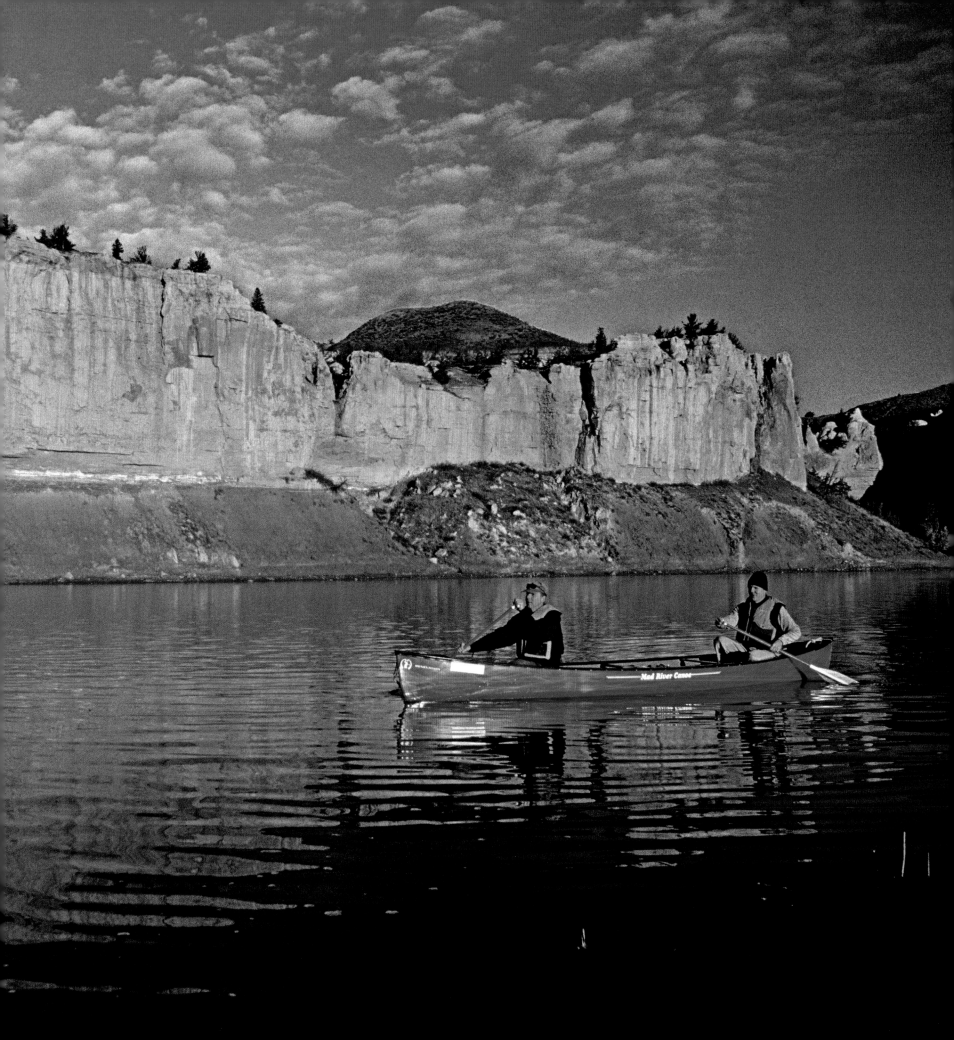

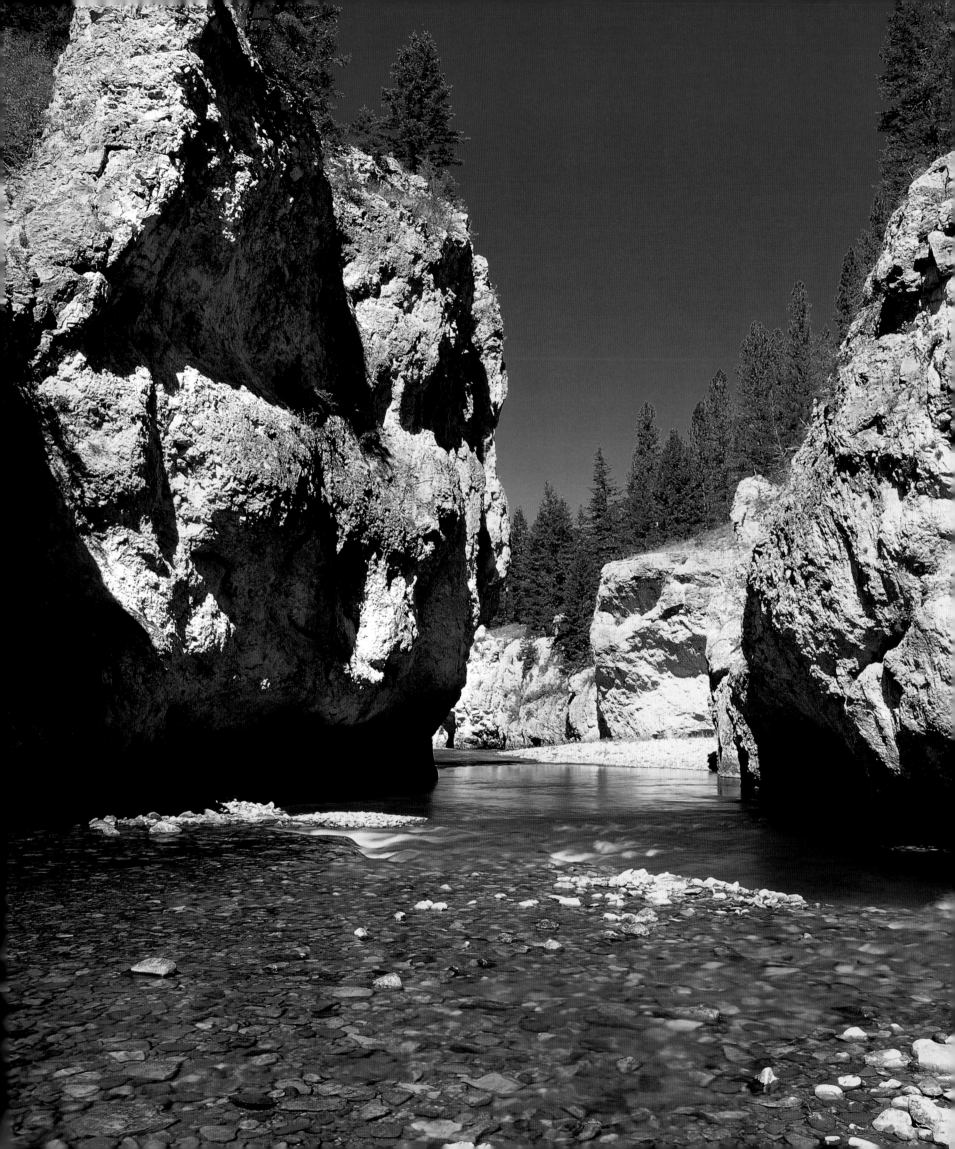

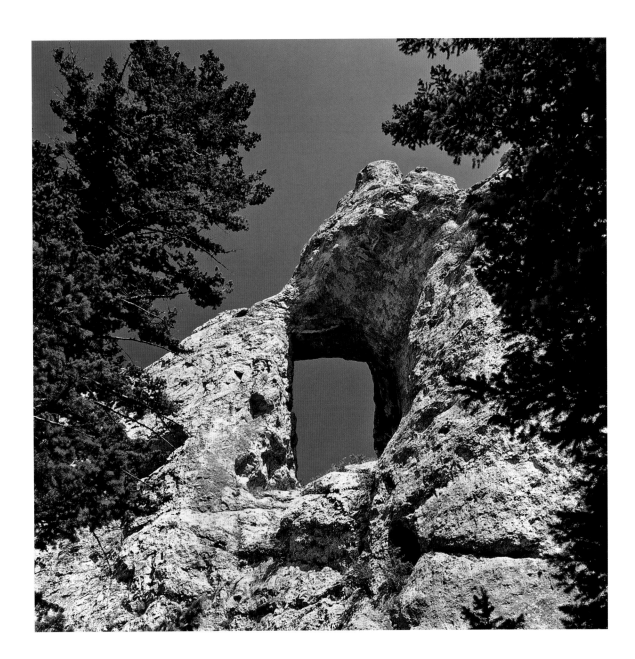

Above: Holes and arches abound in the limestone cliffs of the Little Belt Mountains. Natural arches are created by wind erosion, natural bridges by water. JOHN LAMBING

Left: Belt Creek has carved a thoroughfare through the limestone of Sluice Boxes State Park. The park has beautiful natural features, as well as hiking trails that lead to a ghost town, mining relics, abandoned railroad trestles, and other historical curiosities. JOHN LAMBING

Right: Canyon Ferry Reservoir is renowned for its smooth ice and gorgeous backdrop, drawing iceboat enthusiasts from around the world. JOHN LAMBING

Below, top: A climber assesses his possible route up an icefall on the Rocky Mountain Front. JOHN LAMBING

Below, bottom: Rushing water doesn't freeze easily, and this stream in the Seeley-Swan Valley is resisting complete ice-over. JOHN LAMBING

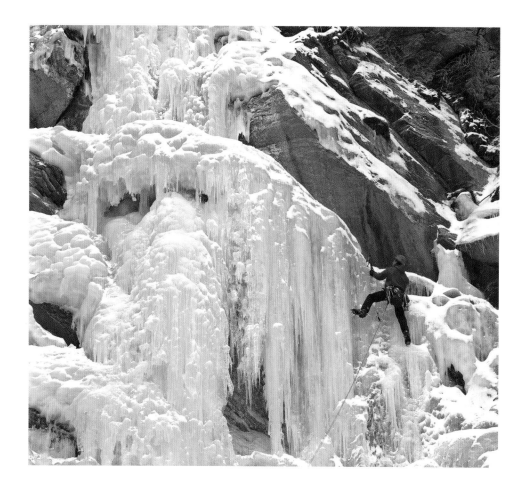

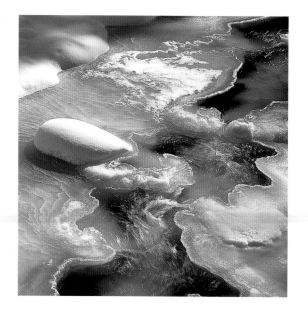

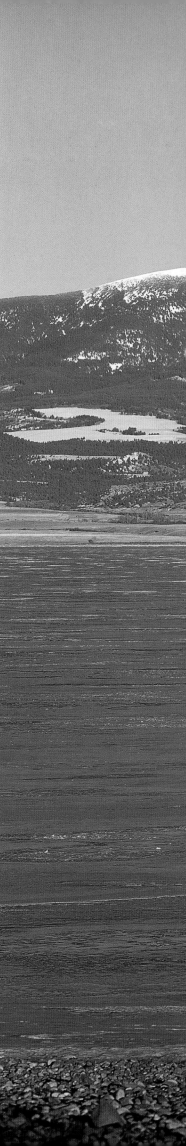

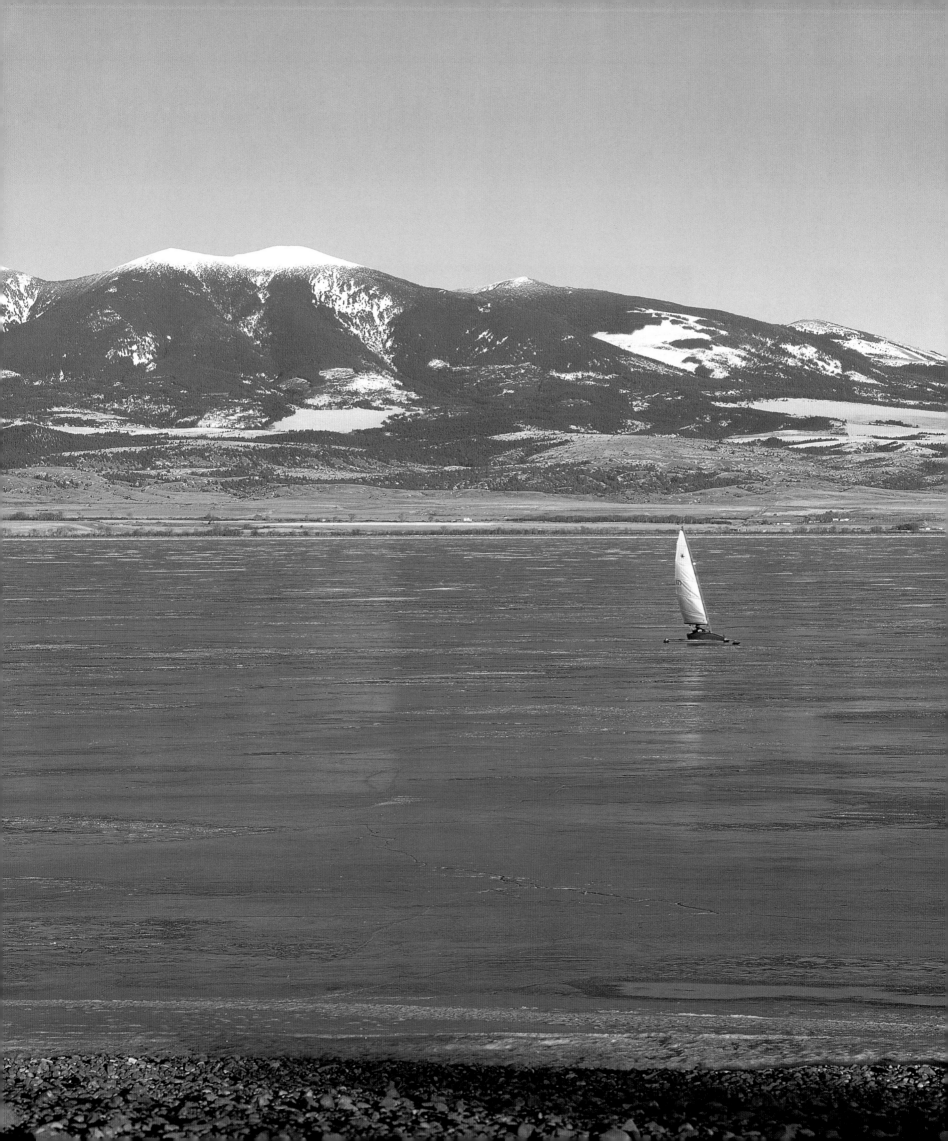

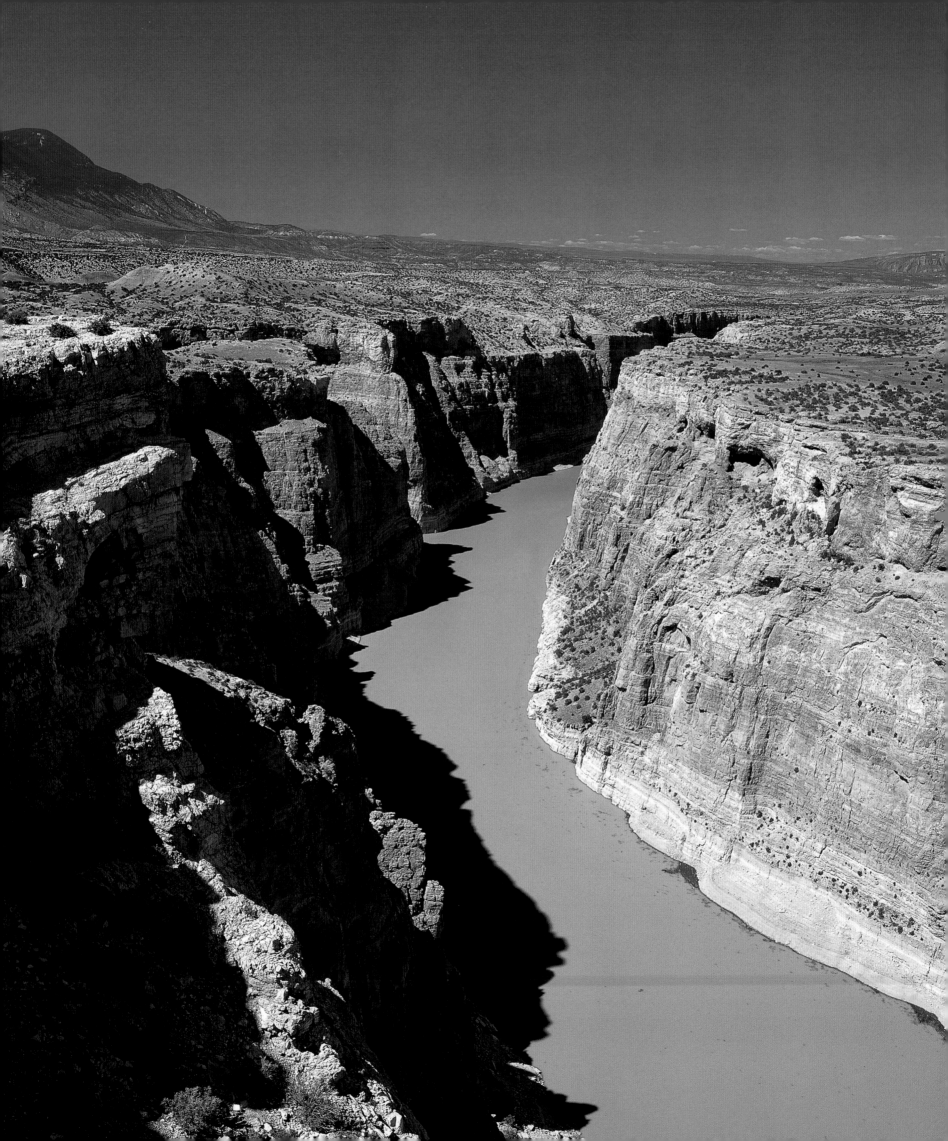

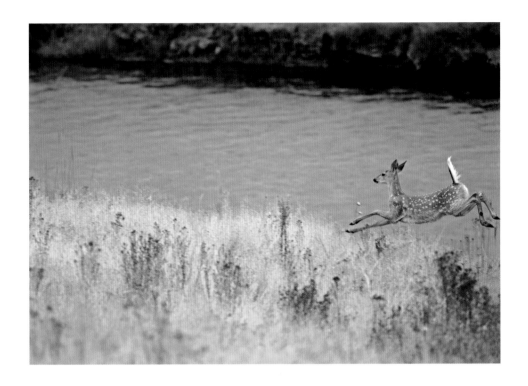

Left: Its tail-flag waving, a white-tailed deer fawn takes flight next to Mission Creek in the National Bison Range Wildlife Refuge. CHUCK HANEY

Facing page: The Bighorn River cut this canyon through southern Montana. A dam at the mouth of the canyon backed up water to create a 71-mile-long reservoir, now enclosed within Bighorn Canyon National Recreation Area. JOHN LAMBING

Below: A bull moose pauses between taking mouthfuls of aquatic vegetation in Glacier National Park's Fishercap Lake. CHUCK HANEY

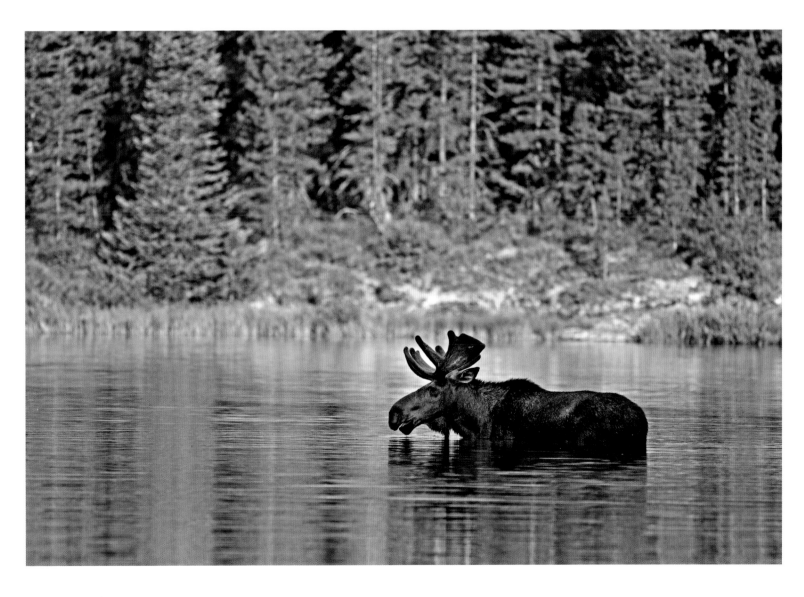

Right: Wetlands in the Bull River Valley reflect the surrounding Cabinet Mountains. The area's rich diversity of plant life ranges from immense old-growth cedars in the valleys to tiny subalpine plants clinging to 8,738-foot Snowshoe Peak, the highest summit in the Cabinets. JOHN LAMBING

Below: A few ghostly trunks stand in stark contrast to the colorful, dense undergrowth on the slopes of an area near Inspiration Pass in the Swan Range that burned years ago. The young trees are growing vigorously and will soon create another thick forest. JOHN LAMBING

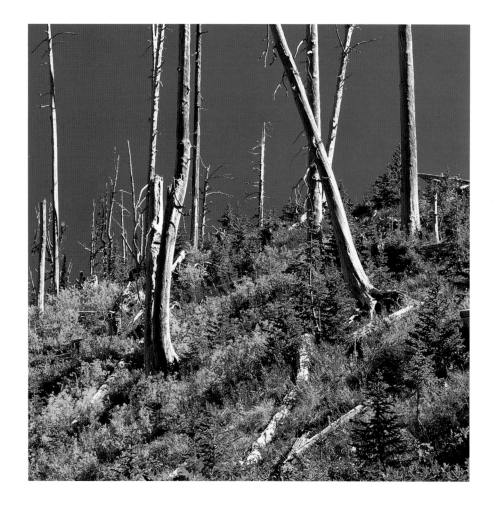

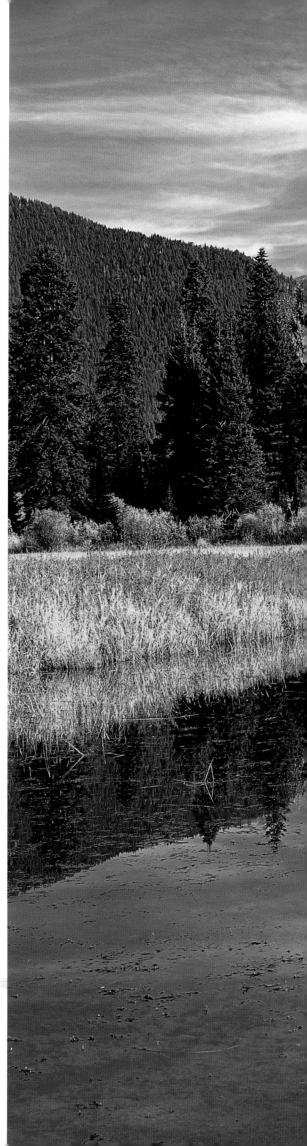

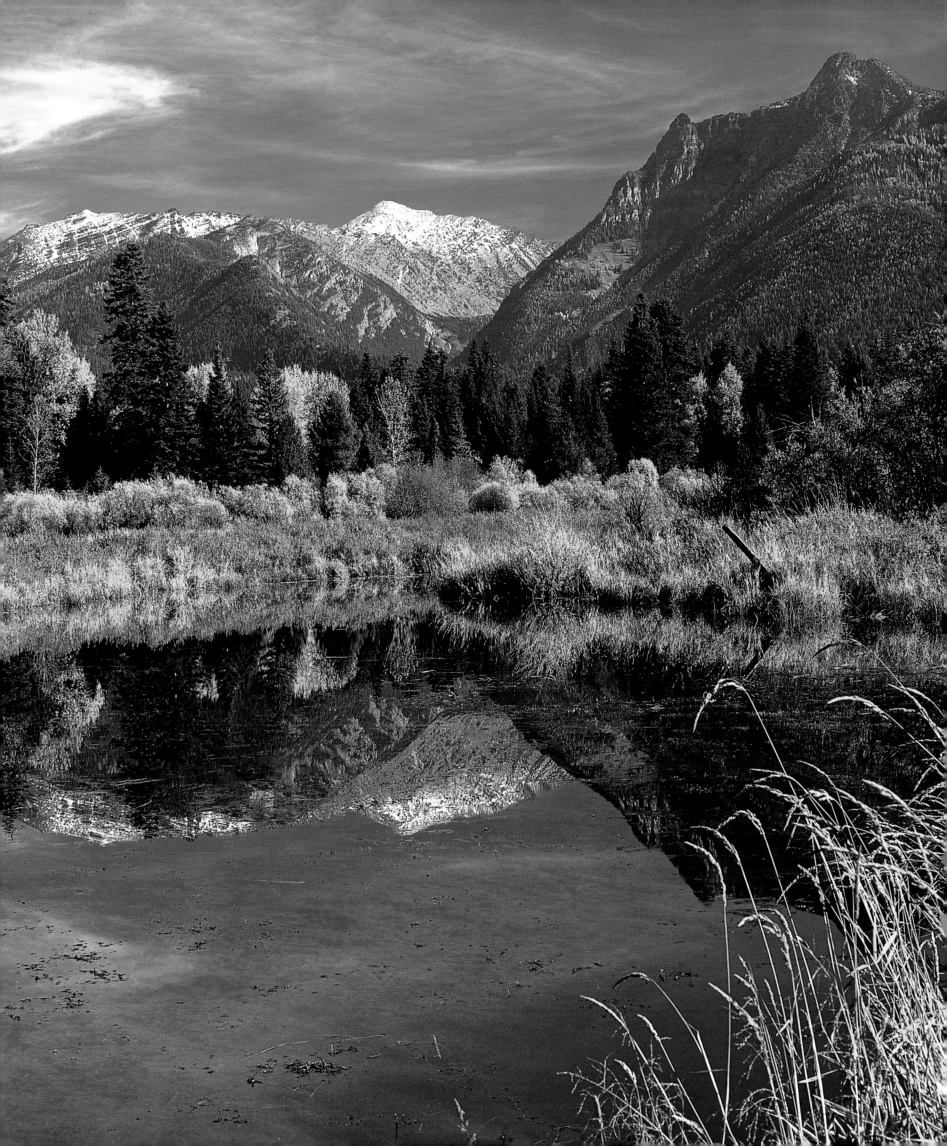

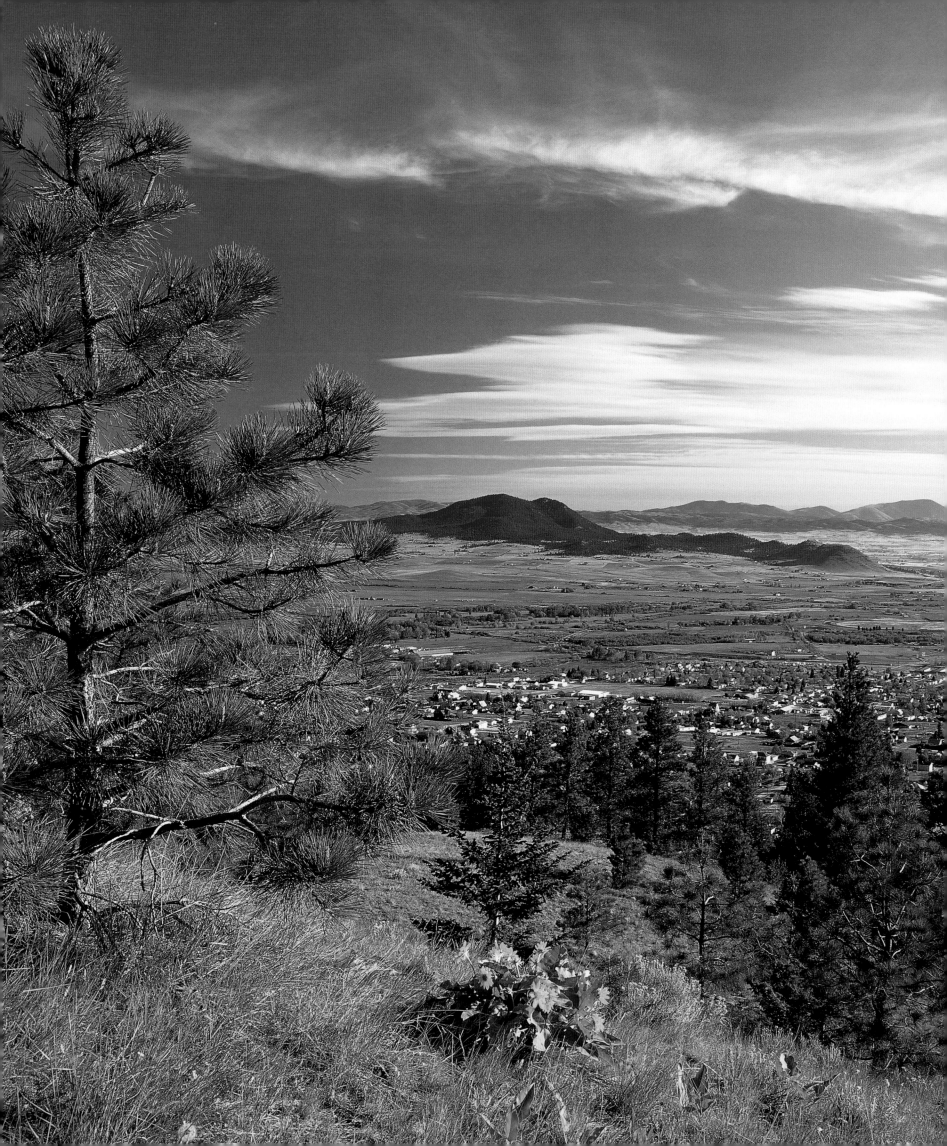

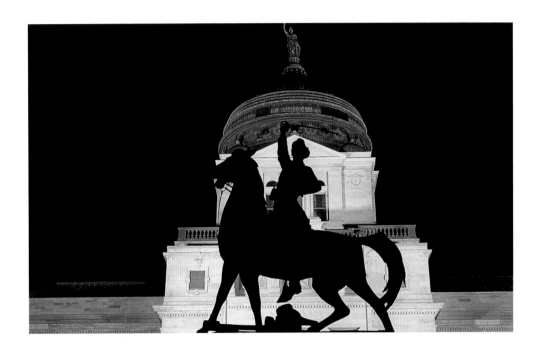

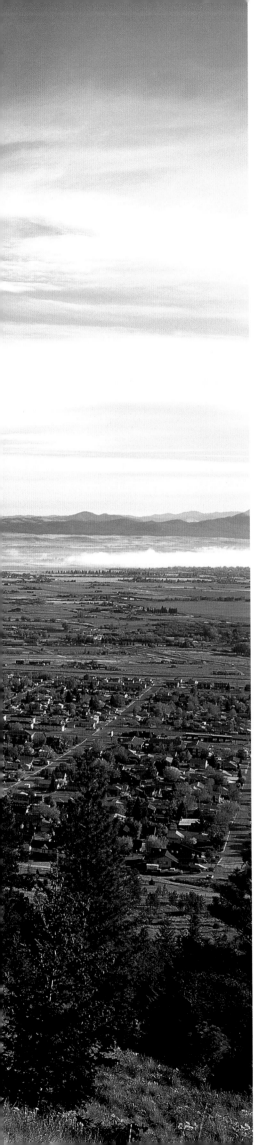

Above: A statue of Thomas Francis Meagher, a Union veteran of the Civil War who twice served as acting governor of Montana Territory, eternally raises his sword in front of the state capitol in Helena. JOHN LAMBING

Left: From the trails on Mount Helena, Helena's largest city park, hikers and mountain bikers can enjoy 360-degree vistas of the area, including this view of the Scratchgravel Hills and Sleeping Giant north of town. JOHN LAMBING

Below: An official city landmark, Helena's twenty-five-foot-high Old Fire Tower, known as the Guardian of the Gulch, was built in 1876 after a fire devastated the businesses along Last Chance Gulch. It watched over the downtown area until 1931. Today, Helenans decorate the historic fire tower during the holidays. JOHN LAMBING

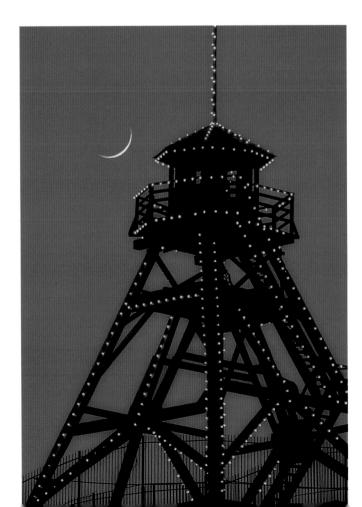

Right: Golden bouquets of arrowleaf balsamroot adorn a grassy meadow in the foothills of the Big Snowy Mountains near Lewistown. CHUCK HANEY

Below, top: Prickly pear cactus plants produce exquisite blossoms each spring. JOHN LAMBING

Below, bottom: This wild sunflower awaits a passing insect to carry its pollen to another blossom. JOHN LAMBING

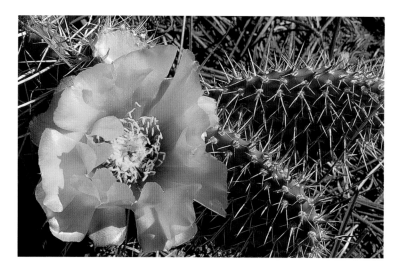

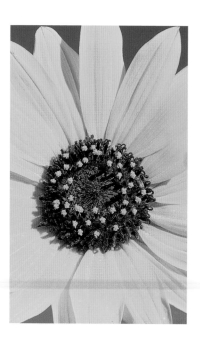

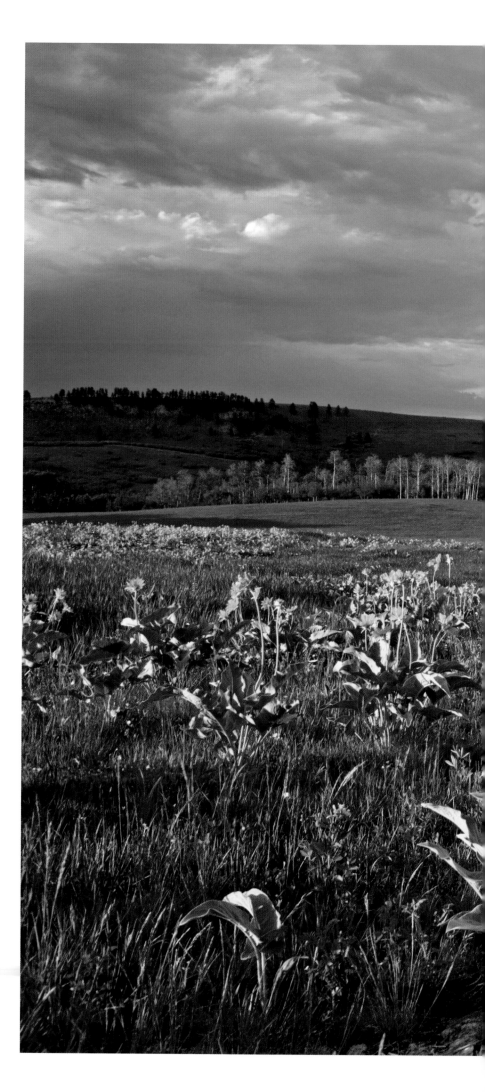

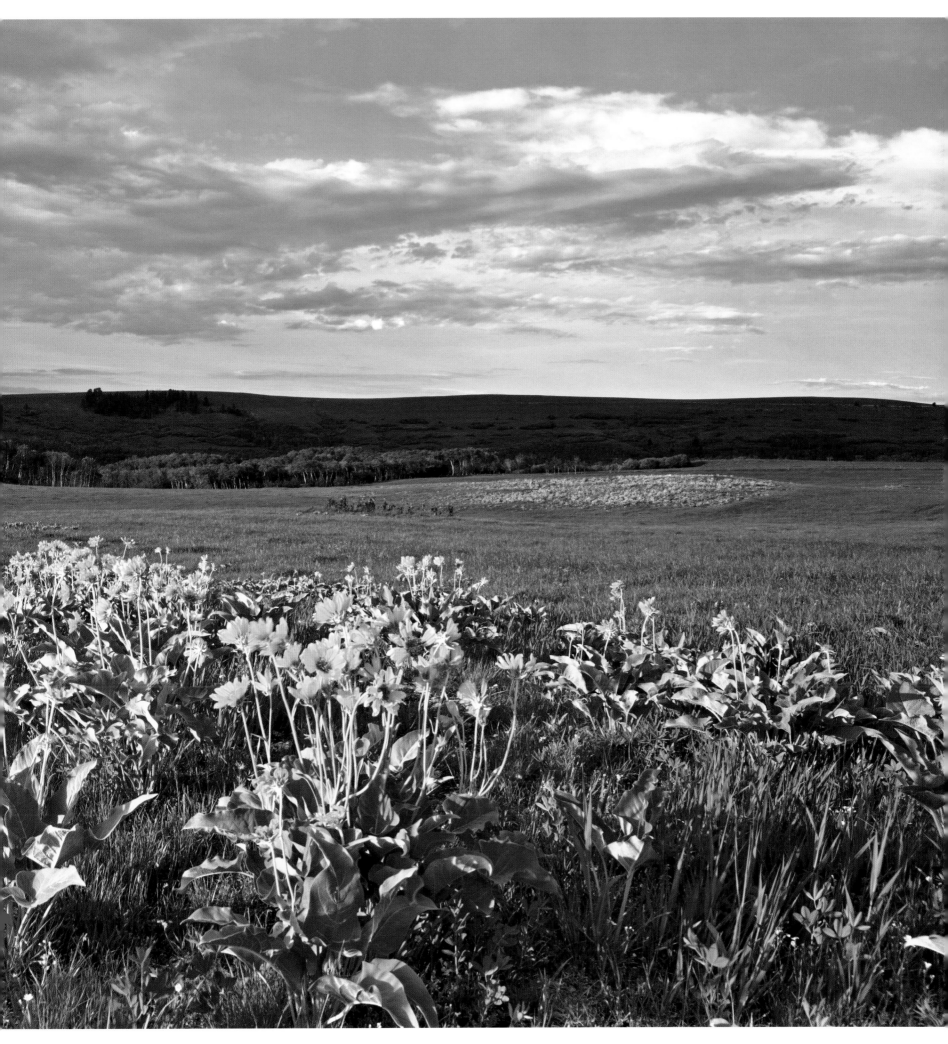

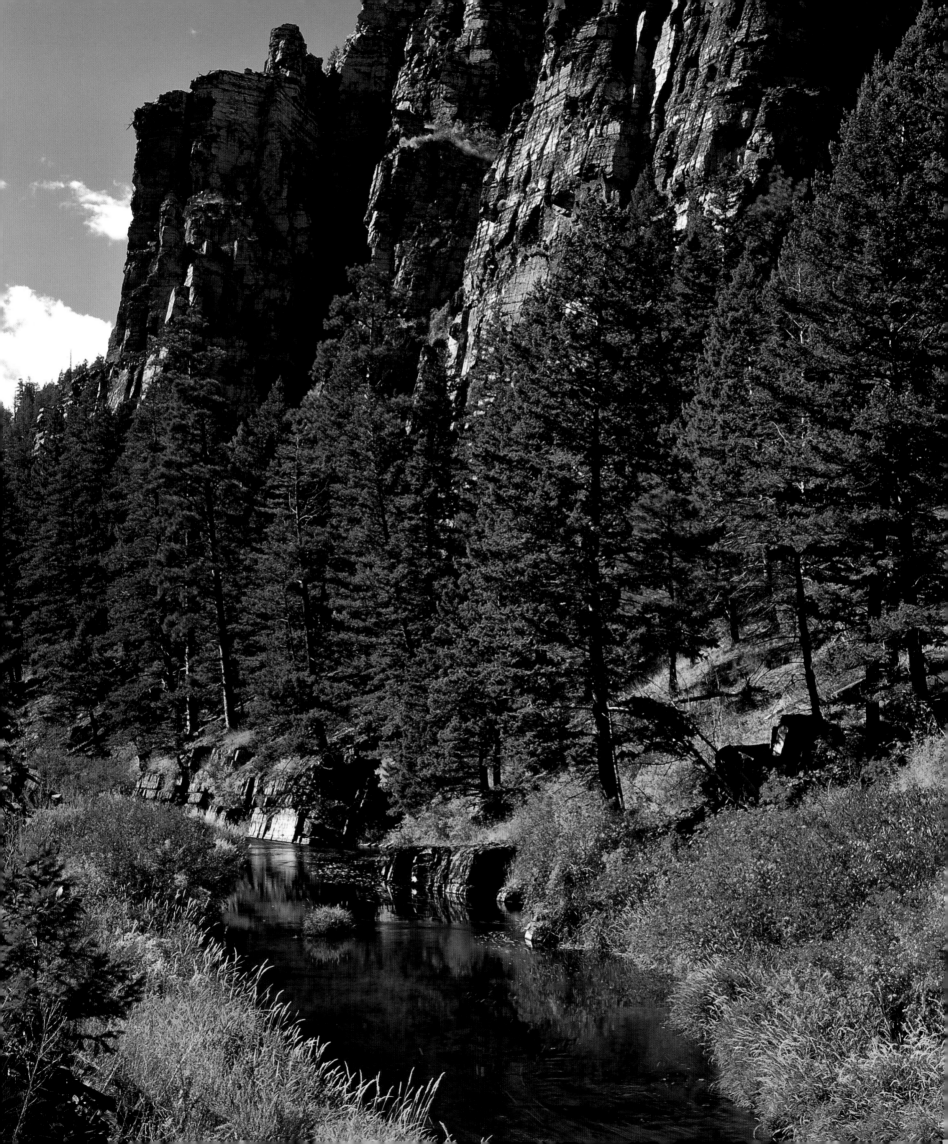

Left: Little Prickly Pear Creek runs along the base of steep cliffs in Wolf Creek Canyon, north of Helena. The canyon is renowned for its colorful, dramatic mudstone walls that vary in hue from sage green to deep maroon. JOHN LAMBING

Below: Each autumn, mountain ash trees produce big clusters of red berries favored by cedar waxwings and other songbirds. JOHN LAMBING

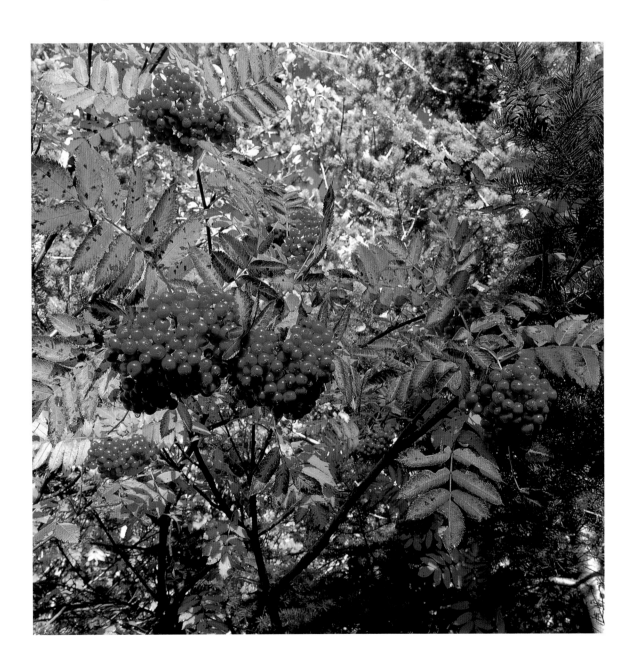

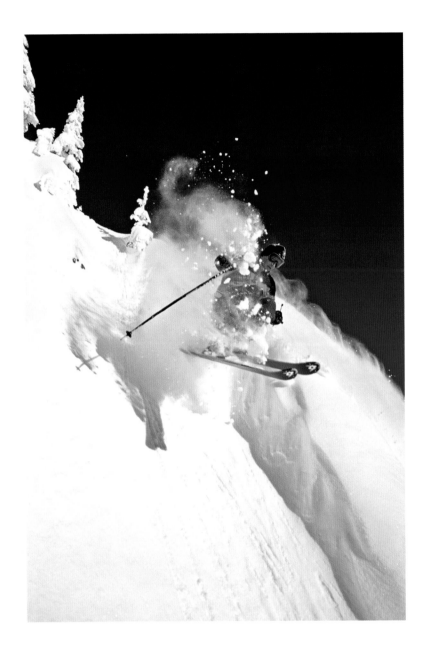

Above: Big air and big powder abound at Whitefish Mountain Resort, in Whitefish north of Kalispell. The ski area averages 300 inches of snow annually. CHUCK HANEY

Right: The southern edge of Glacier National Park offers fabulous cross-country skiing, both in the park and in the adjacent national forest. Few trails are groomed, so opportunities for breaking trail through fluffy, light powder are abundant. CHUCK HANEY

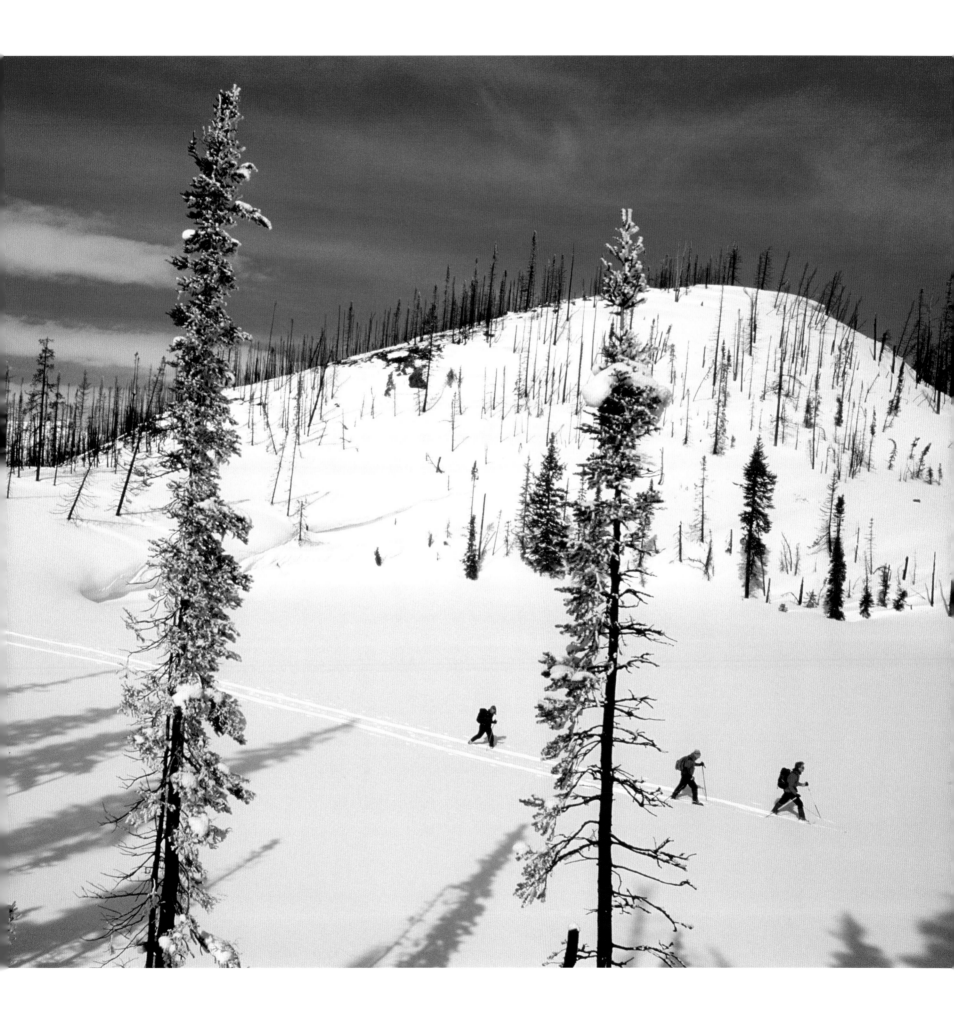

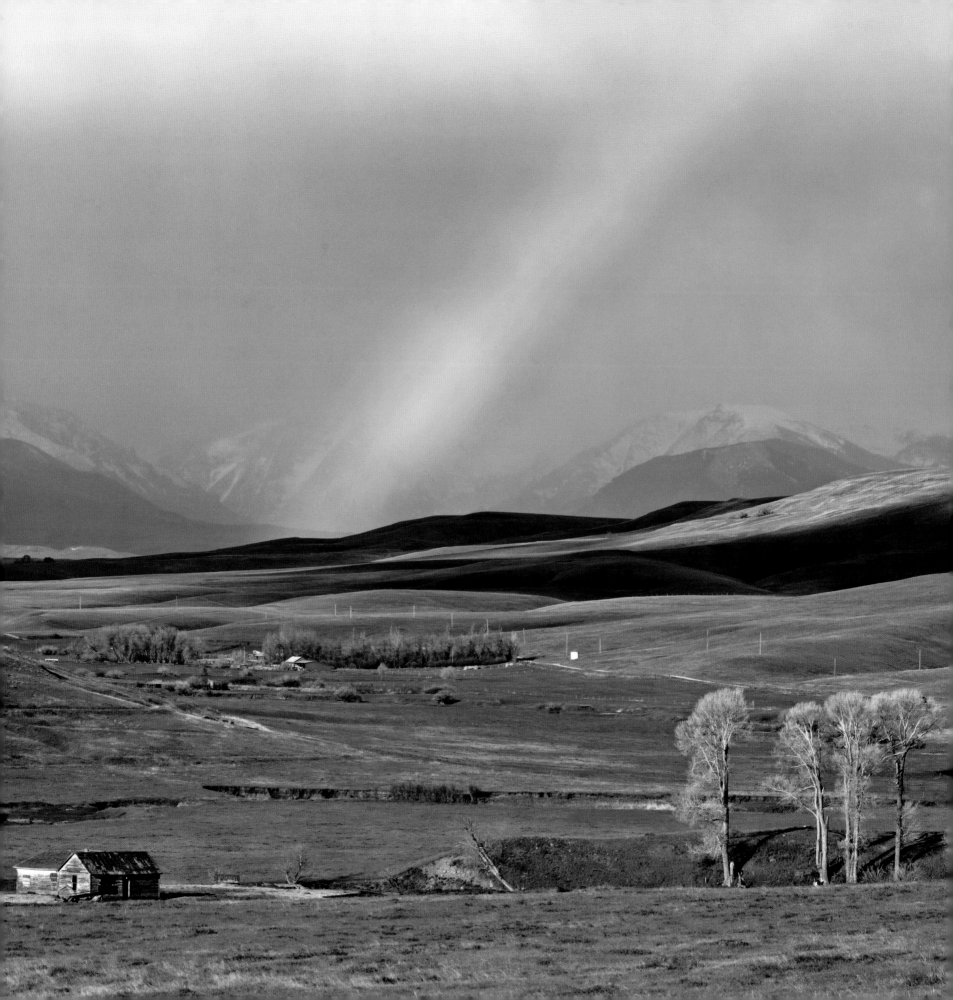

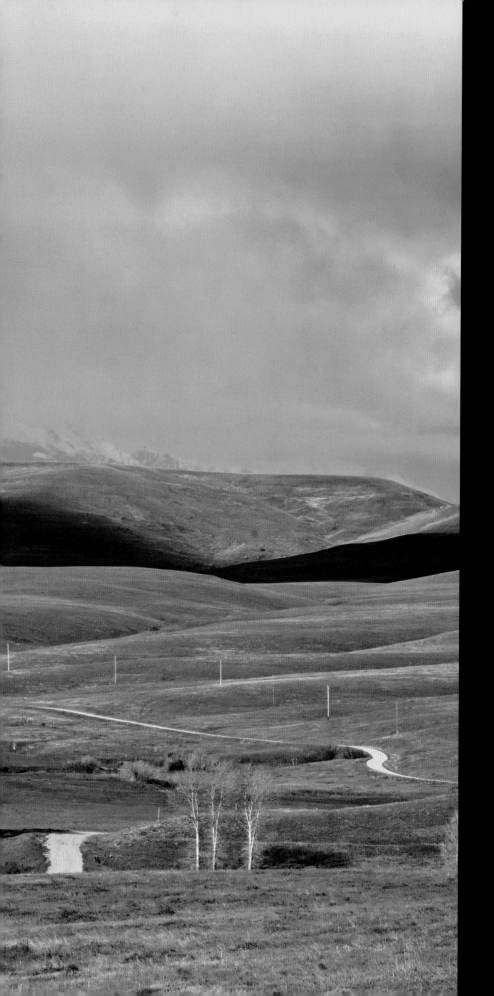

Above, top: Bright-blue camas blooms are pro
in western Montana's moist fields. JOHN LAN

Above, bottom: The nodding flower head of a
wild onion will soon produce tiny bulblets
JOHN LAMBING

Left: A rainbow marks the margin between
ing fields and the Beartooth Mountains, se
from the green grasslands along Volney Cr
CHUCK HANEY

Right: The Anaconda Range cradles Georgetown Lake at elevation 6,361 feet. Its year-round fishery and beautiful scenery make it a popular vacation destination. CHUCK HANEY

Below: At dawn, a dramatic snag seems to grasp for the moon as it reaches its last quarter. JOHN LAMBING

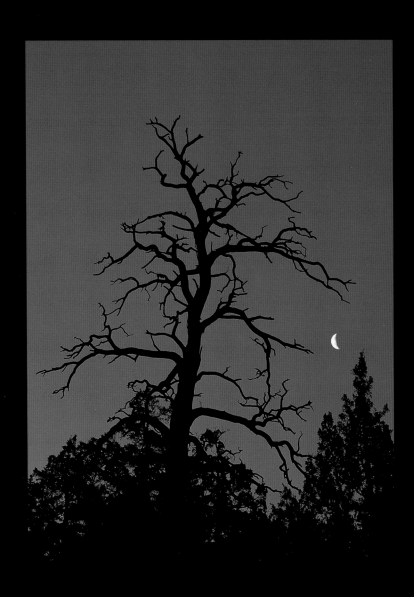

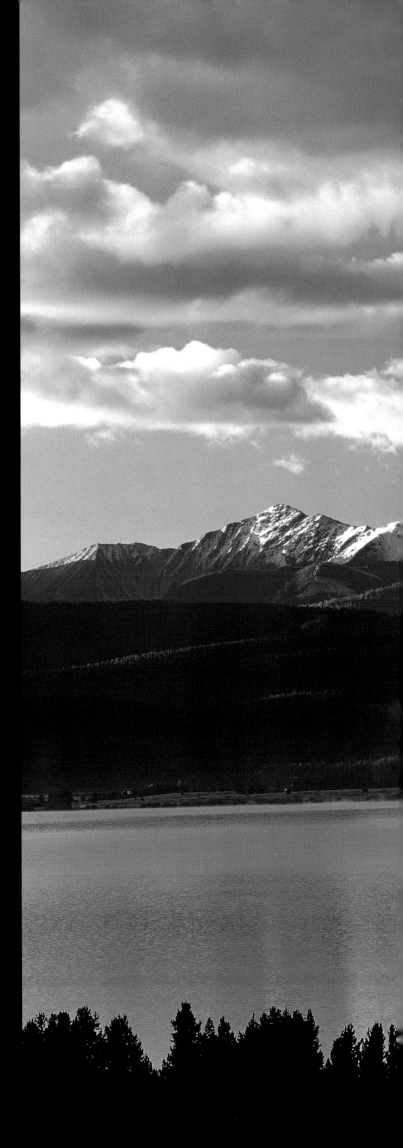

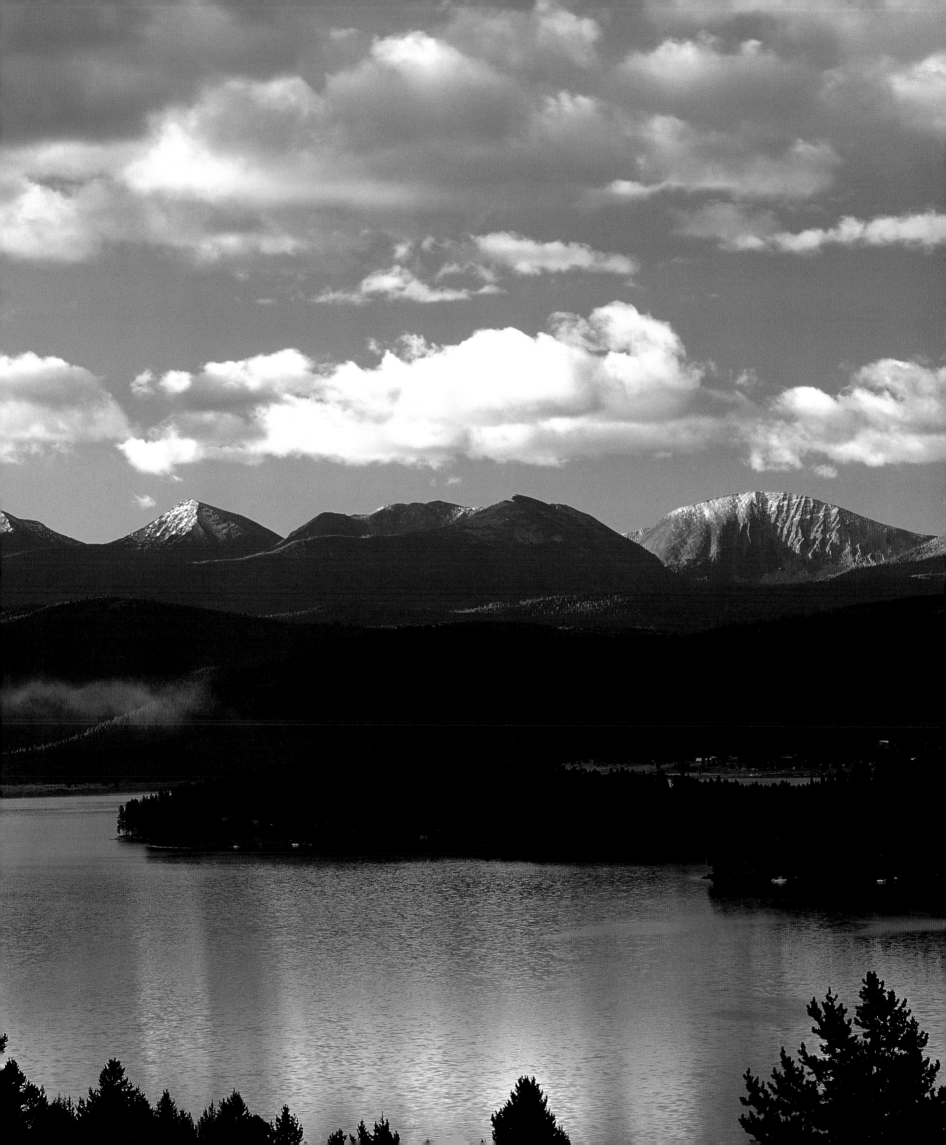

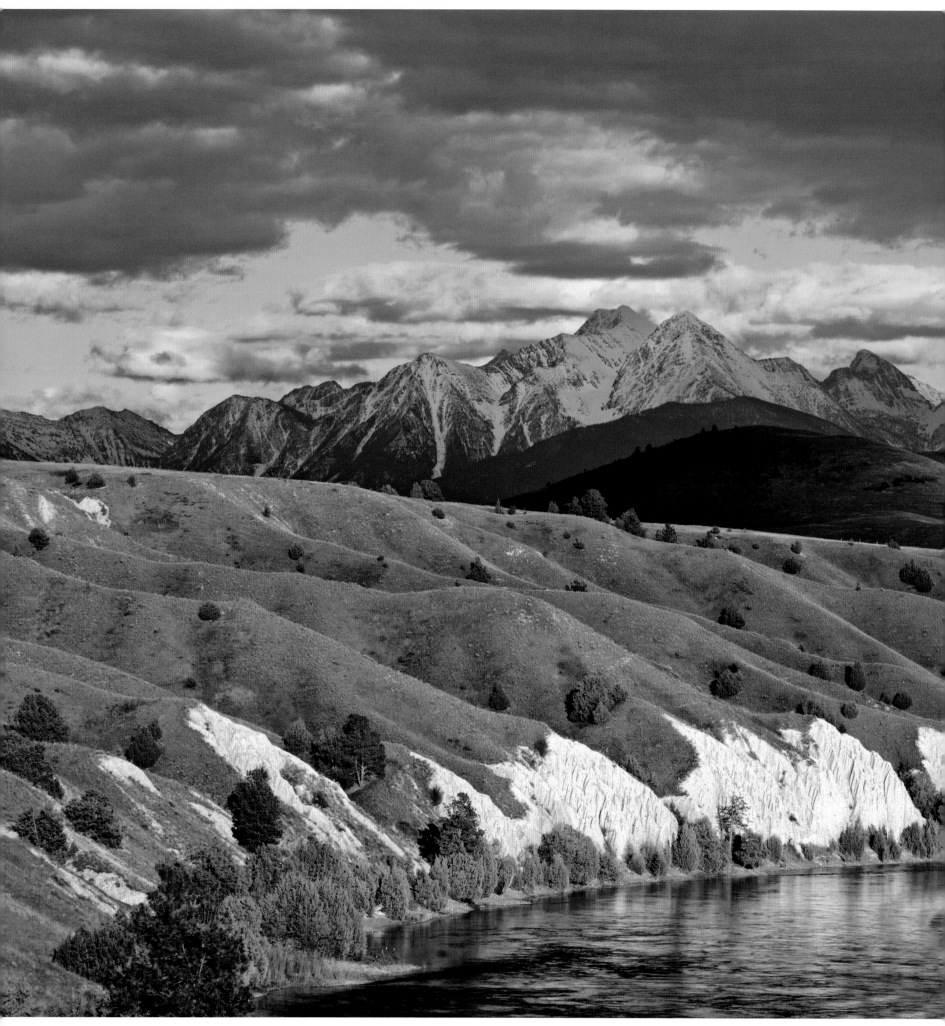

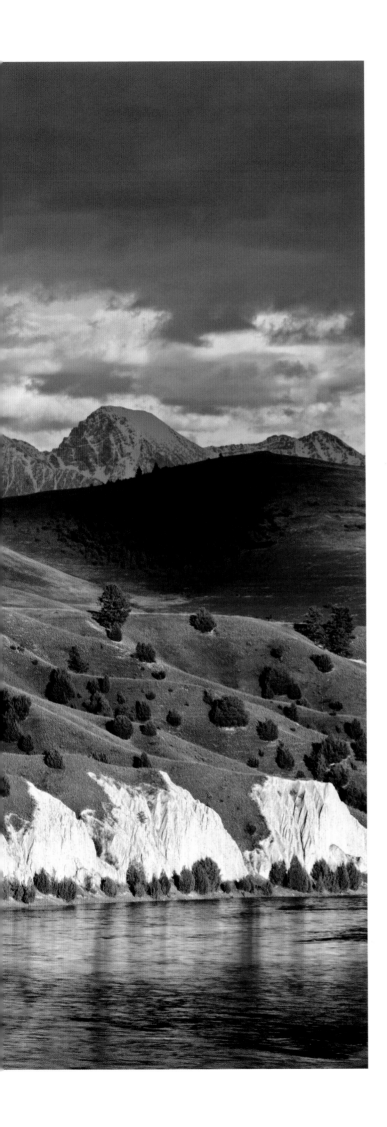

Left: The Mission Mountains provide a dramatic backdrop for the clay cliffs exposed along the Flathead River south of Kerr Dam. CHUCK HANEY

Below: The Marias River originates in the Rocky Mountains and meanders through Montana's high plains to its confluence with the Missouri River near Loma. Captain Meriwether Lewis named this river in 1805 for his cousin, Maria. JOHN LAMBING

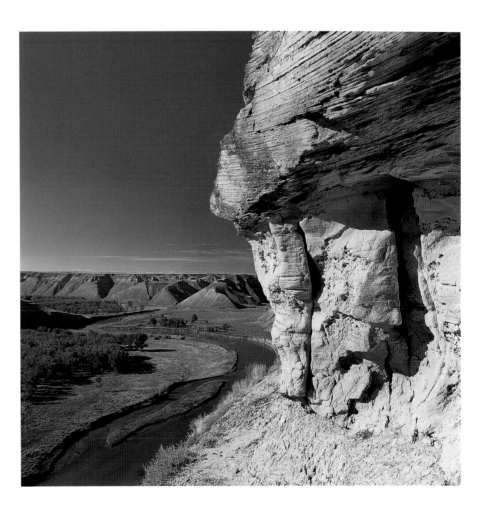

Right: The Yellowstone River flows from Lake Yellowstone in the park, through the Grand Canyon of the Yellowstone, and on north. It then turns west along the park's northern boundary and flows through this narrow section named the Black Canyon before exiting the park near Gardiner. JOHN LAMBING

Below: Total focus keeps this recreational kayaker upright in Brennan's Wave, a boating play area on the Clark Fork River in downtown Missoula. CHUCK HANEY

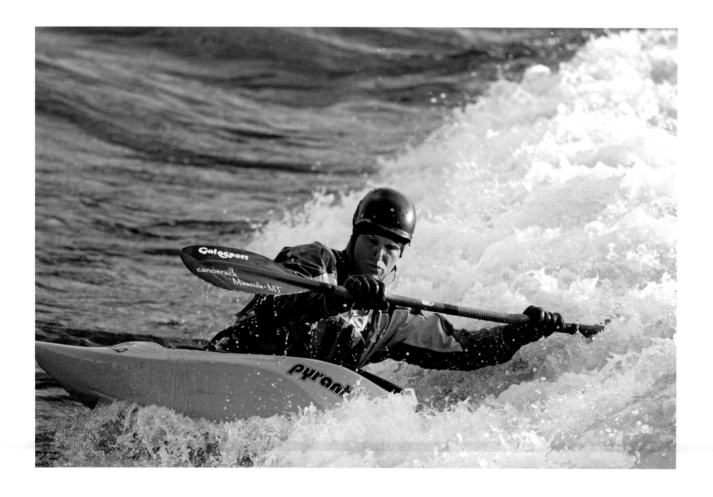

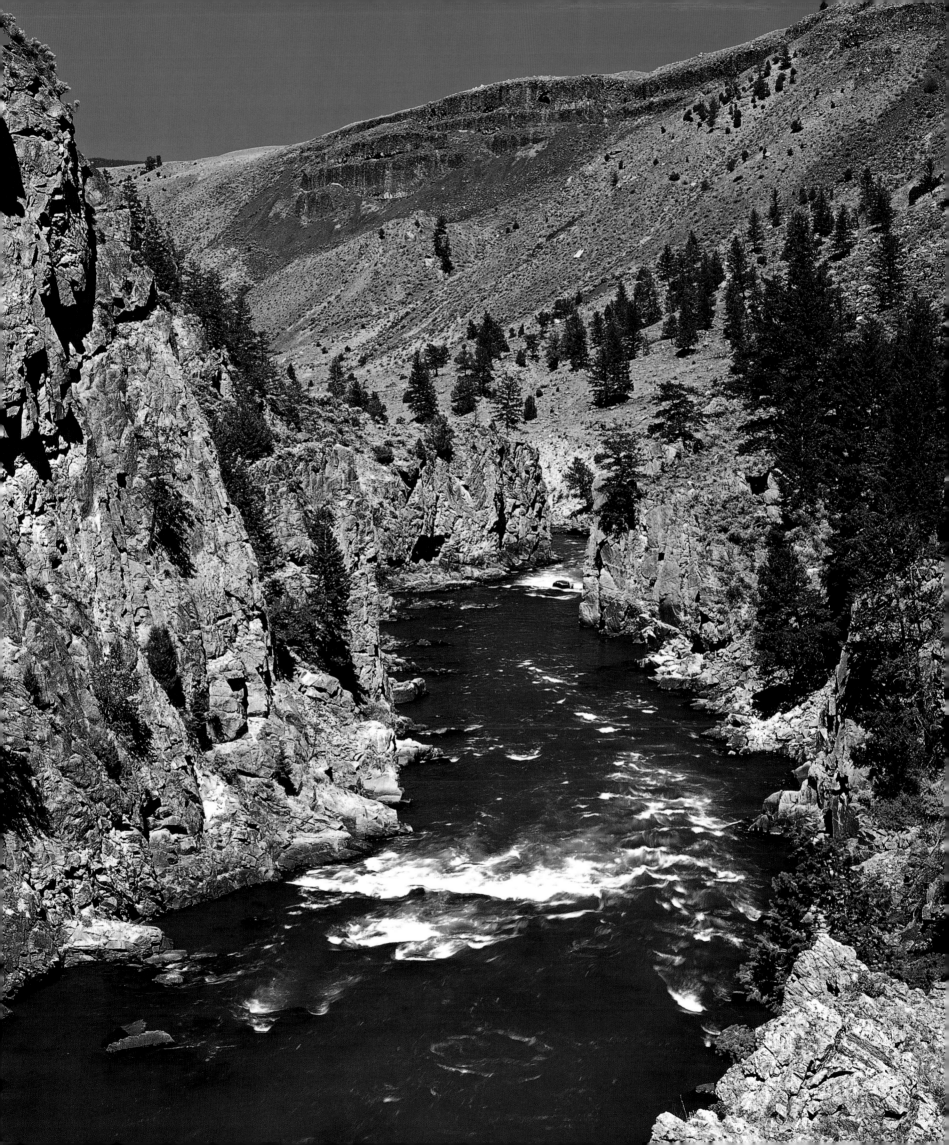

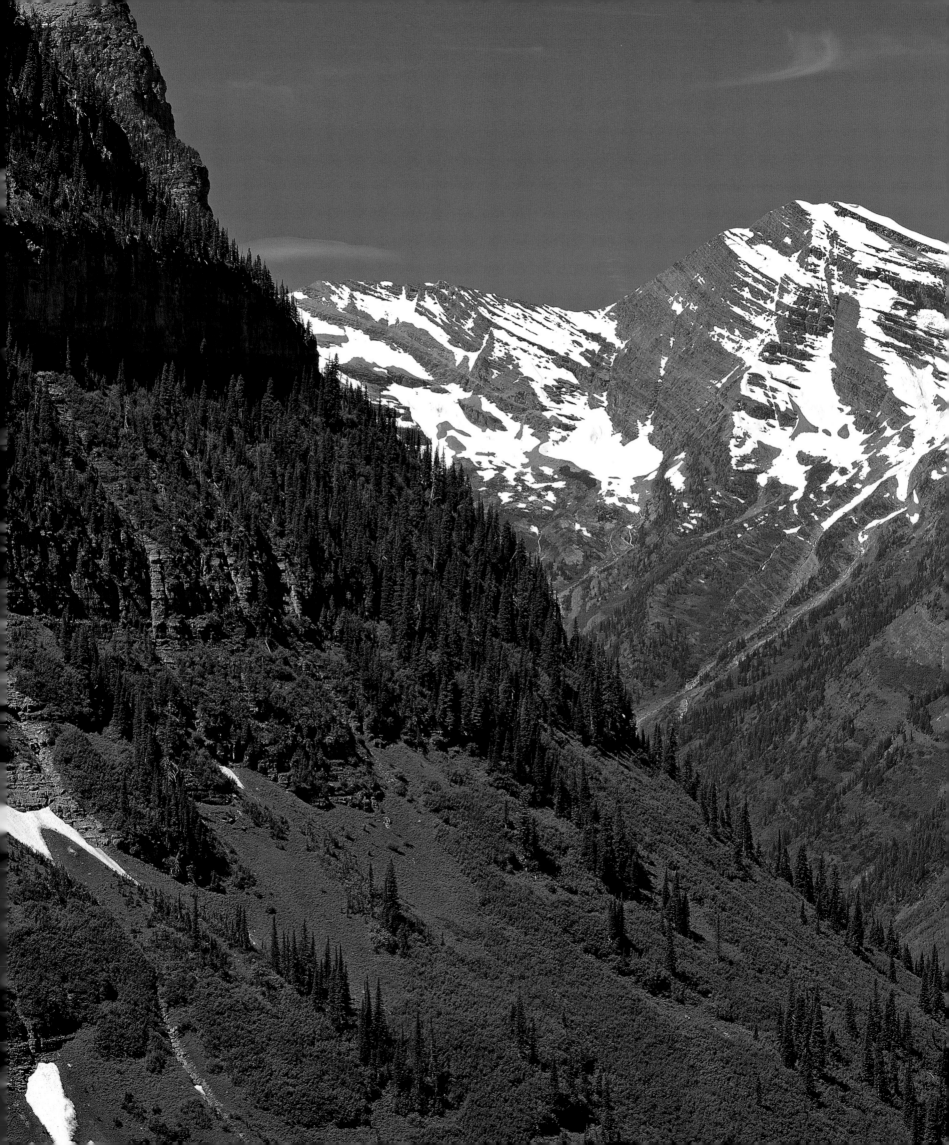

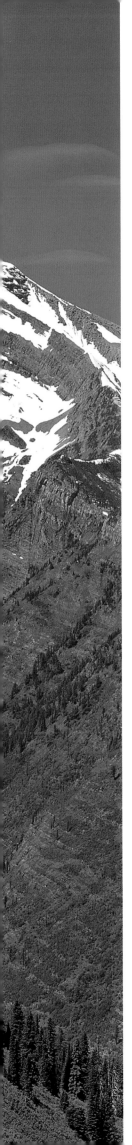

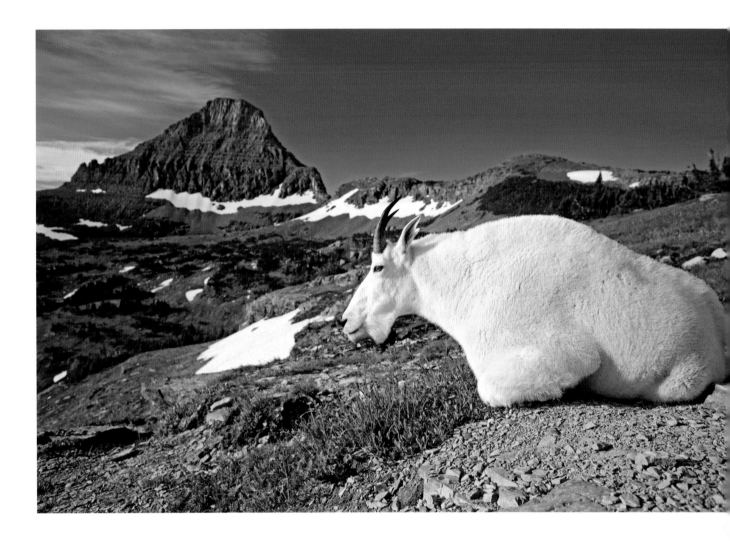

Above: A mountain goat billy rests in the sunshine high atop Logan Pass in Glacier National Park. Visitors to the pass are almost guaranteed wildlife sightings, including mountain goats, marmots, bears, and even an occasional reclusive wolverine. CHUCK HANEY

Left: The massive bulk of Heaven's Peak rises to 8,848 feet in Glacier National Park. Snowmelt provides moisture throughout much of the summer, keeping the slopes emerald green until the first frosts of autumn. JOHN LAMBING

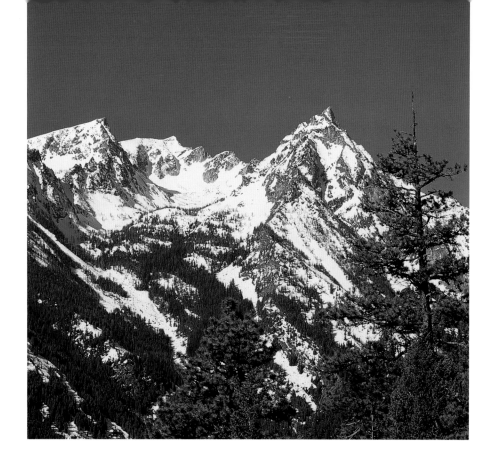

Above: Likely the most recognizable summit in the Bitterroot Range, Trapper Peak soars to 10,108 feet. JOHN LAMBING

Right: Tamarack Lake collects snowmelt from Warren Peak high in the Anaconda-Pintler Wilderness. JOHN LAMBING

Below: Crow Creek Falls is a popular hiking destination in the Elkhorn Mountains. JOHN LAMBING

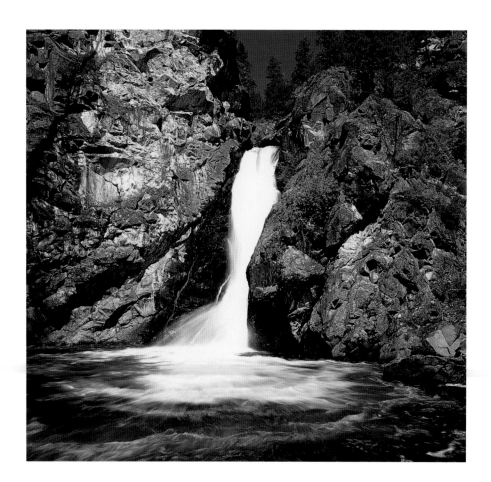

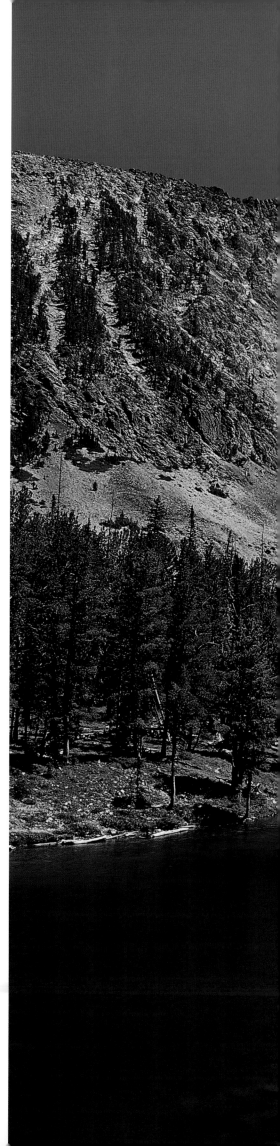

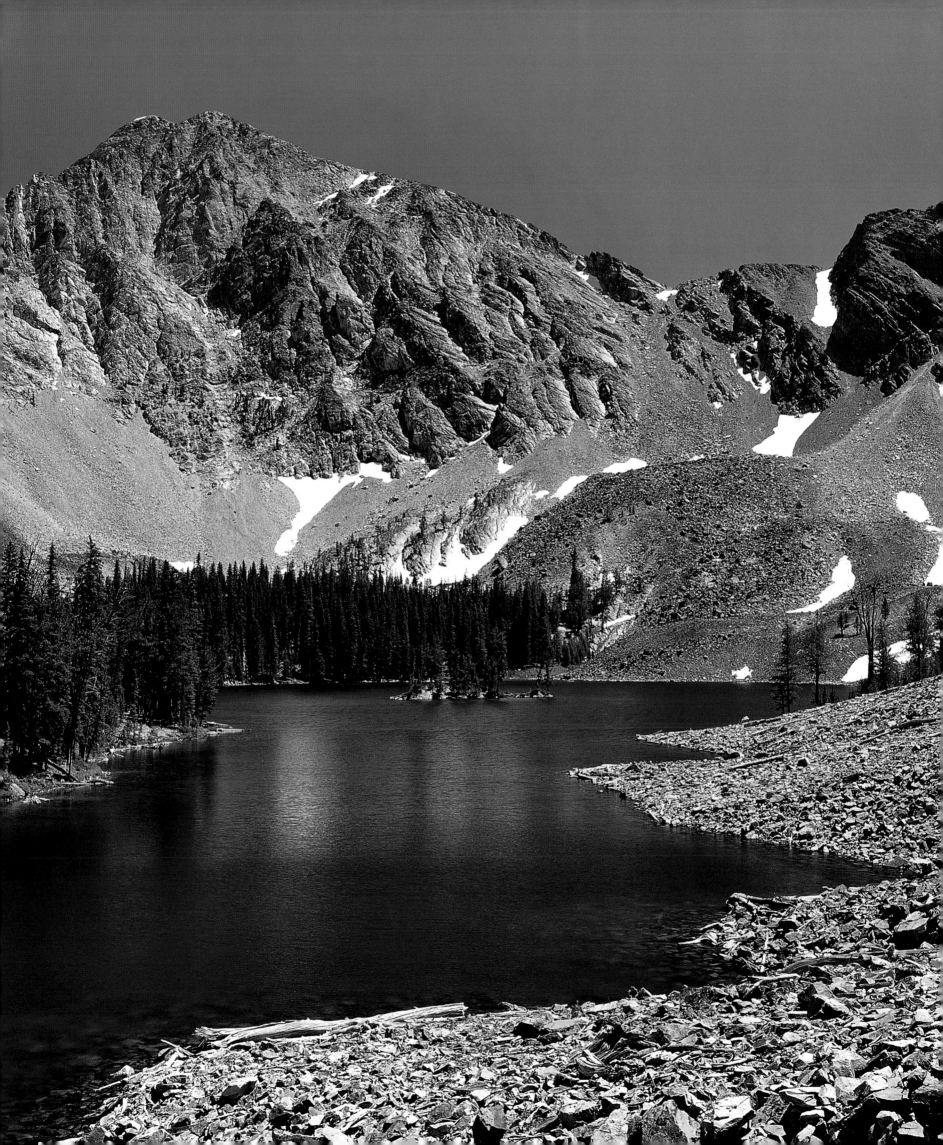

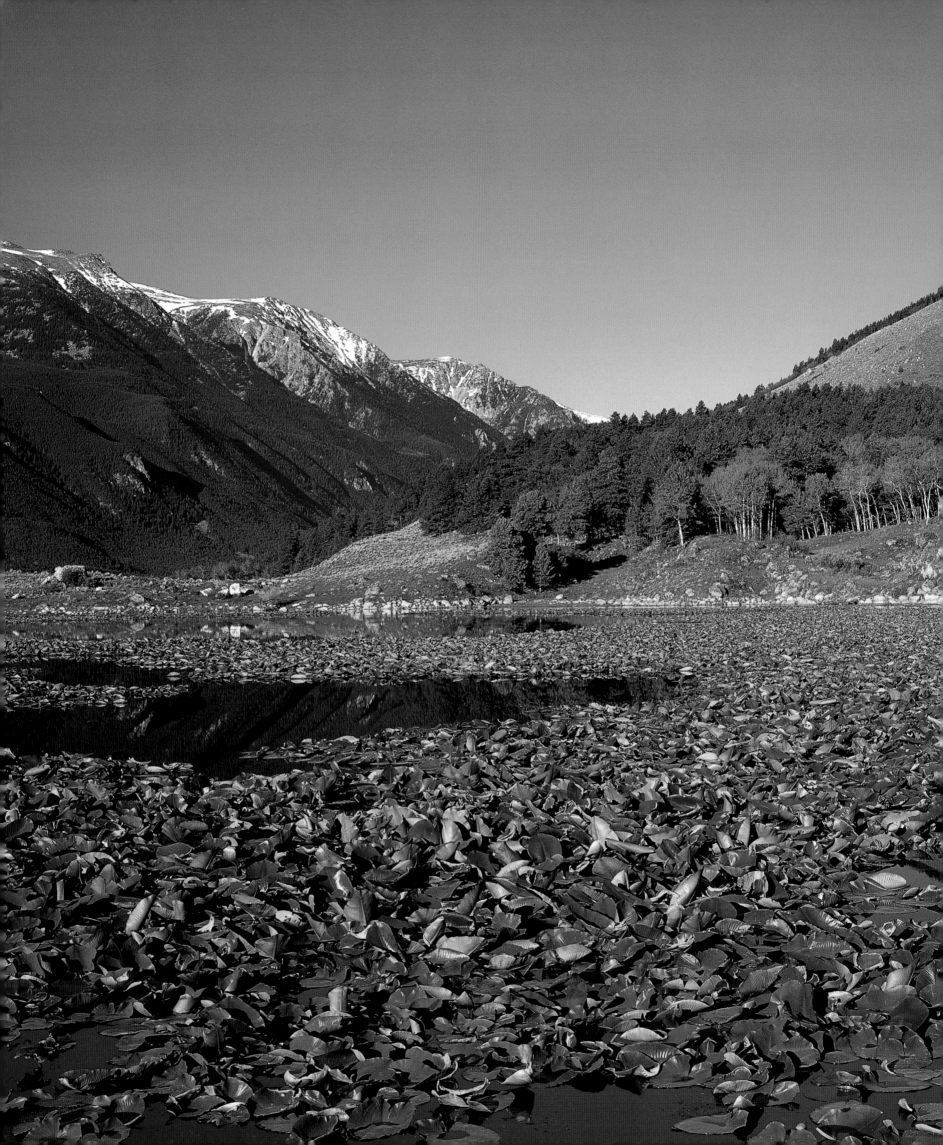

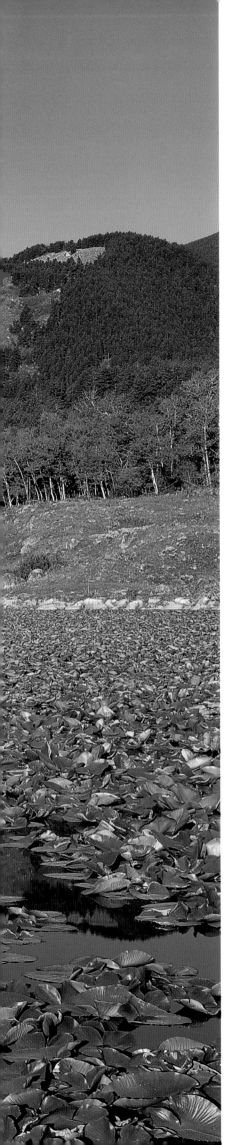

Left: The thick pads of yellow pond lilies cover a small lake in the West Rosebud Creek basin in the Beartooth Mountains. JOHN LAMBING

Below, top: Snow geese frame the moon at Freezeout Lake National Wildlife Refuge. CHUCK HANEY

Below, bottom: Hoarfrost forms on many surfaces when there's a source of open water and sub-freezing temperatures. Here, the crystals are clinging to a dried thistle blossom. JOHN LAMBING

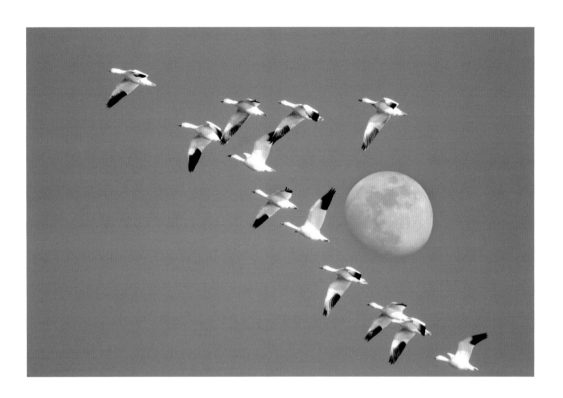

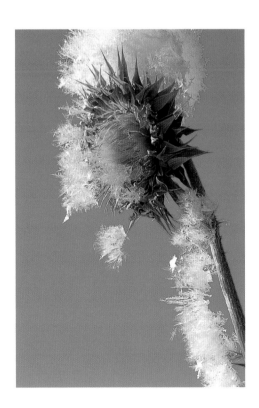

57

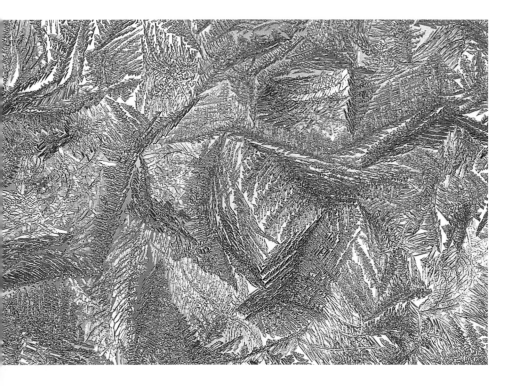

Above: Ice crystals form intricate feathery patterns on windows when the inside temperature is warmer and moister than outside below-freezing temperatures. JOHN LAMBING

Right: Mountain ash berries linger on the tree throughout most of the winter. Here, they guide the eye to a classic red barn near Kalispell. CHUCK HANEY

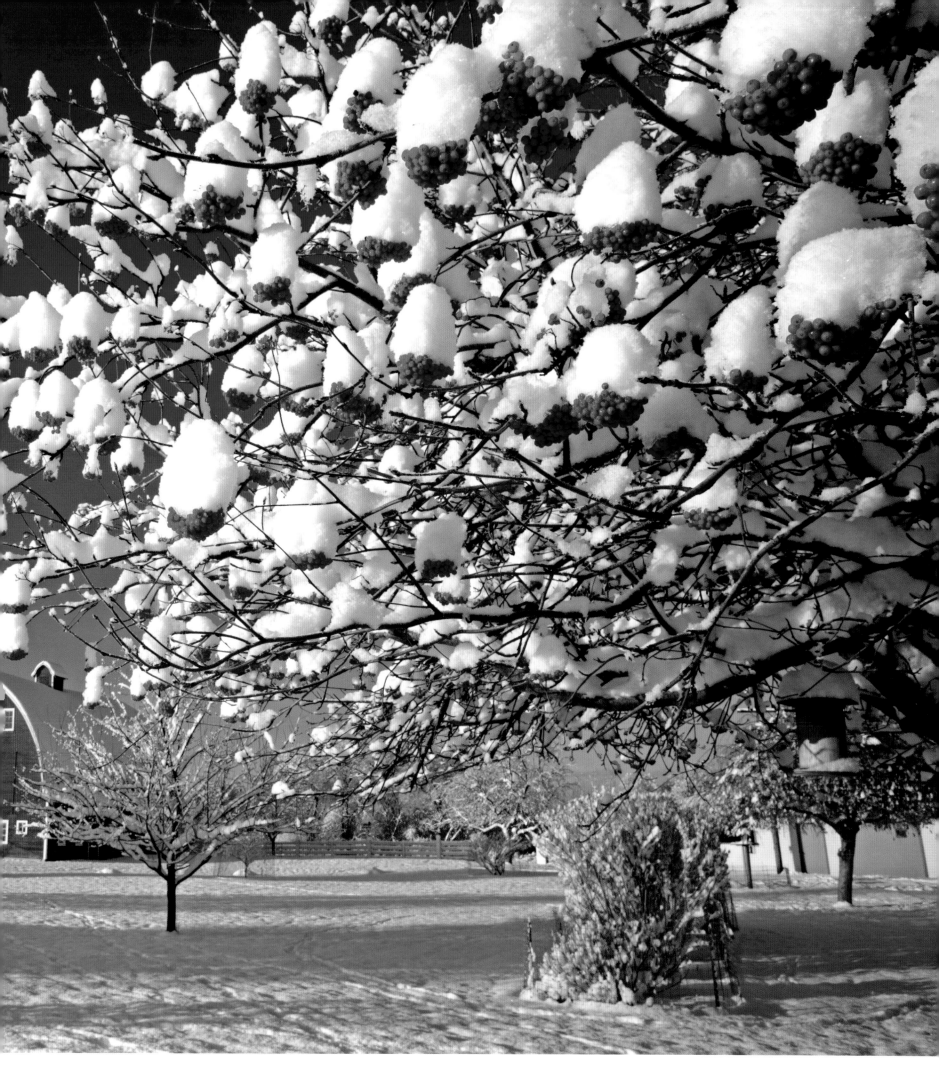

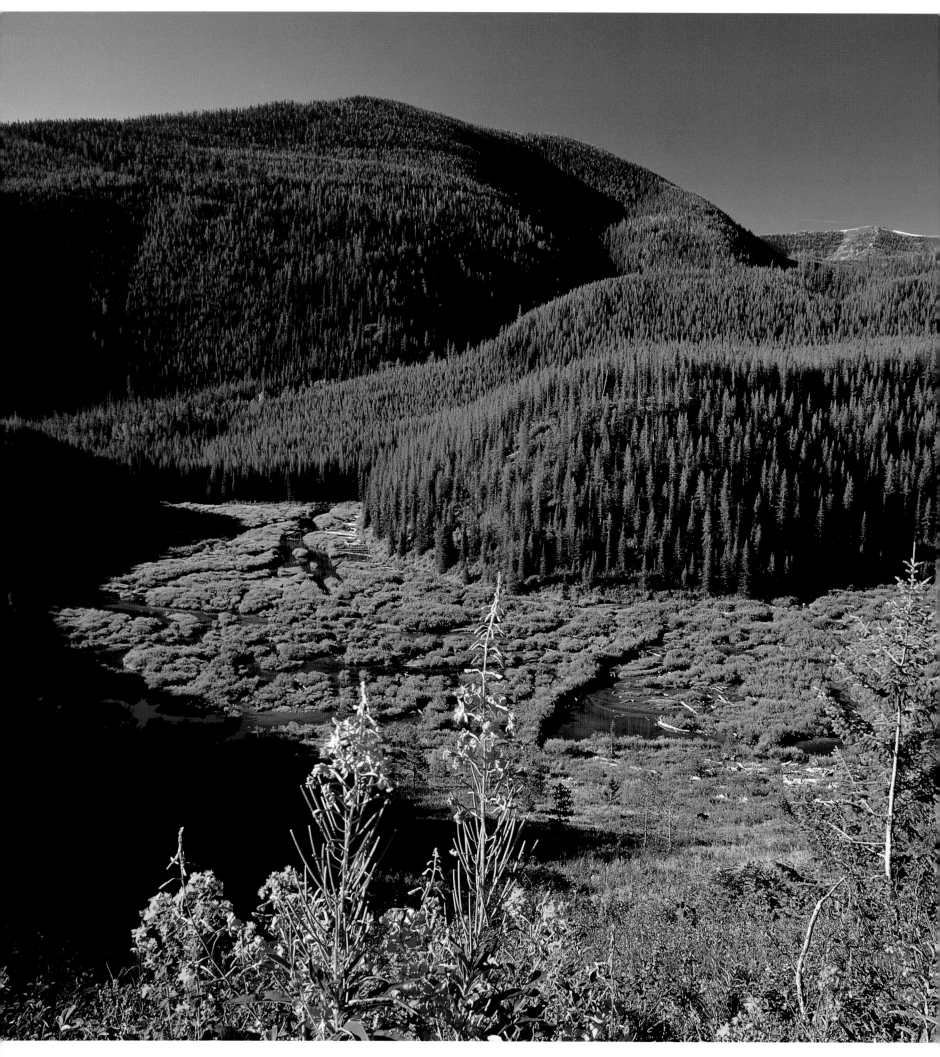

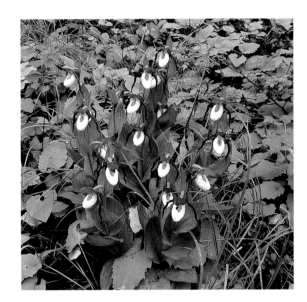

Left: An uncommon (and uncommonly beautiful) plant, the mountain lady's slipper orchid looks like a ballerina's toe shoe, complete with ribbon ties. CHUCK HANEY

Far left: Fireweed blooms cover the slope above Yakinikak Creek in Montana's northwestern corner. CHUCK HANEY

Below: The immense volume of water in Flathead Lake creates a moderating effect on temperatures, which allows cherry orchards to flourish along its shores. CHUCK HANEY

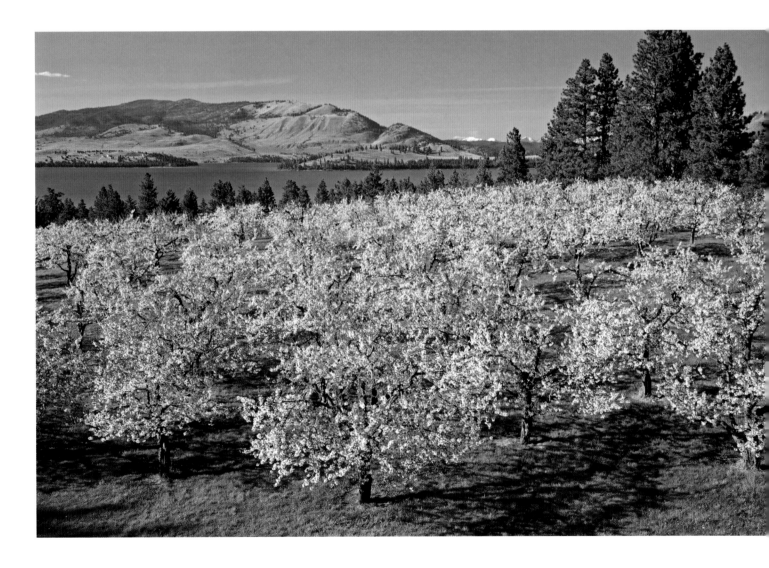

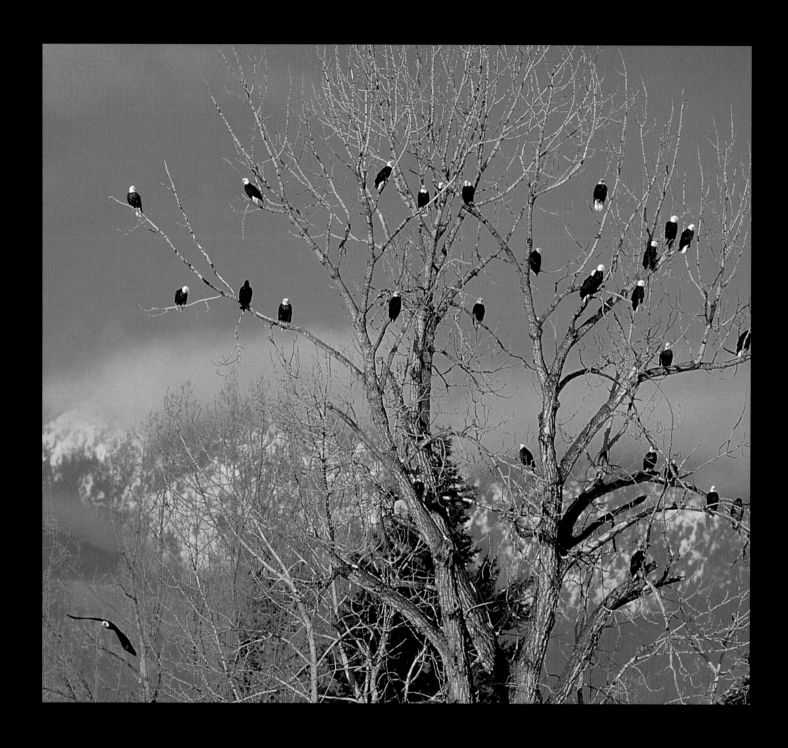

Above: Many bald eagles remain in Montana year-round. Fish-eaters by preference, they often congregate where fish are spawning in the autumn and near the few areas of open water in winter. CHUCK HANEY

Facing page: Wind-blown snow on ice creates interesting geometric patterns on Medicine Lake. The surrounding national wildlife refuge encompasses 31,702 acres of waterfowl and upland bird habitat. CHUCK HANEY

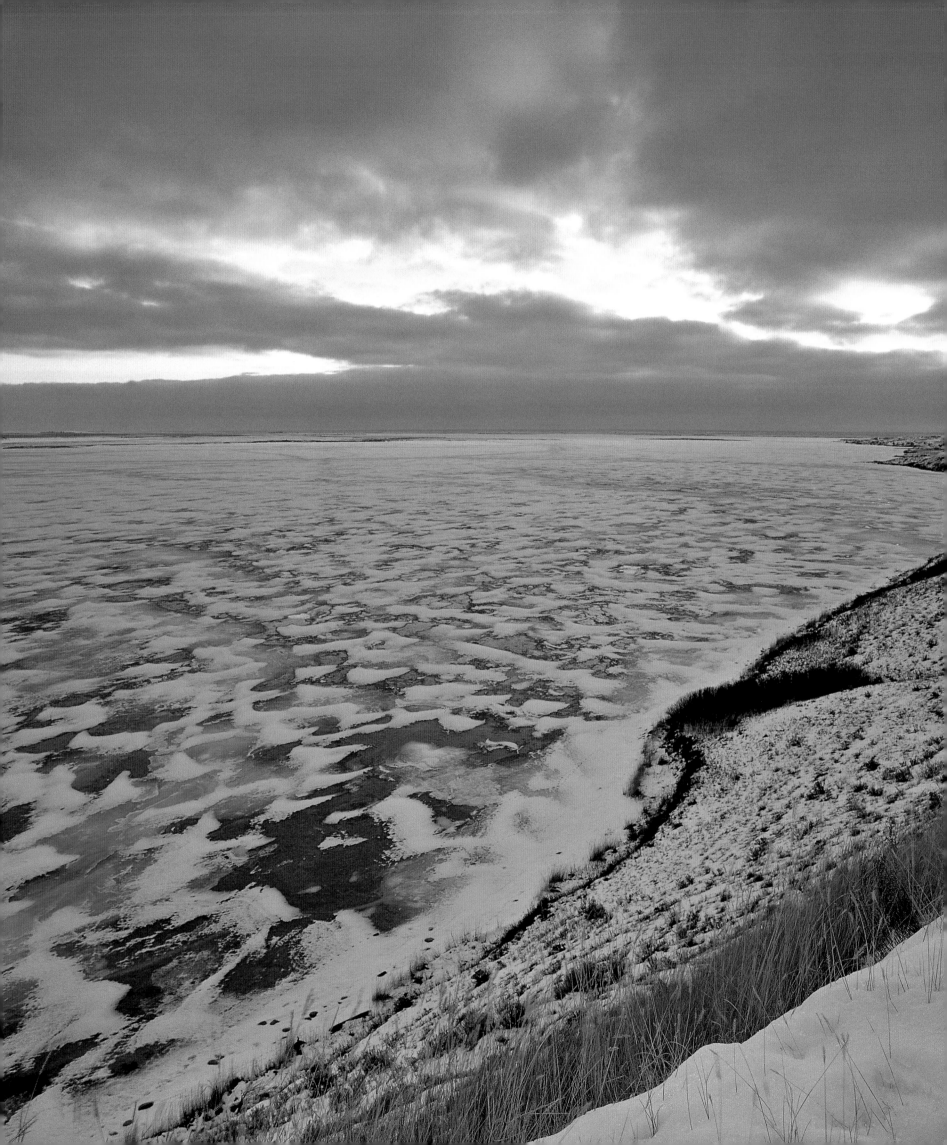

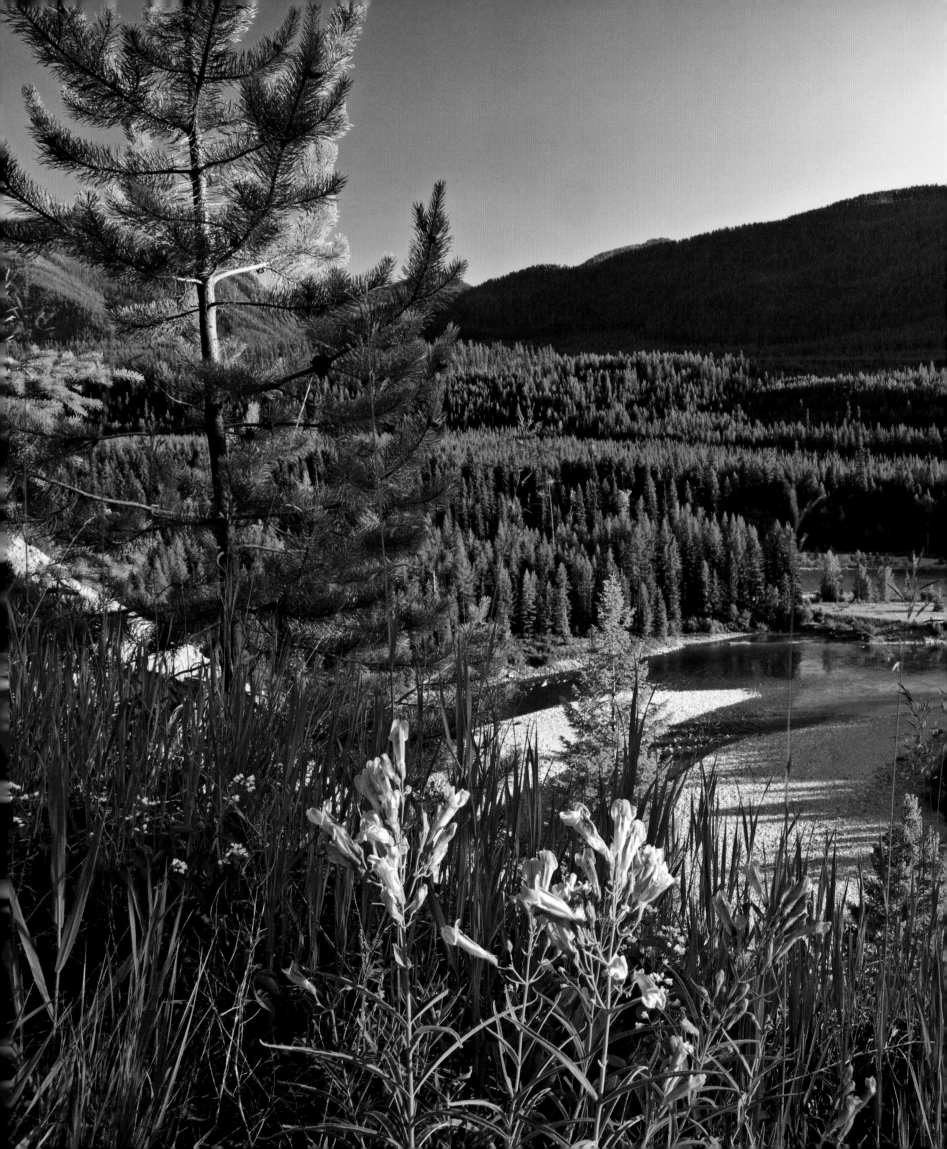

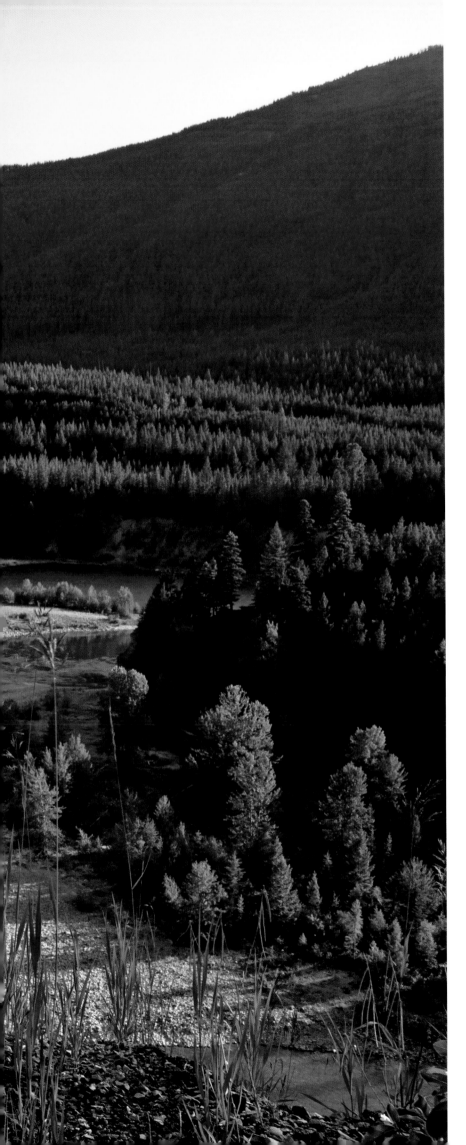

Left: Shrubby beardtongue blooms in the gravelly soils along the South Fork Flathead River, a designated Wild and Scenic River. The South, Middle, and North forks of the Flathead River pour into Flathead Lake from the north and emerge as the Flathead River at the southern end of the lake. CHUCK HANEY

Below: The seed heads of prairie smoke have feathery plumes that allow the wind to pick up the seeds and disperse them through an area. CHUCK HANEY

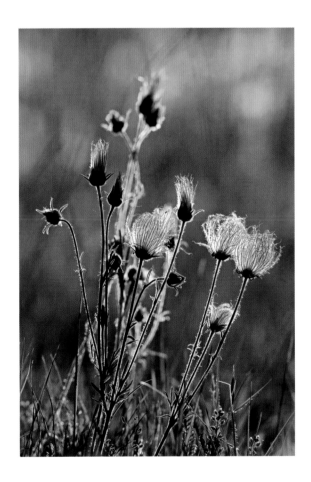

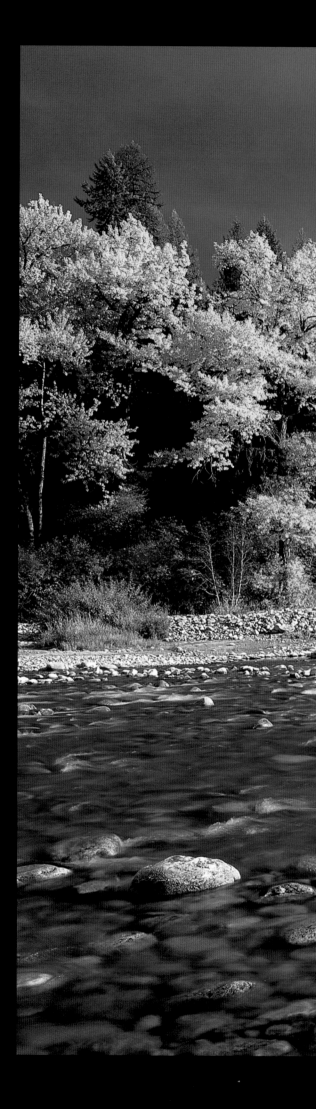

Right: The Yaak River flows through fifty-three miles of far northwestern Montana before reaching this cobblestone shallows at its confluence with the Kootenai River. Several species of trout thrive in the Yaak, including the uncommon redband. JOHN LAMBING

Below: The crystal-clear waters of McDonald Creek, in Glacier National Park's southwestern corner, support diverse vegetation renowned for beautiful autumn color. CHUCK HANEY

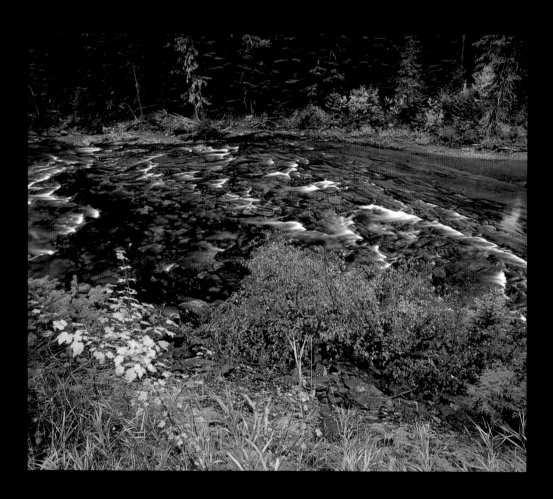

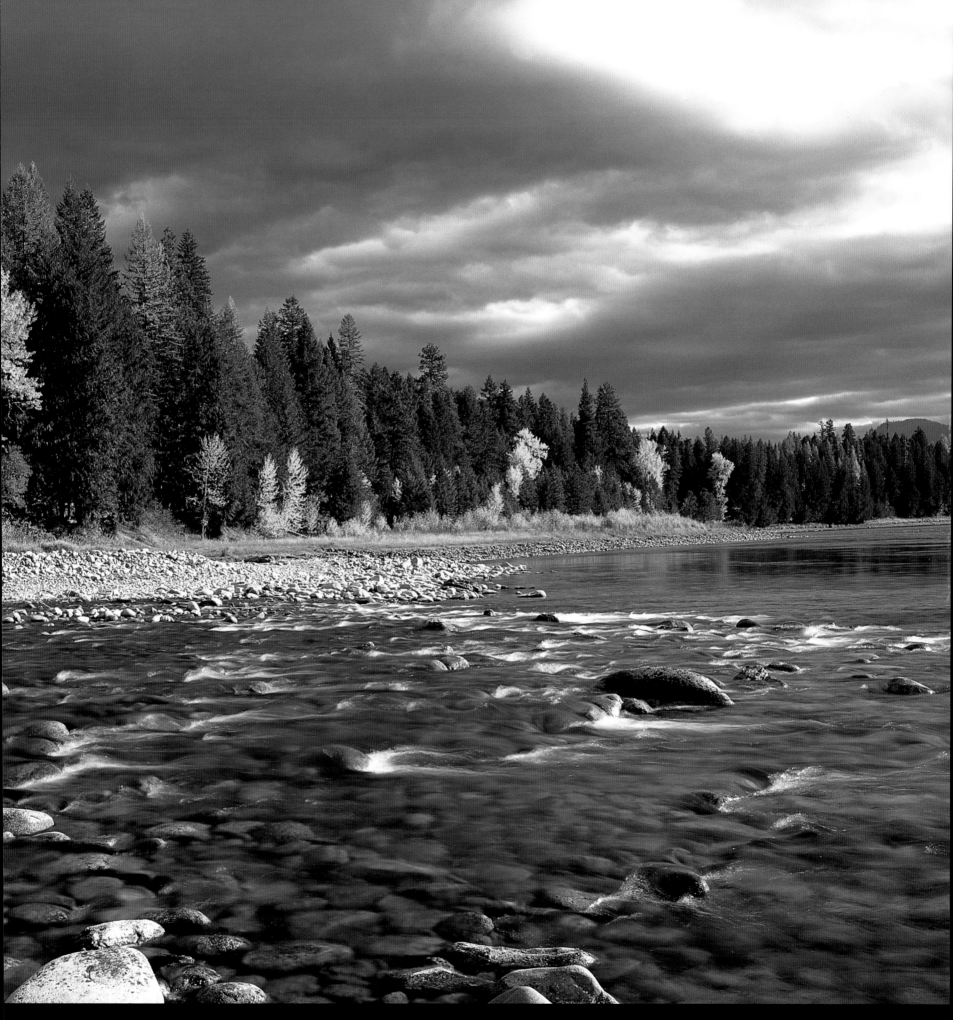

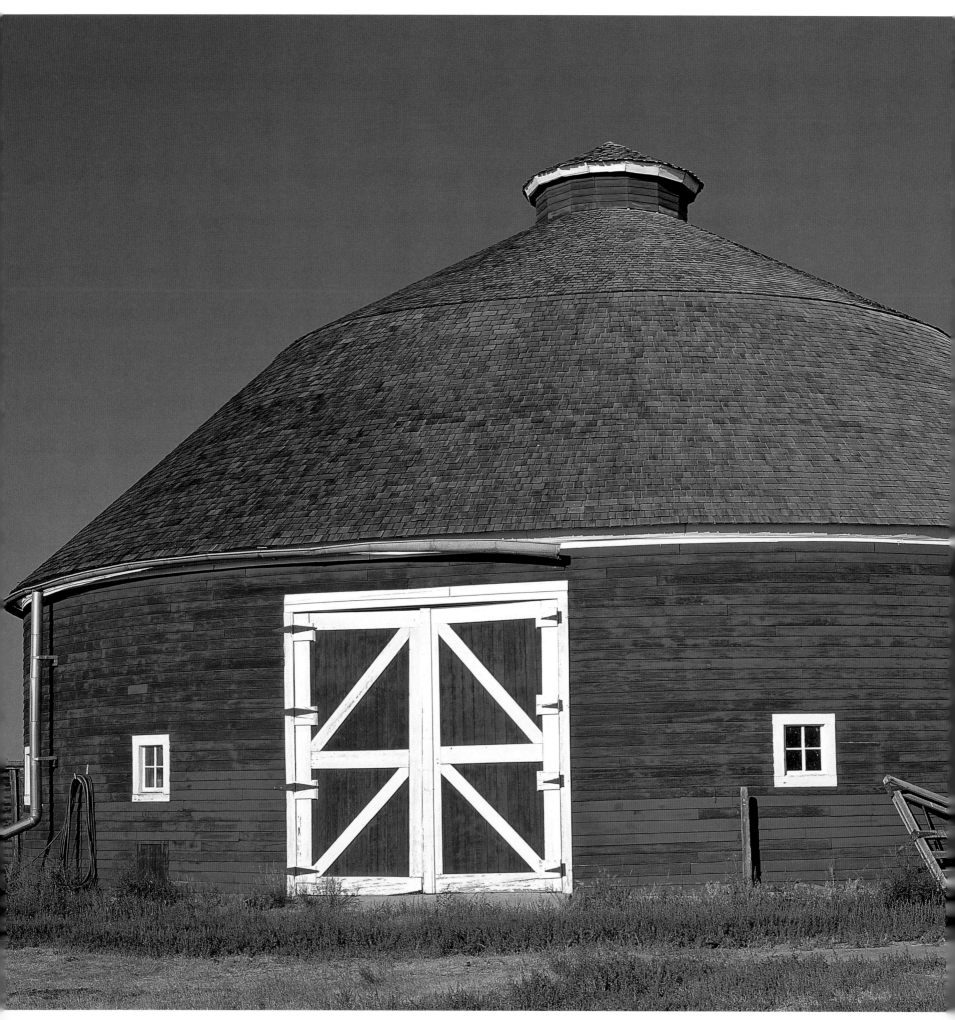

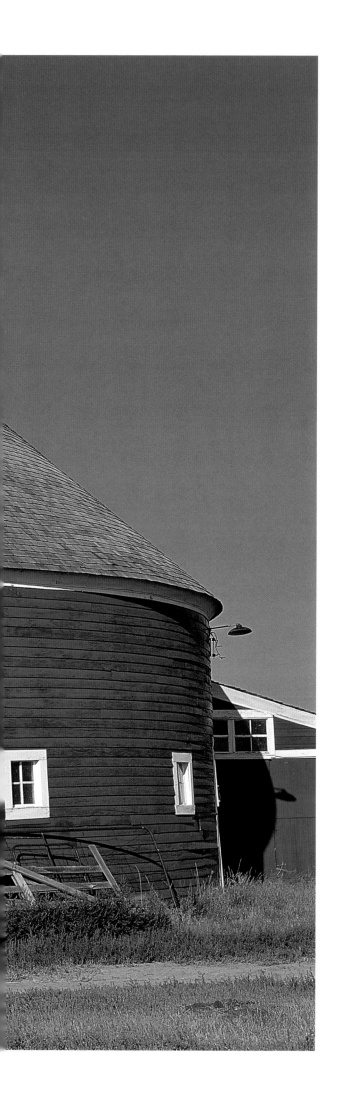

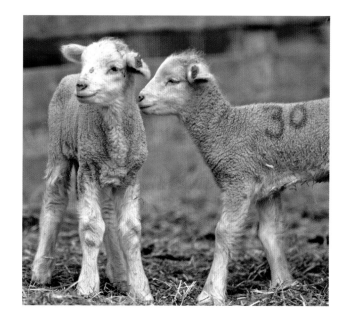

Left: Purebred Targhee lamb twins pause before resuming play in their pen near Cascade. CHUCK HANEY

Far left: This distinctive round barn near Collins was built by Arthur "Big" Fitzgerald in 1913. The two-wall construction required builders to soak the exterior planks in the river so they would bend around the frame; the open cupola allows air to flow through the nine-foot haymow. JOHN LAMBING

Below: Yearning to grow up to be cowboys—on the Hughes Ranch near Stanford. CHUCK HANEY

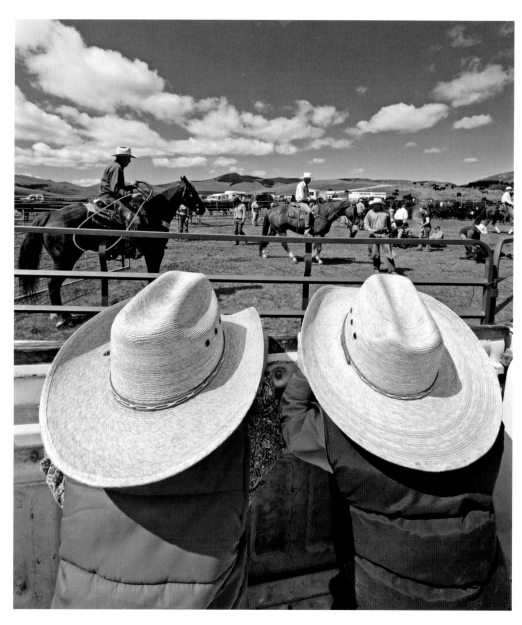

Right: Fresh snow highlights the steep ledges alongside Silver Falls in the Flathead National Forest. CHUCK HANEY

Below: The Kootenai River in northwestern Montana is the Columbia River's second-largest tributary, in volume of runoff. The Kootenai originates in Canada's Kootenay National Park, runs south into Montana and Idaho, heads back north into British Columbia, and then empties into the Columbia River. CHUCK HANEY

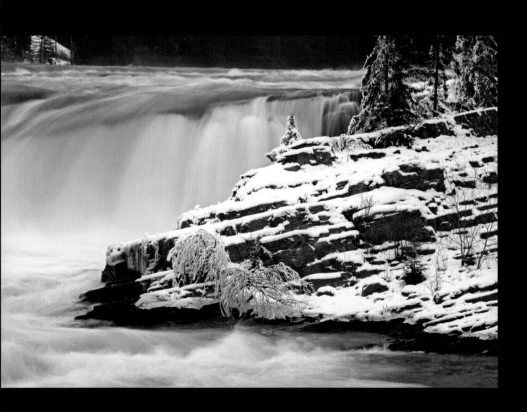

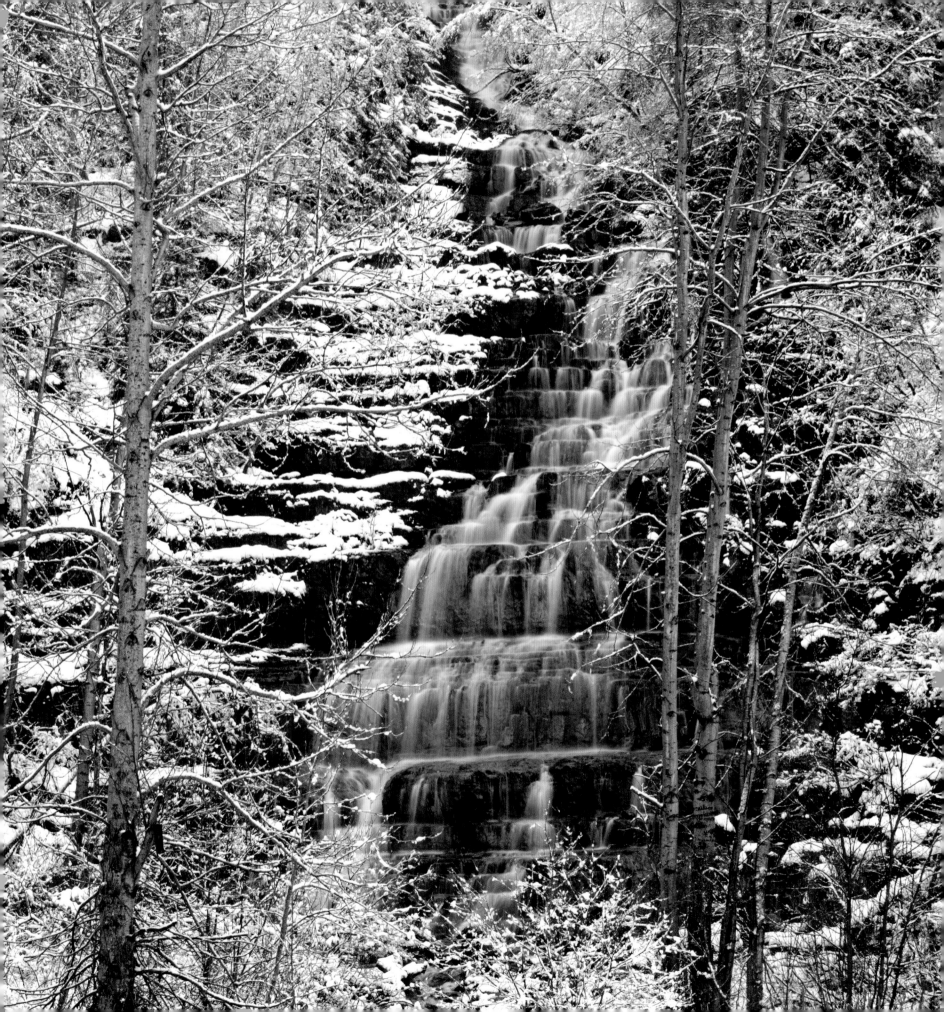

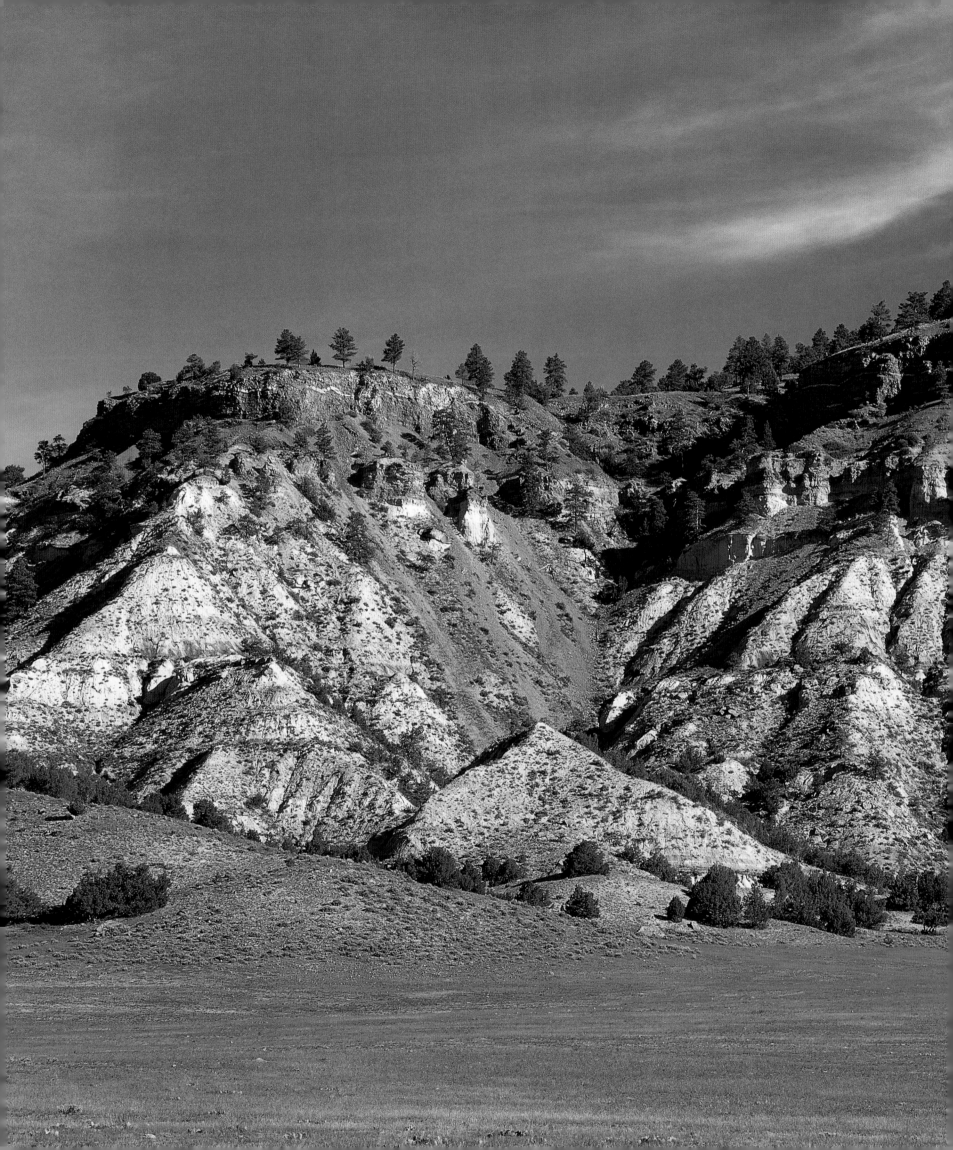

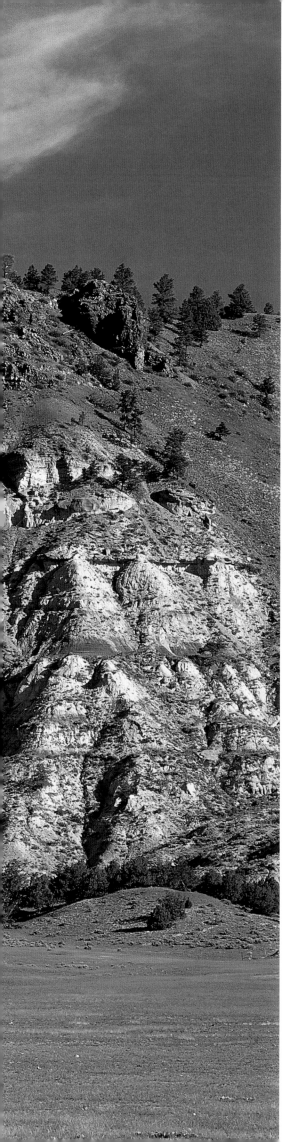

Left: The Battle of Powder River occurred here in March 1876 when Colonel Joseph J. Reynolds set out to destroy an encampment of Northern Cheyenne Indians, intending to push them back to the reservations. Instead, the unsuccessful attack drew the Cheyenne into the Great Sioux War, which is best known for the Battle of the Little Bighorn. JOHN LAMBING

Below: Bighorn sheep live in small bands of rams, ewes, and lambs. This ram and his band were photographed near Big Sky, in the Gallatin Valley. JOHN LAMBING

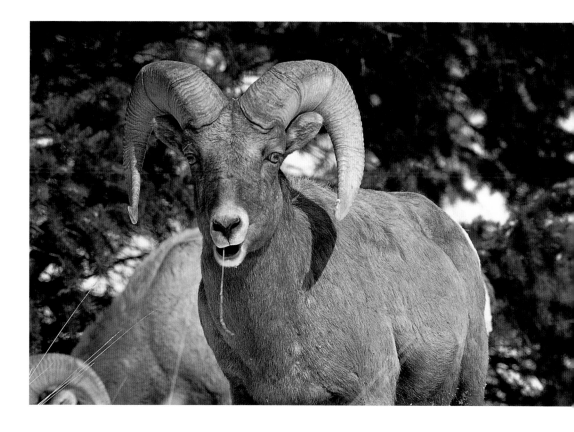

Right: Pompeys Pillar juts up next to the Yellowstone River and contains Captain William Clark's signature, the only known "graffiti" left by the Lewis and Clark Expedition. JOHN LAMBING

Below: Palisades Falls is one of many waterfalls seen from a popular hiking trail that wends up Hyalite Canyon, south of Bozeman. CHUCK HANEY

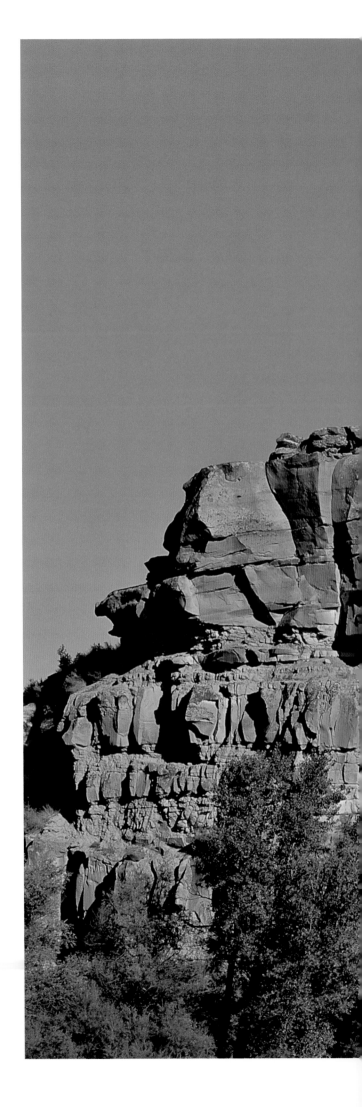

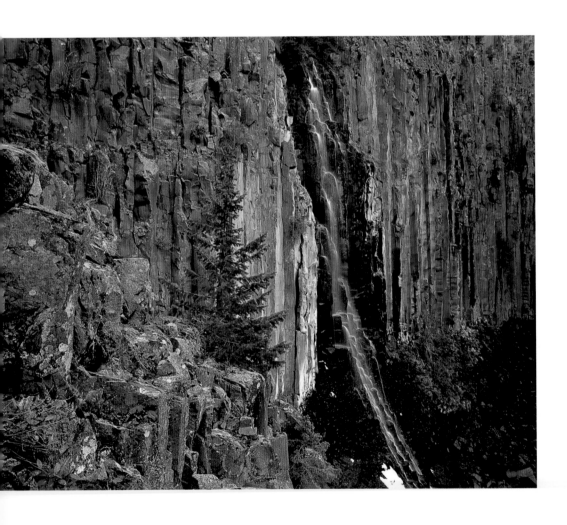

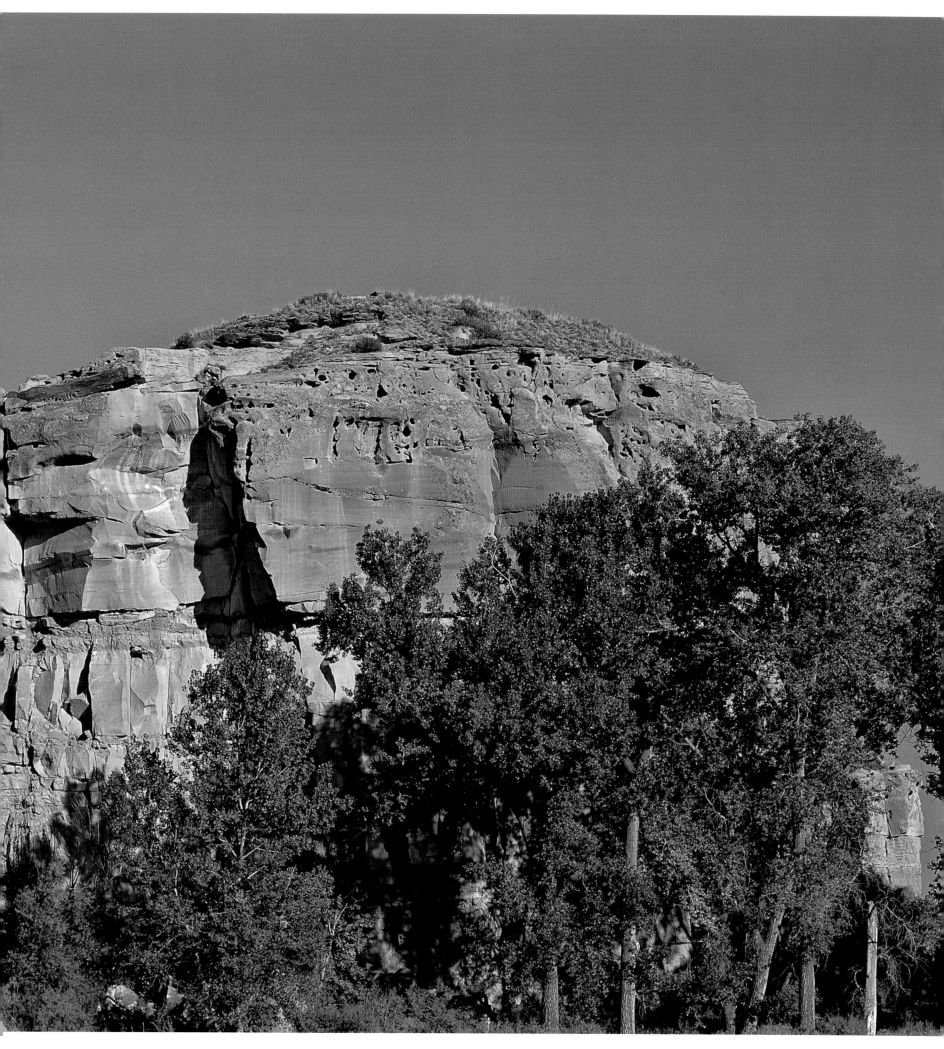

Right: An old grain elevator is the only thing that marks the location of Sipple, near Lewistown. CHUCK HANEY

Below: Residents of the Utica area have created an annual What the Hay contest that inspires fun and creativity using locally grown hay. This entry is named "Hay Jude." CHUCK HANEY

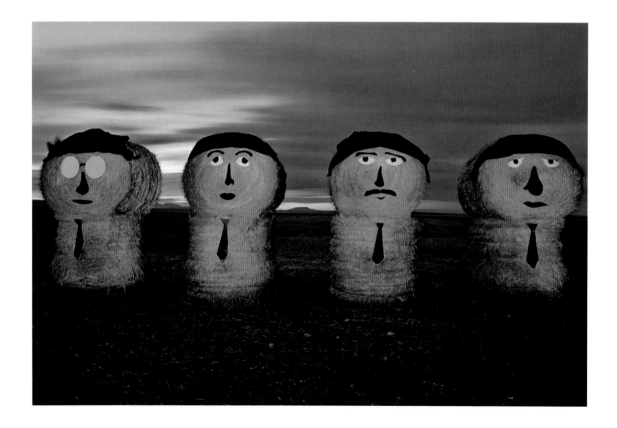

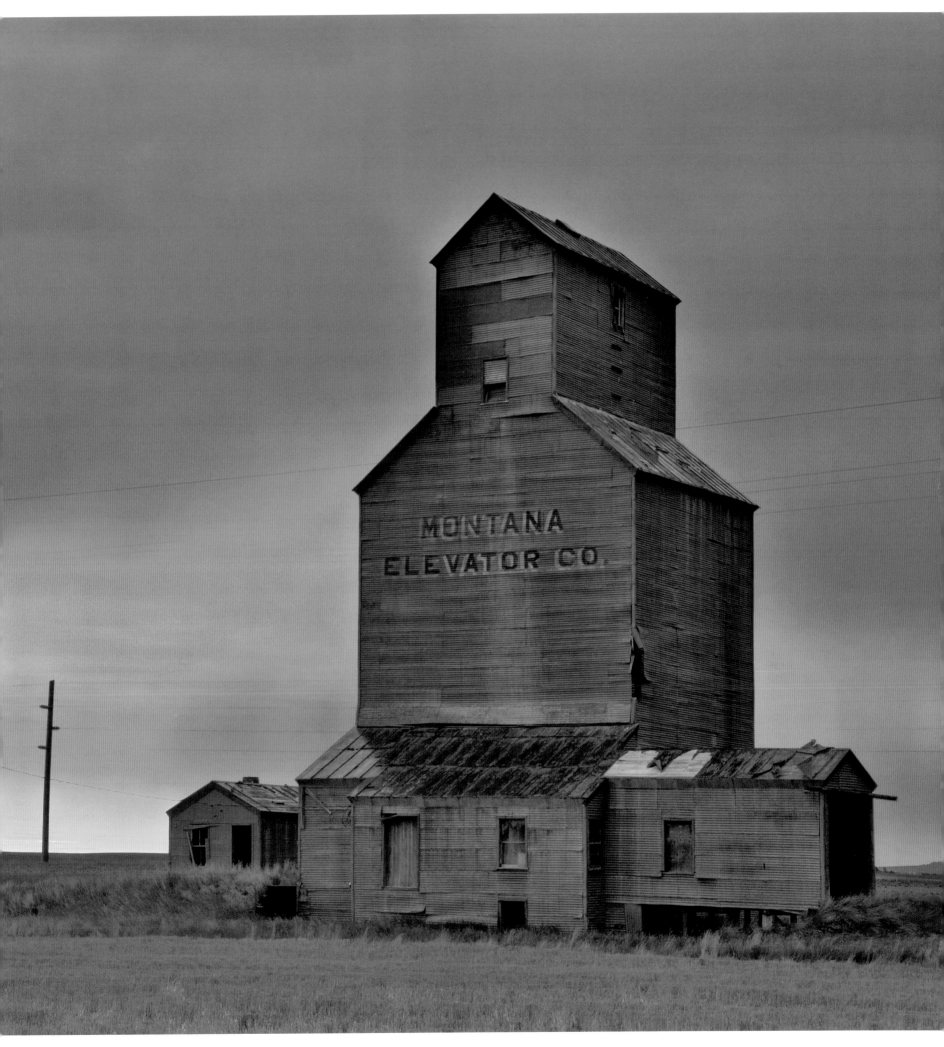

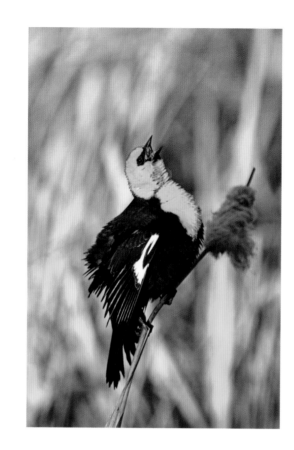

Right: Yellow-headed blackbird males sing to attract mates. CHUCK HANEY

Far right: A slower pace and an enjoyment of the simple things underpin much of life in rural Montana. This fenceline is lit by strong sunlight breaking through a stormy sky near Belt Butte. CHUCK HANEY

Below: A pair of mallards forage in a pond near Bozeman. CHUCK HANEY

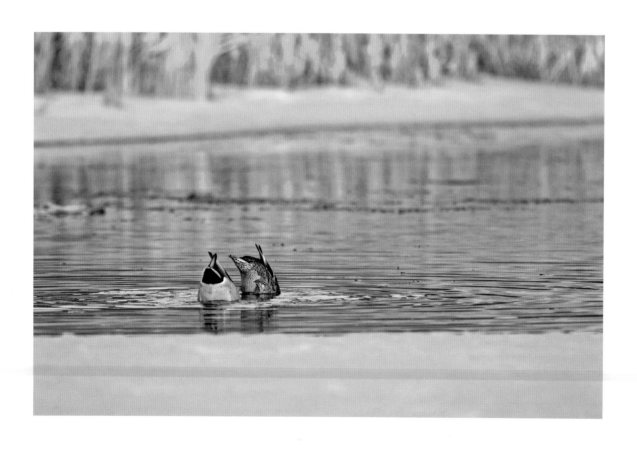

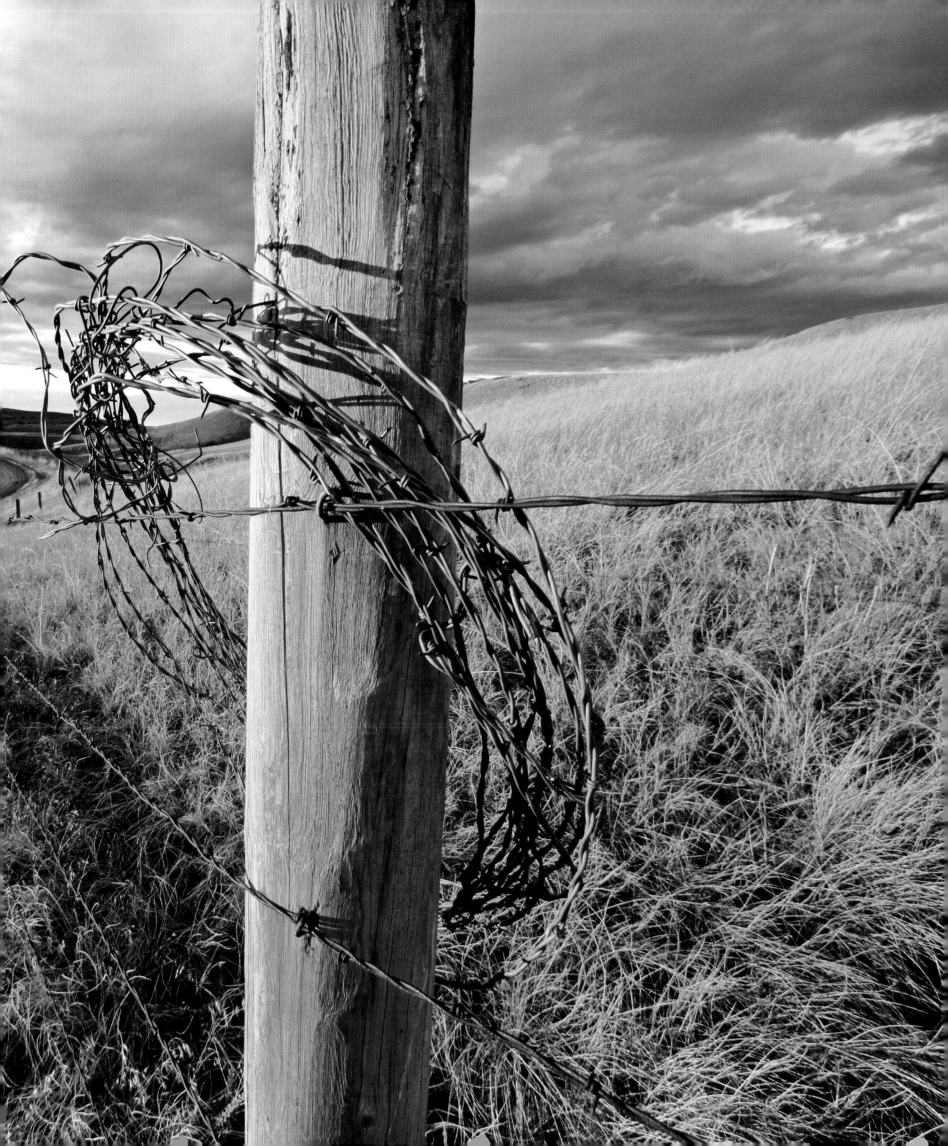

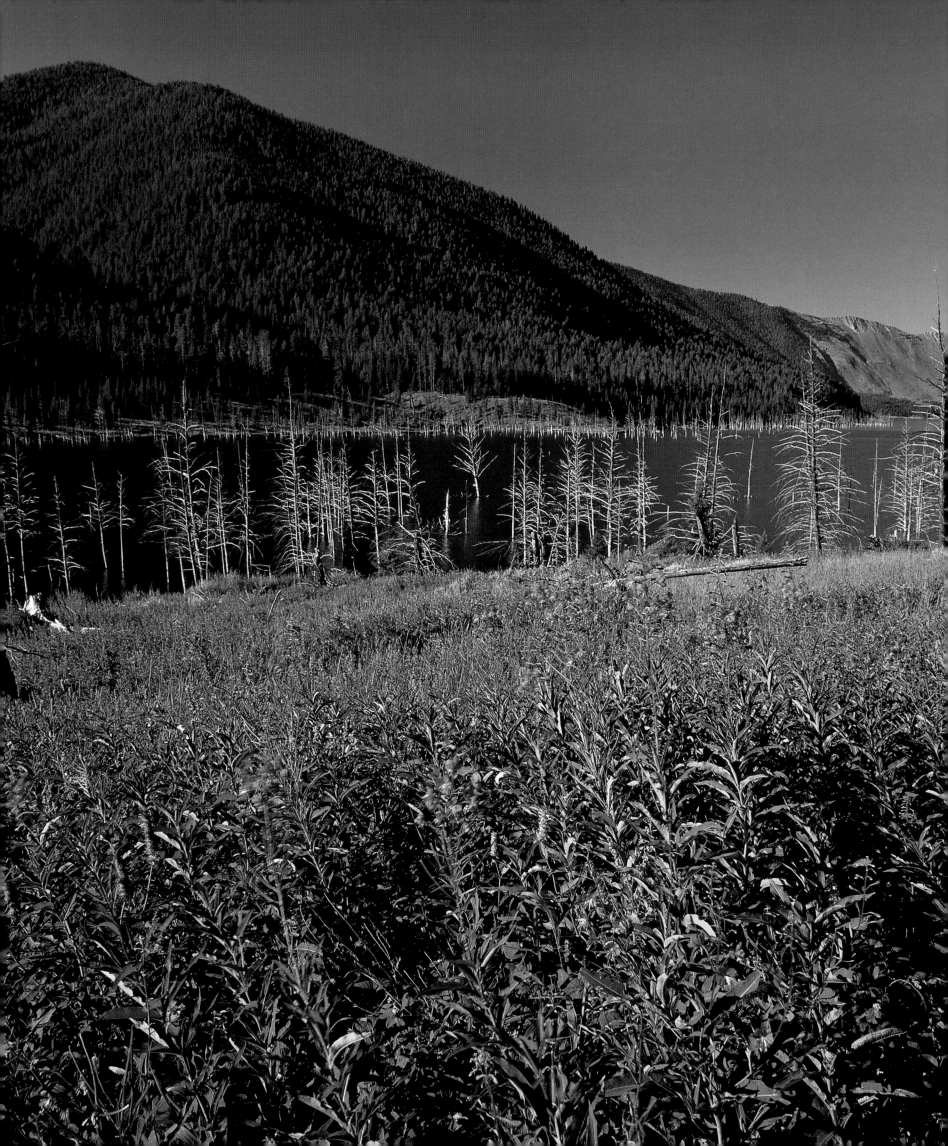

Left: A rare member of the rose family in Montana, *Kelseya uniflora* finds enough good habitat in Trout Creek Canyon to support spring blooming. It grows only on limestone rock, usually on steep cliff faces. JOHN LAMBING

Far left: Fireweed seed is lifted aloft by strong winds and is often the first species to colonize a burned or disrupted area. It quickly stabilizes the soils and incidentally creates great beauty, as seen here alongside Earthquake Lake. CHUCK HANEY

Below: Monkeyflowers love the wet soils along rushing streams, such as here on Miner Creek, which gathers water high in the Beaverhead Mountains and flows to the Big Hole River near Jackson. JOHN LAMBING

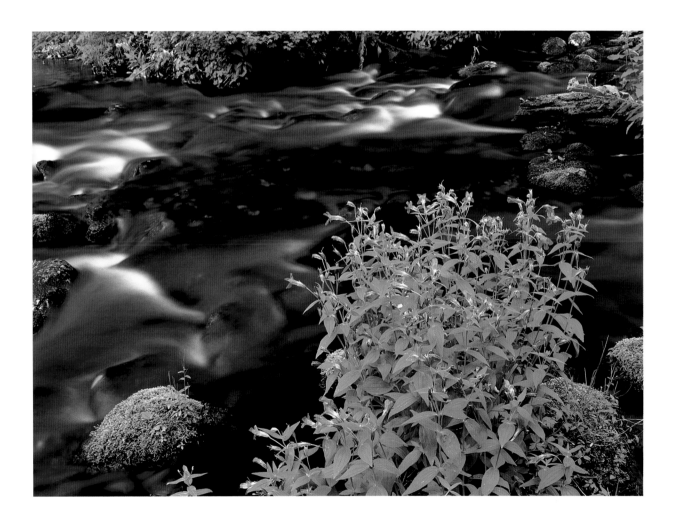

Right: Fort Union was the most important trading post on the upper Missouri River from 1828 to 1867. Living history reenactments and other historical displays at the compound portray life on the frontier. Assiniboine, Crow, Cree, Ojibway, Blackfeet, Hidatsa, and other tribes traded furs for guns, blankets, cookware, and more. CHUCK HANEY

Below: Montana's state flower is the bitterroot, which blooms in early spring. Native Americans harvested the plant for its nourishing root, which could be stored for years. Baking it decreased its bitter taste. JOHN LAMBING

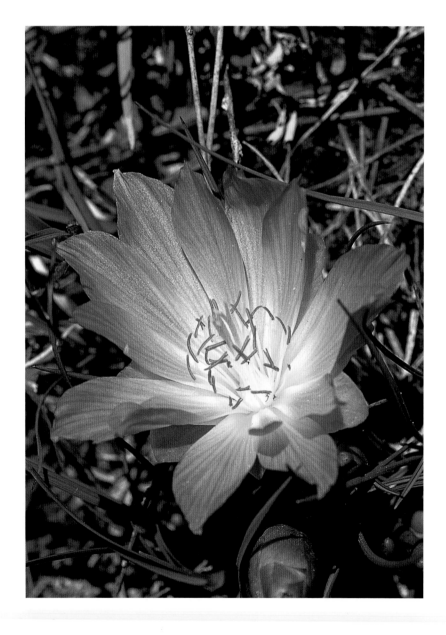

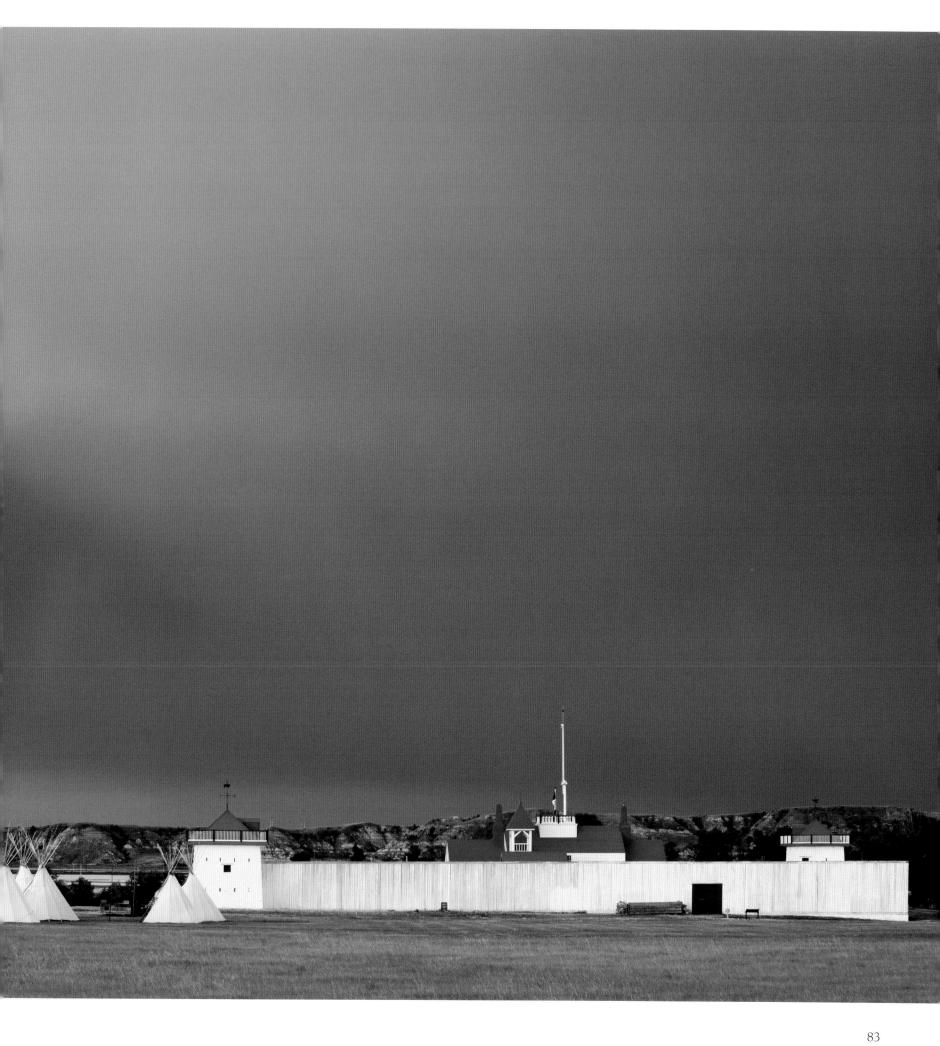

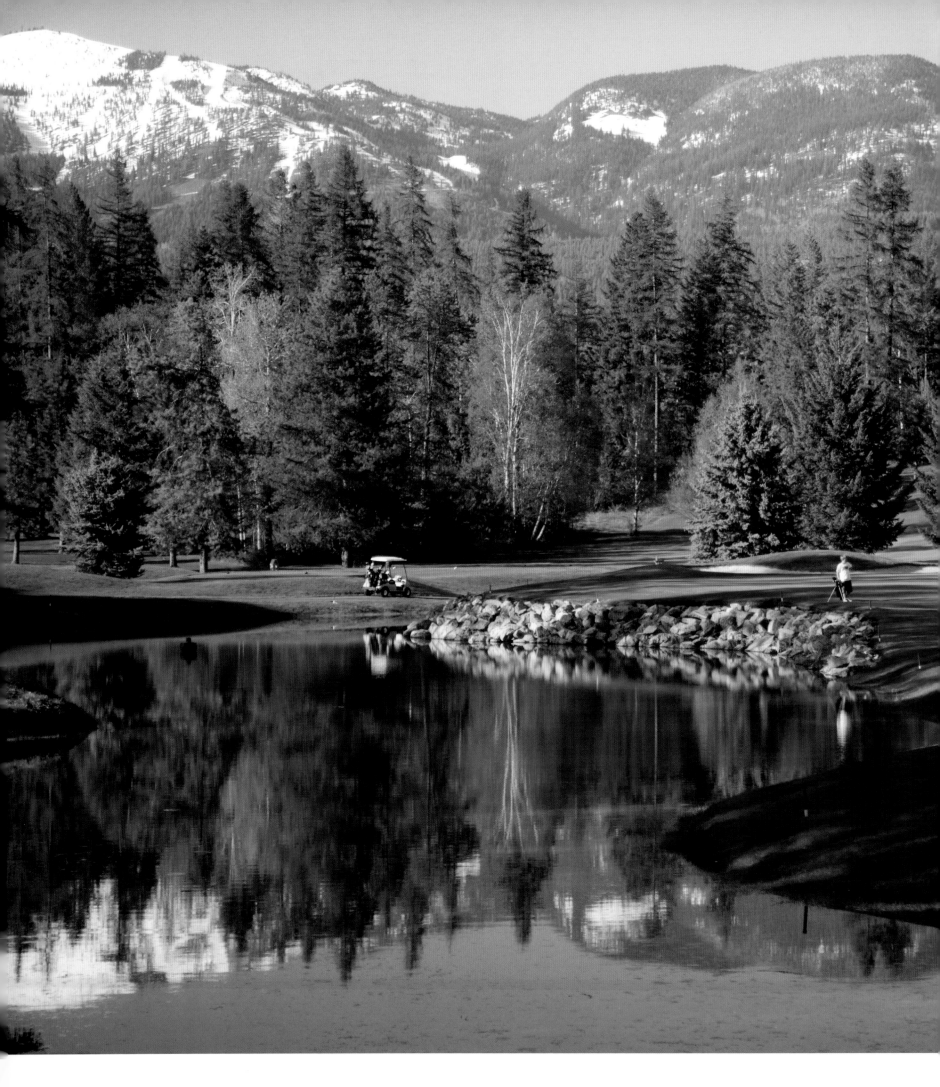

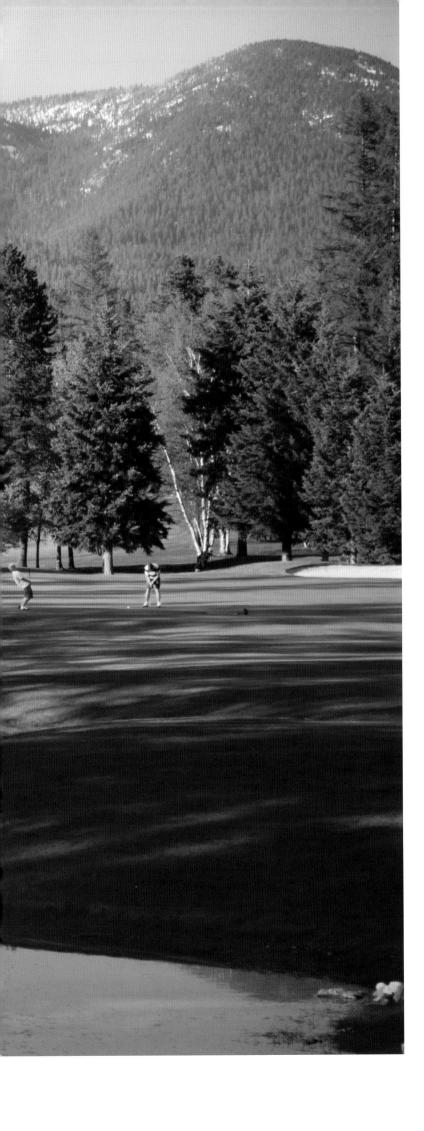

Left: A public golf course in Whitefish draws youngsters intent upon learning a new lifetime sport. In the background, the Whitefish Range harbors wildlife that includes gray wolves and grizzly bears, frogs and salamanders. CHUCK HANEY

Below: Ponderosa pines shelter colorful undergrowth in the Lewis and Clark National Forest. JOHN LAMBING

Right: Flowering spikes of purple lupine hold your attention in the foreground before your eyes invariably rise to view the imposing Choteau Mountain on the Rocky Mountain Front. CHUCK HANEY

Below: An igneous intrusion that resists weathering and erosion, Birdtail Butte juts from the surrounding prairie near Cascade. The formation is a reminder of previous volcanic activity that formed the impressive reefs and buttes in the area. CHUCK HANEY

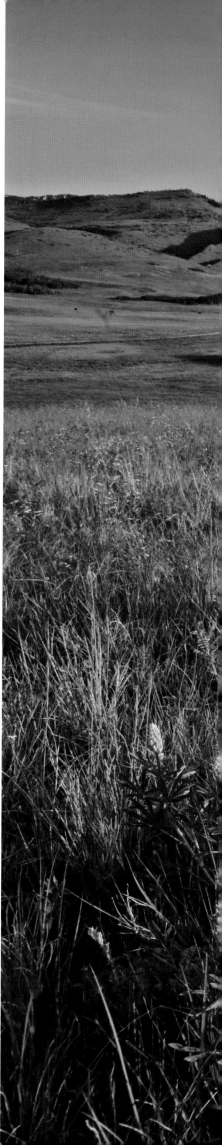

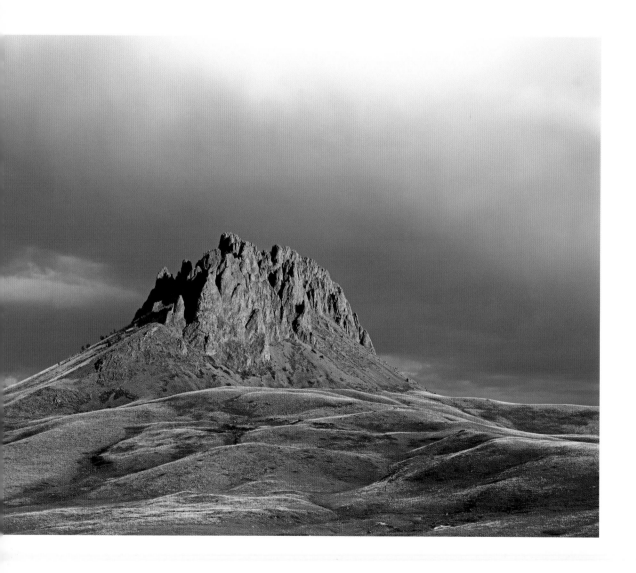

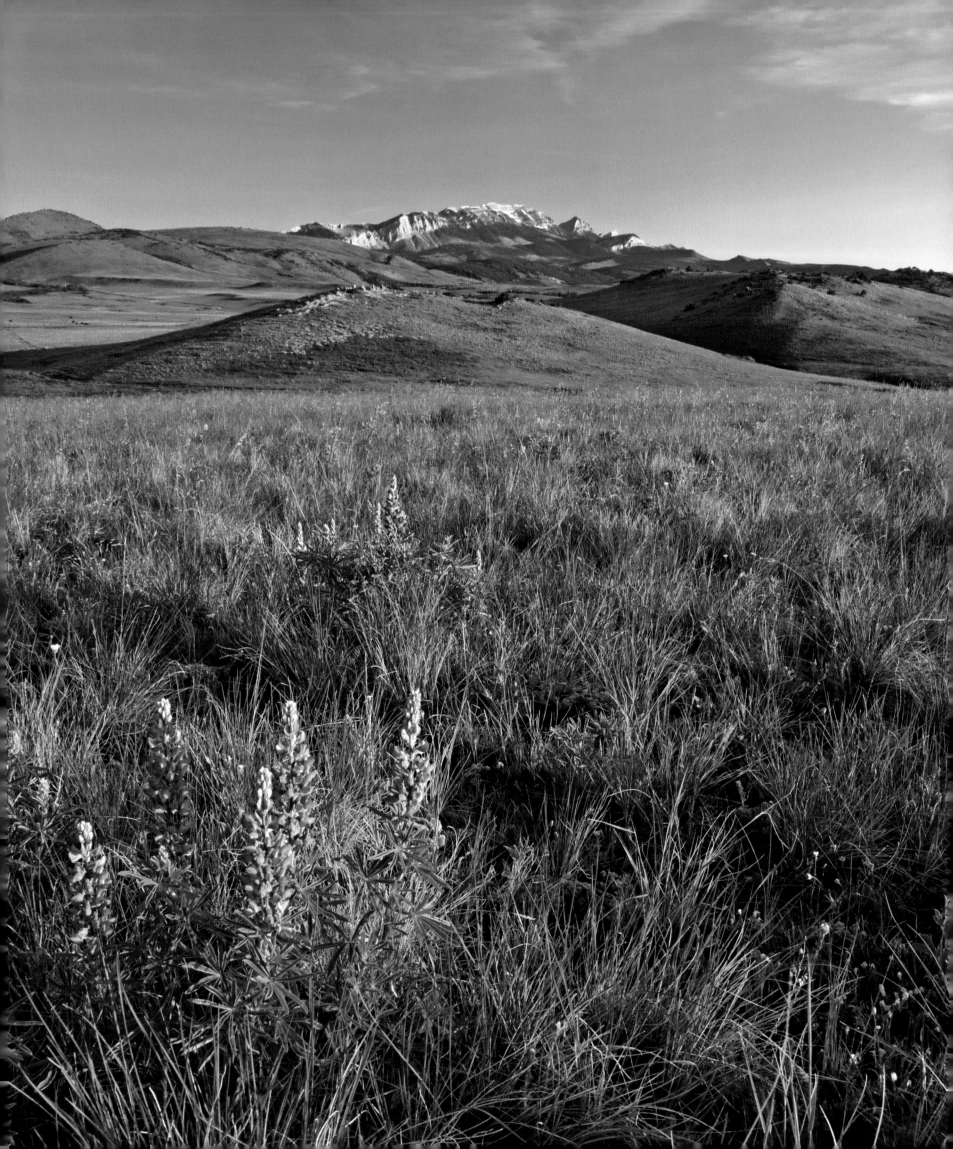

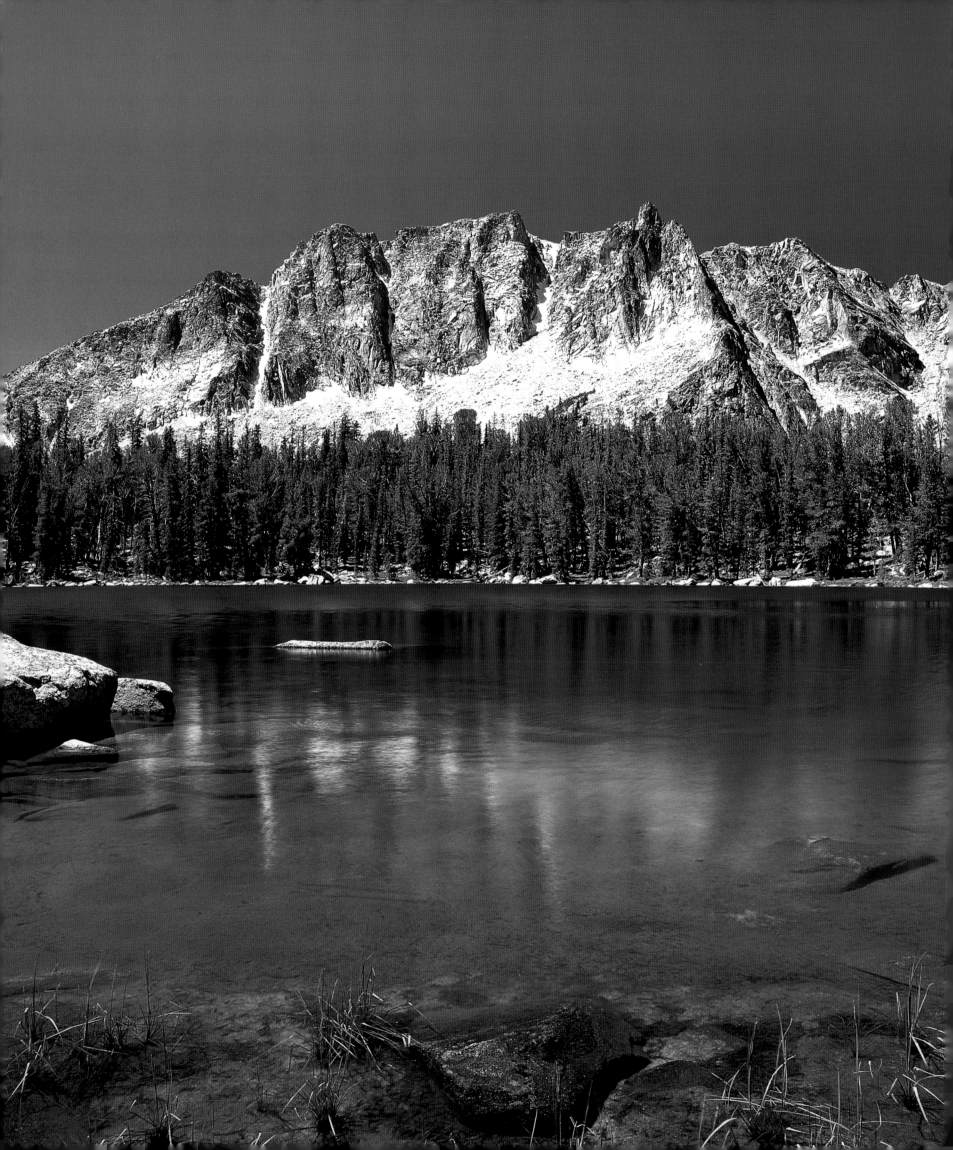

Left: Throughout Montana, hardy apples blossom each spring and produce delicious fruit. CHUCK HANEY

Facing page: Comet Peak rises above Hall Lake in the Pioneer Mountains. JOHN LAMBING

Below: Trumpeter swans have come back from near extinction and can sometimes be seen in southwestern Montana. CHUCK HANEY

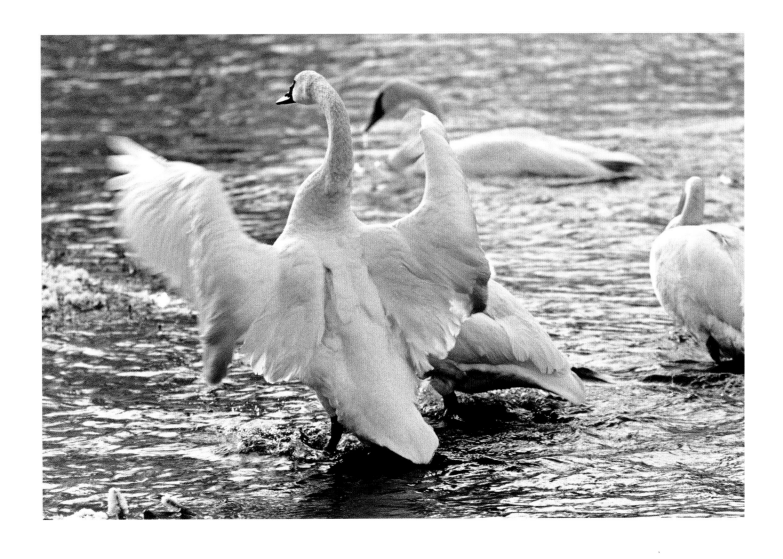

Right: Willow Creek Reservoir reflects the first light of day along the Rocky Mountain Front near Augusta. JOHN LAMBING

Below: Cream-colored, fragrant spikes of yucca blossoms adorn the dry sandstone formations at Makoshika State Park. CHUCK HANEY

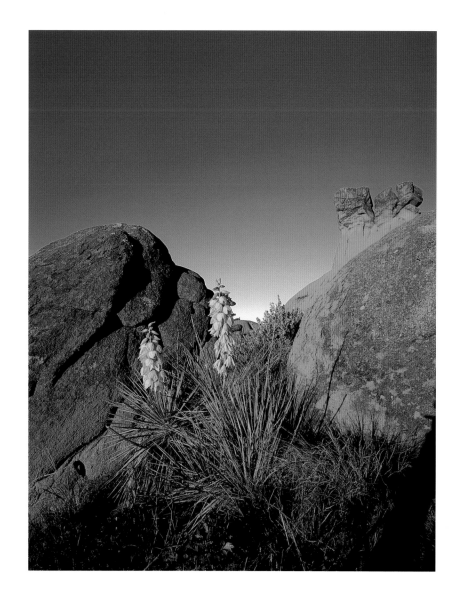

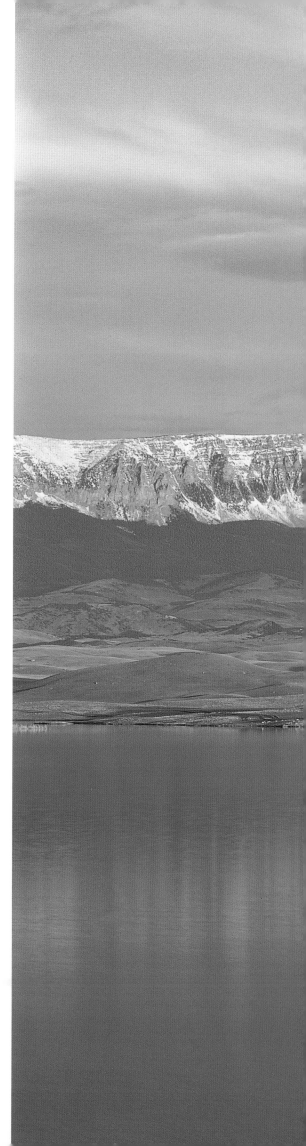

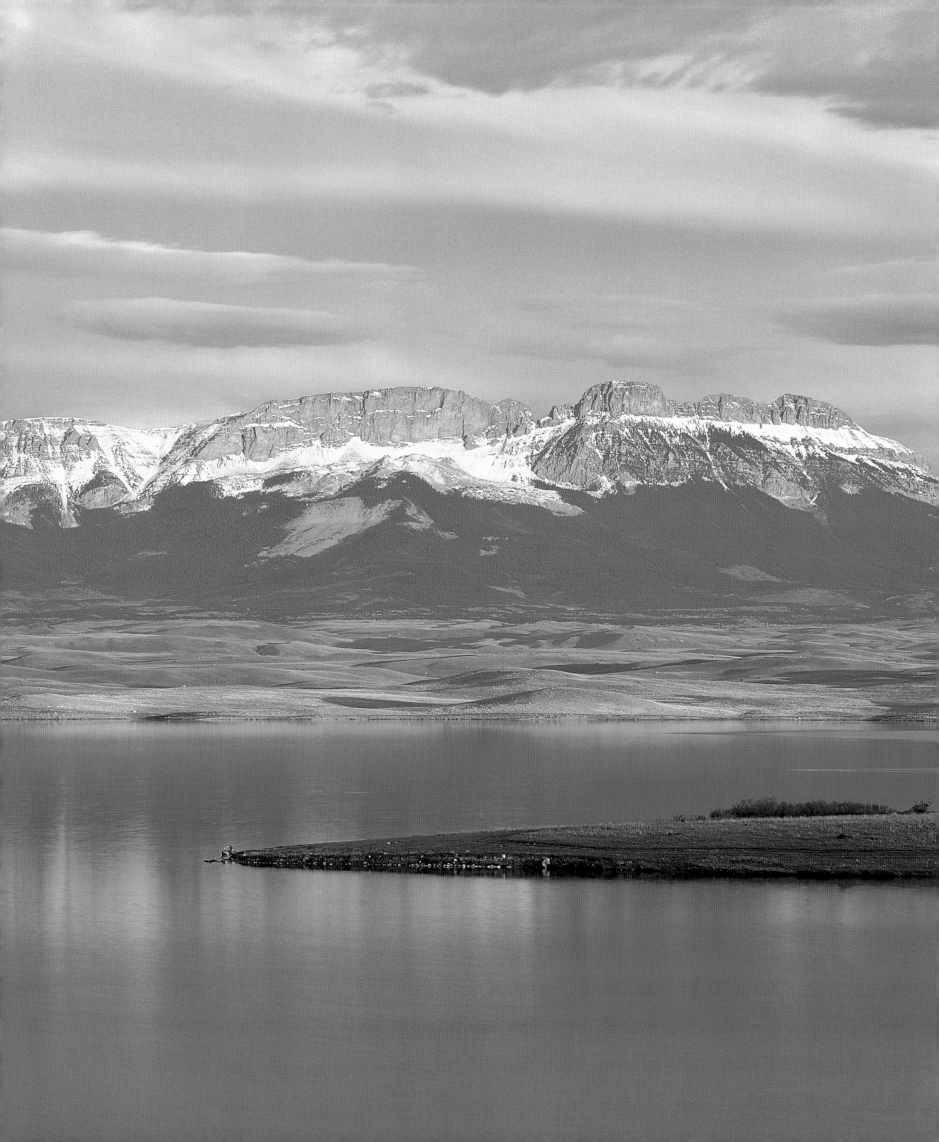

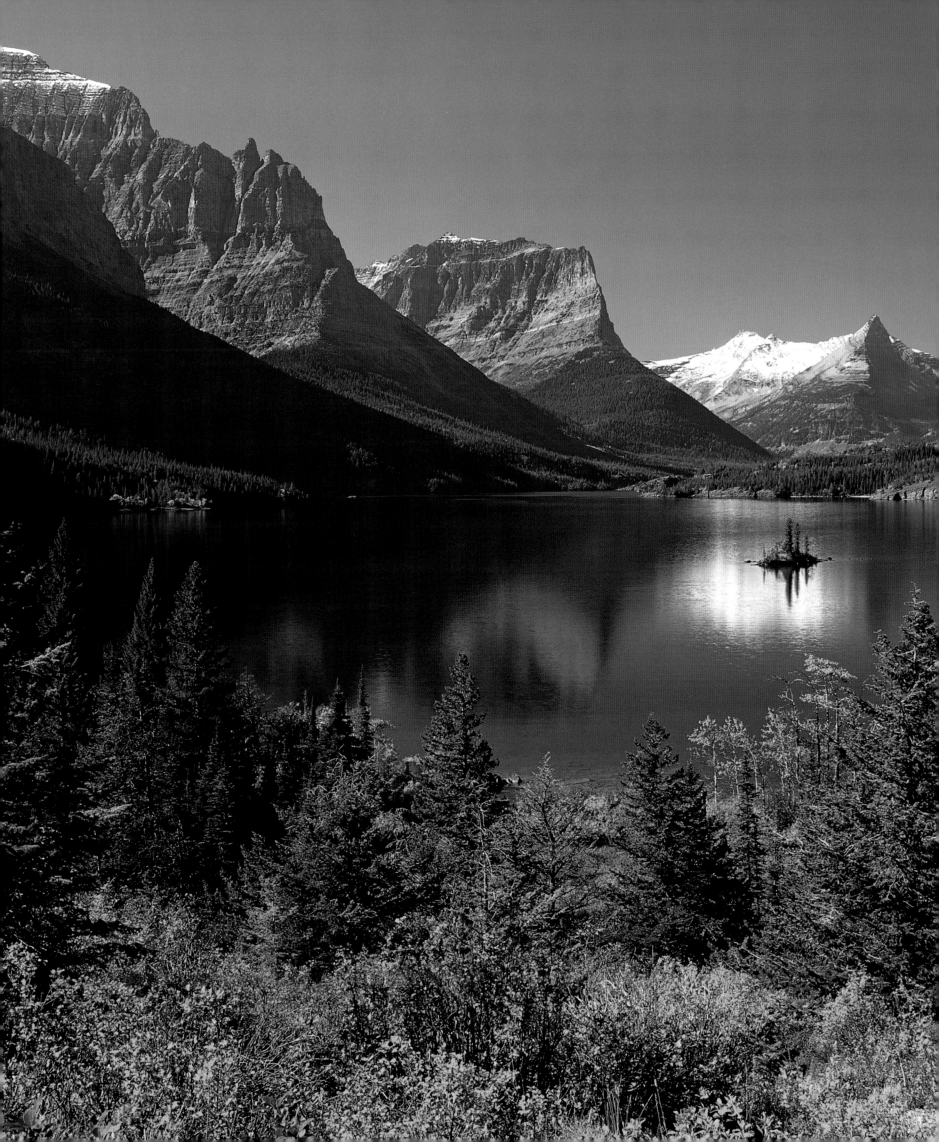

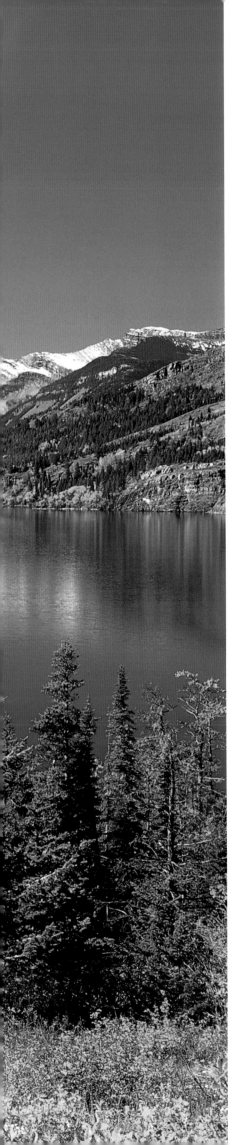

Left: A late fall storm in Glacier National Park dusted the high peaks with snow, reflected in the water around Goose Island in St. Mary Lake. JOHN LAMBING

Below: Autumn colors highlight the course of the Big Hole River near Divide. The Big Hole is one of Montana's most famous trout fisheries. JOHN LAMBING

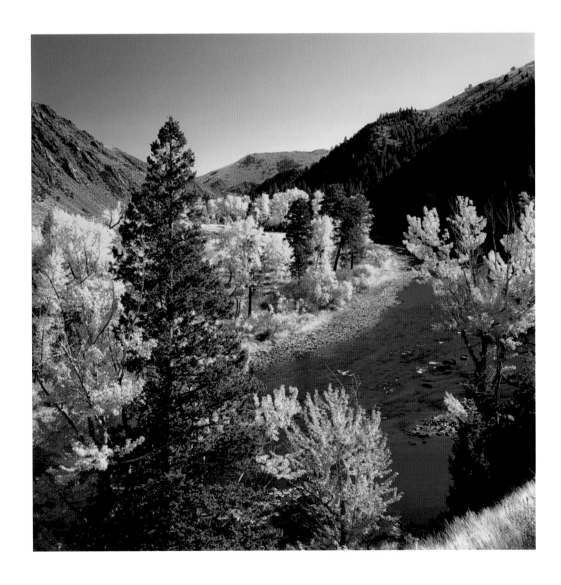

Right and below: Competitors show their exquisite, handcrafted beadwork and other traditional regalia at North American Indian Days Powwow. This annual event held in Browning the second weekend in July is in its fifth decade of celebrating native dancing, games, sports, and other cultural events. CHUCK HANEY

Far right: Anglers return to shore after a day of fishing on Fort Peck Reservoir, which holds game fish such as walleye, sauger, bass, northern pike, and more. CHUCK HANEY

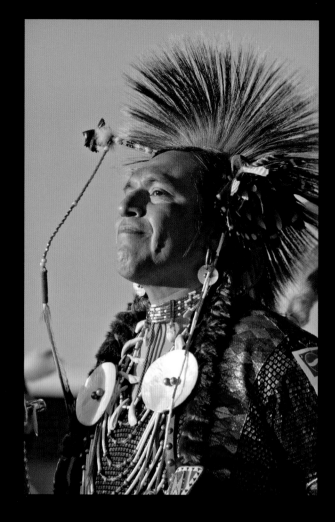

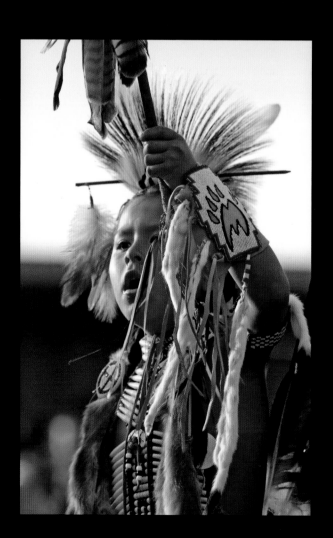

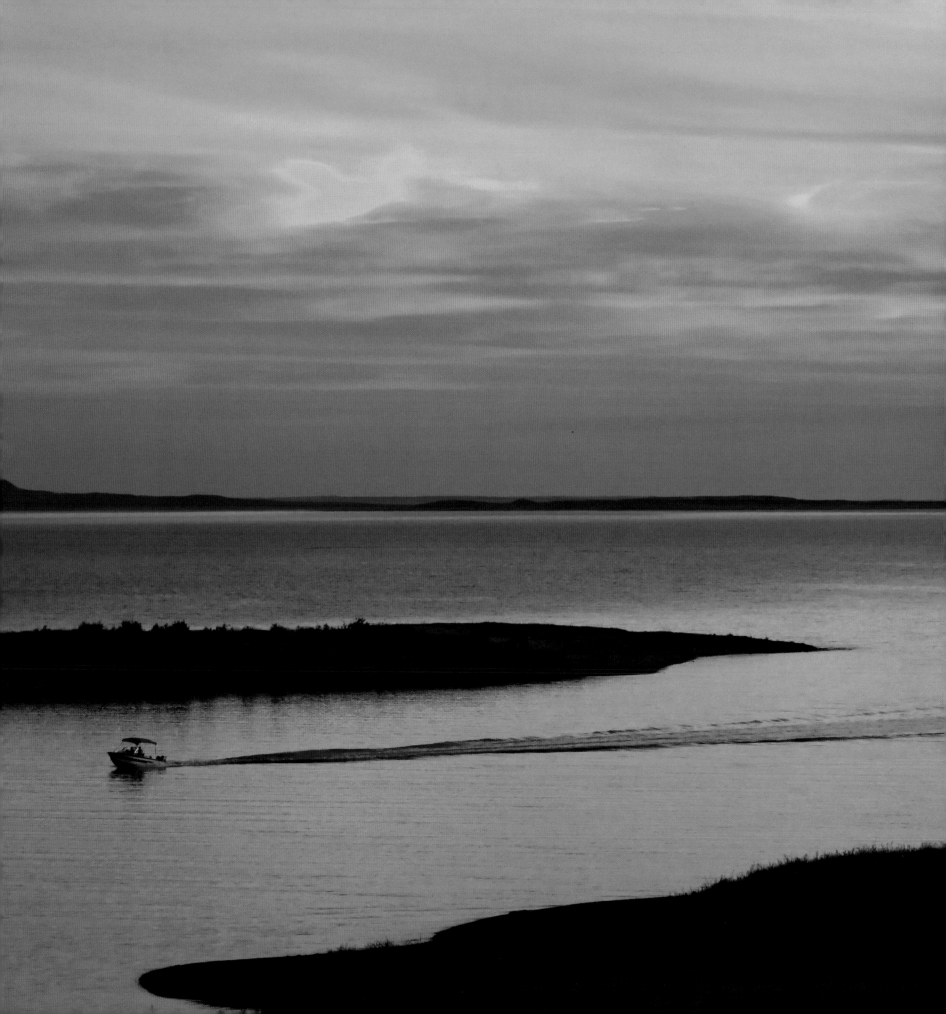

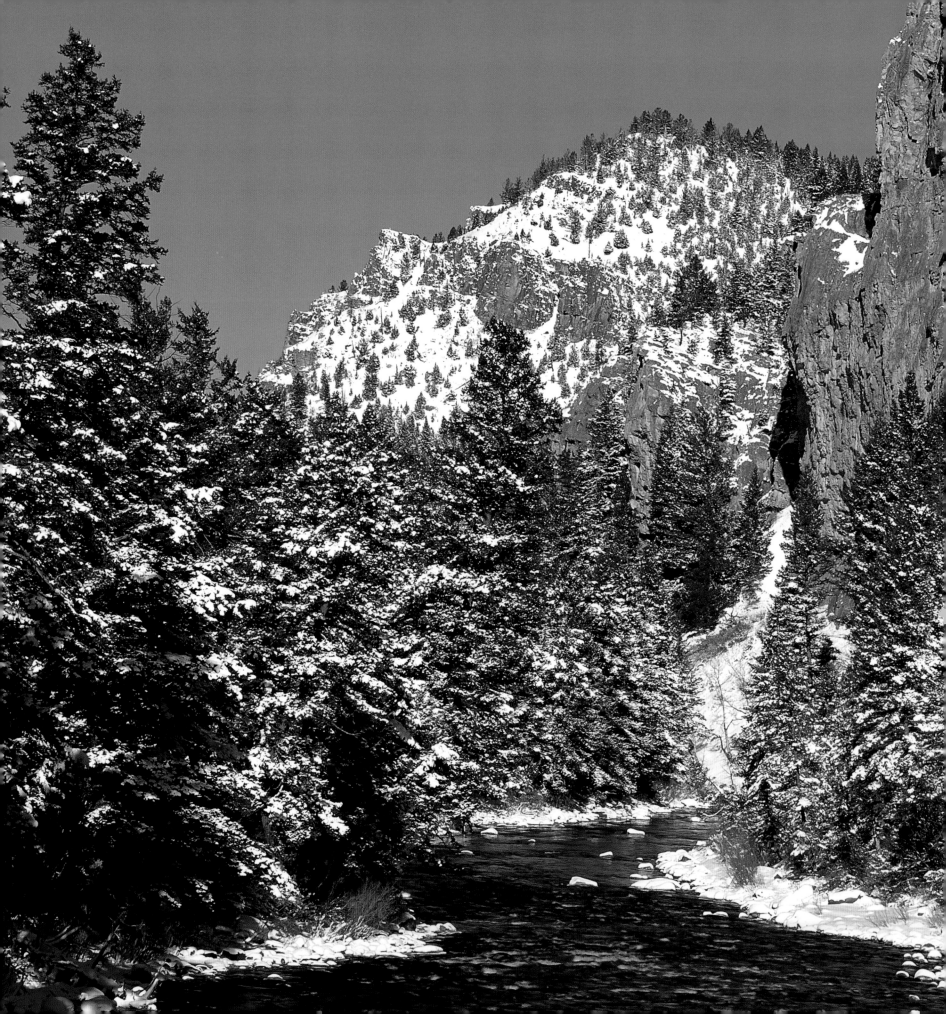

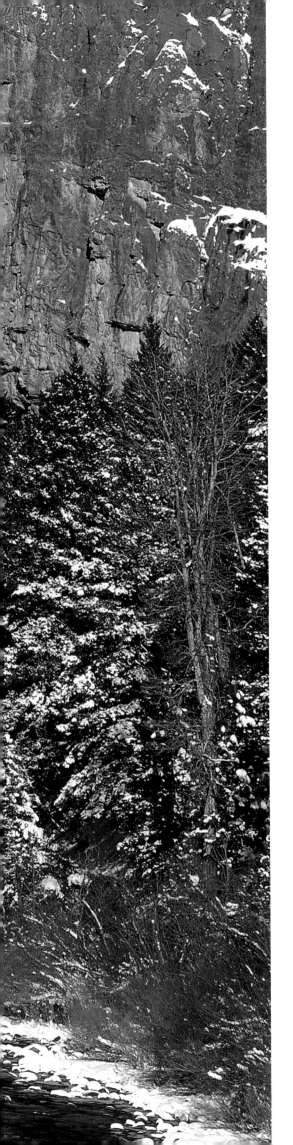

Left: Its headwaters in Yellowstone National Park, the Gallatin River has carved a deep canyon through southern Montana. Near Three Forks, it merges with the Jefferson and Madison rivers at Headwaters State Park to form the mighty Missouri River. JOHN LAMBING

Below: A bison licks snow from its muzzle with its distinctive black and pink tongue. The tall hump at its shoulders acts as an efficient lever, allowing these animals to swing their heavy heads back and forth to "plow" through deep snow and get to the grass beneath. JOHN LAMBING

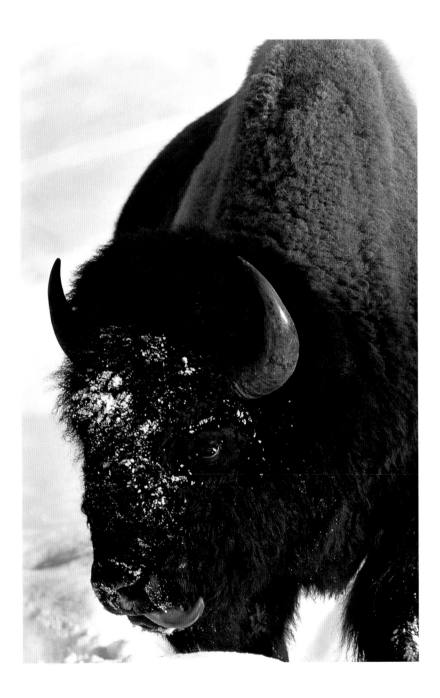

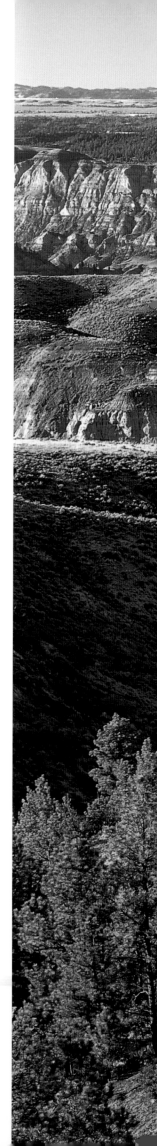

Right: Thousands of years of erosion created these rugged "breaks" in the soft sandstone along the Missouri River north of Winifred. The myriad coulees and islands in this area provide excellent cover for mule deer and various upland game birds and waterfowl. JOHN LAMBING

Below: Pads of yellow pond lilies seem to float in midair amid this forest reflected in a pond. CHUCK HANEY

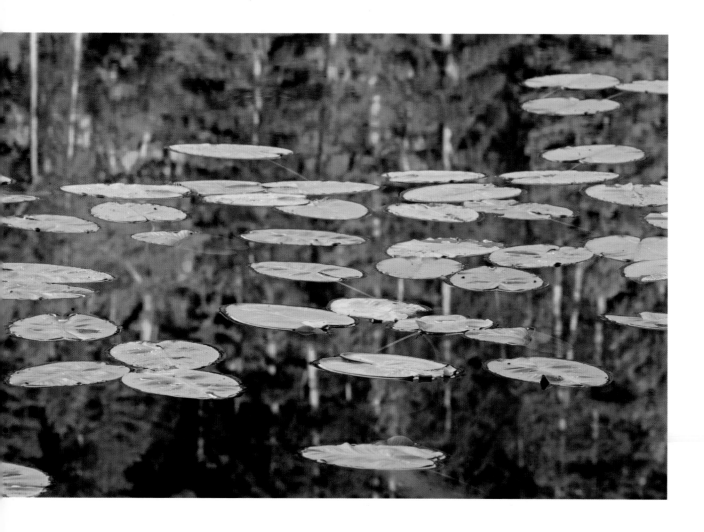

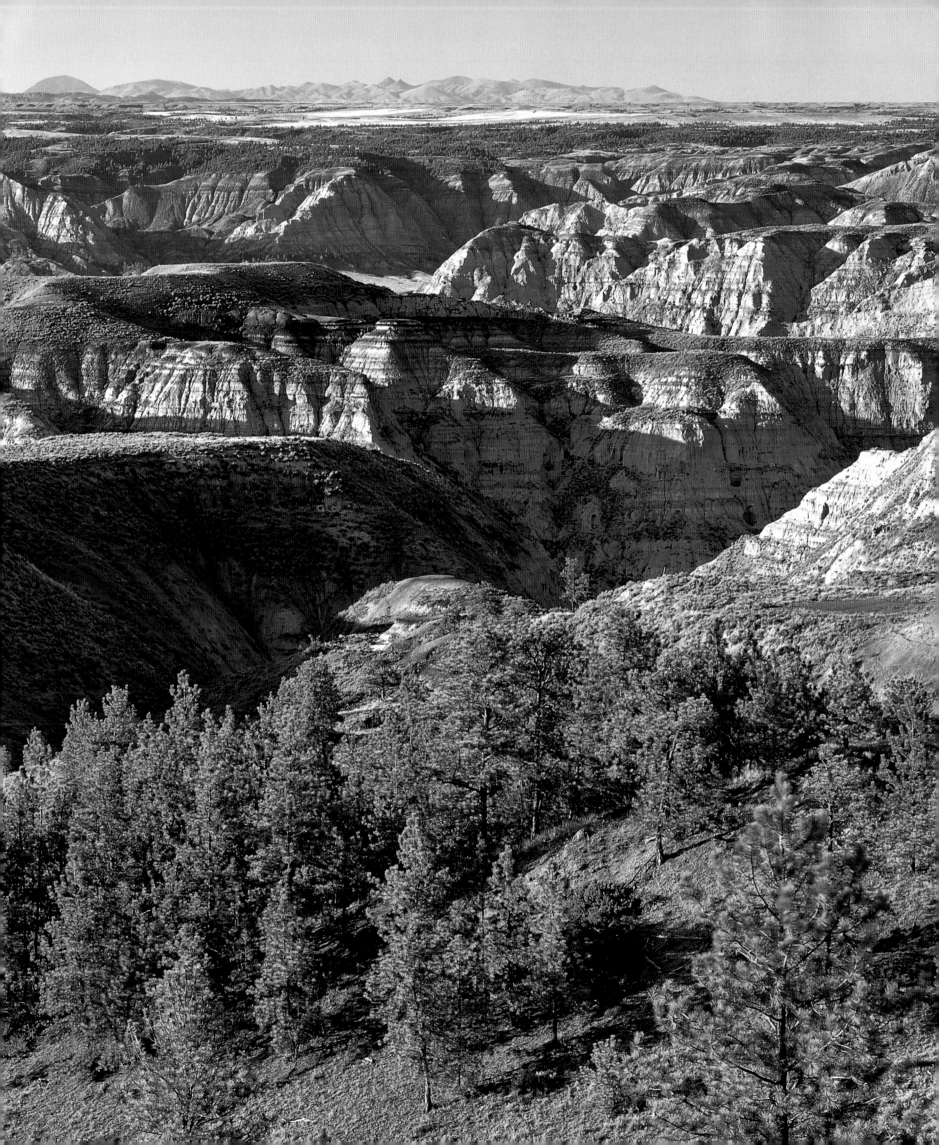

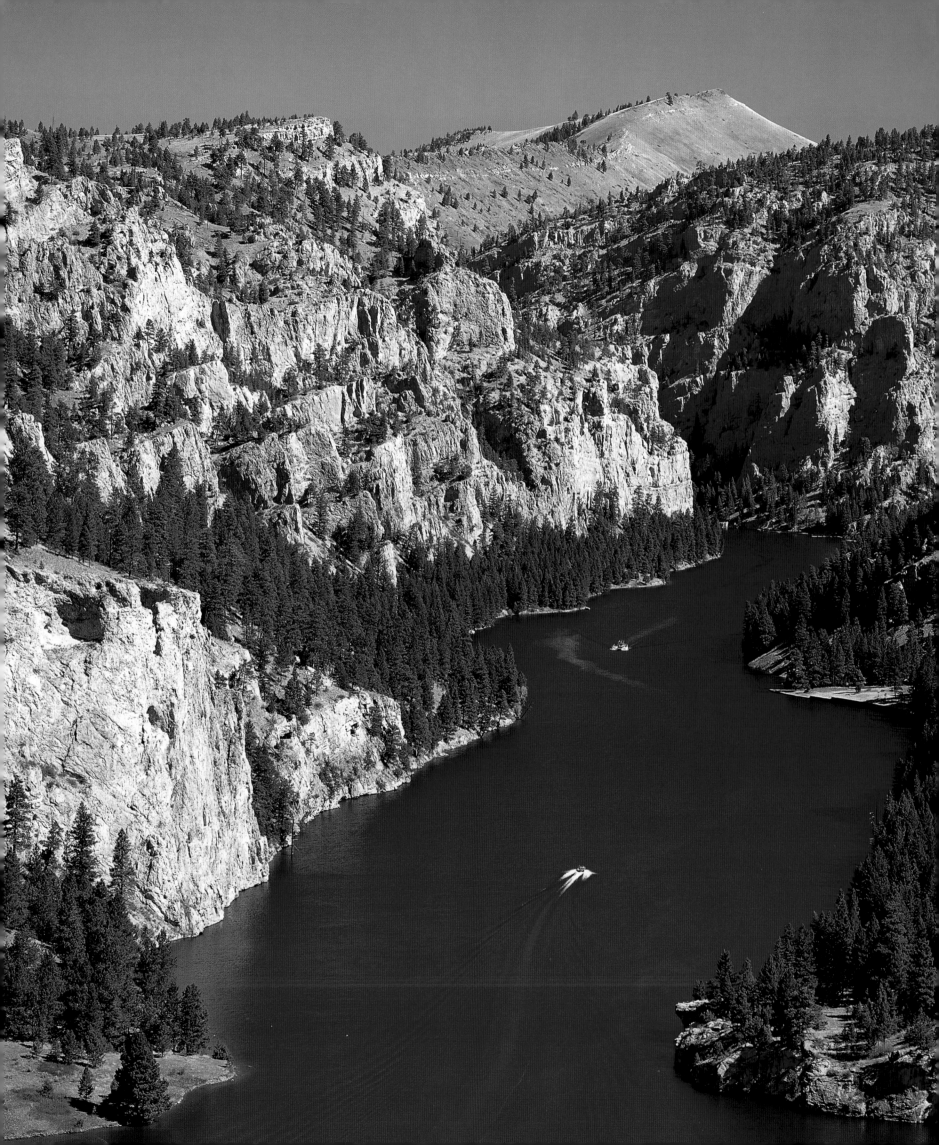

Left: The upper Missouri River has three major dams clustered together in its first hundred miles: Canyon Ferry, Hauser, and Holter. Here, boaters race along the slow water contained behind Holter Dam, in the narrows where the river flows through the Gates of the Mountains. JOHN LAMBING

Below: Libby Dam contains the Kootenai River, backing up the water into ninety-mile-long Lake Koocanusa. Because the river originates in Canada, the reservoir was named to honor the KOOtenai, CANada, and the USA. JOHN LAMBING

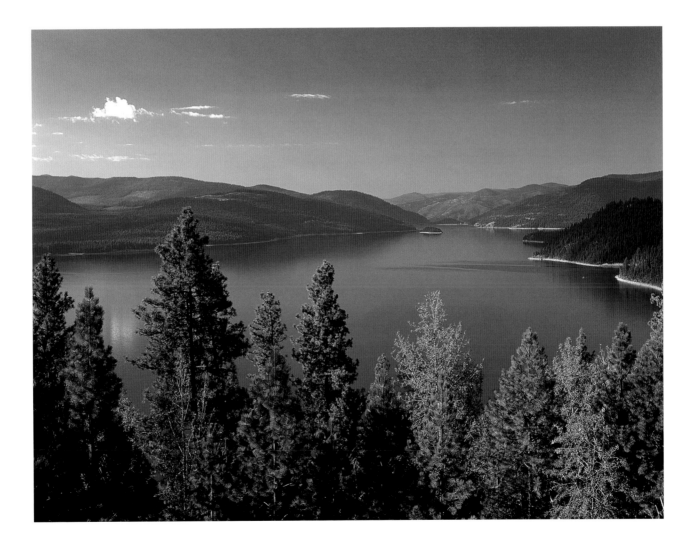

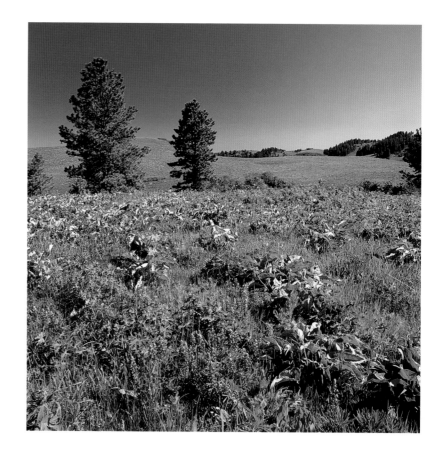

Right: Springtime rains bring on abundant wildflower blooms in the Wolf Mountains, near Lodge Grass. JOHN LAMBING

Facing page: The Absaroka Range rises above a meadow of green grasses and quaking aspen groves. JOHN LAMBING

Below: Lupine plants find good habitat along Jacobson Creek, high in the Pioneer Mountains. CHUCK HANEY

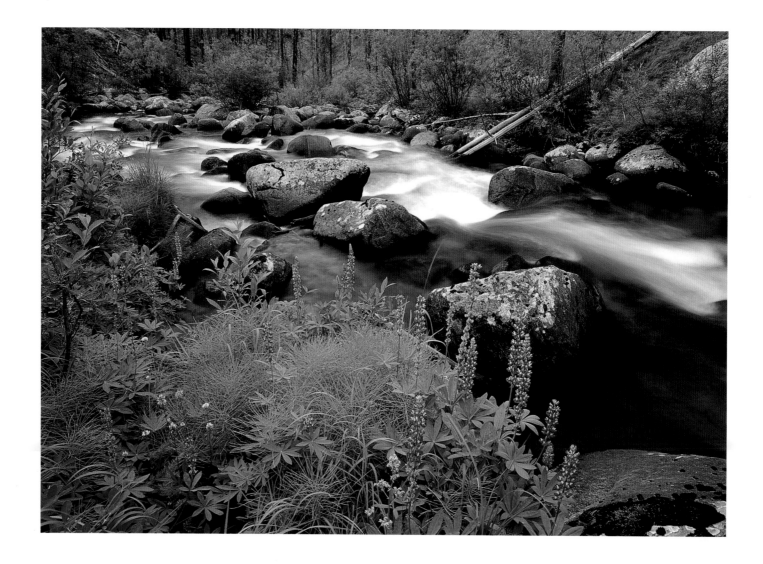

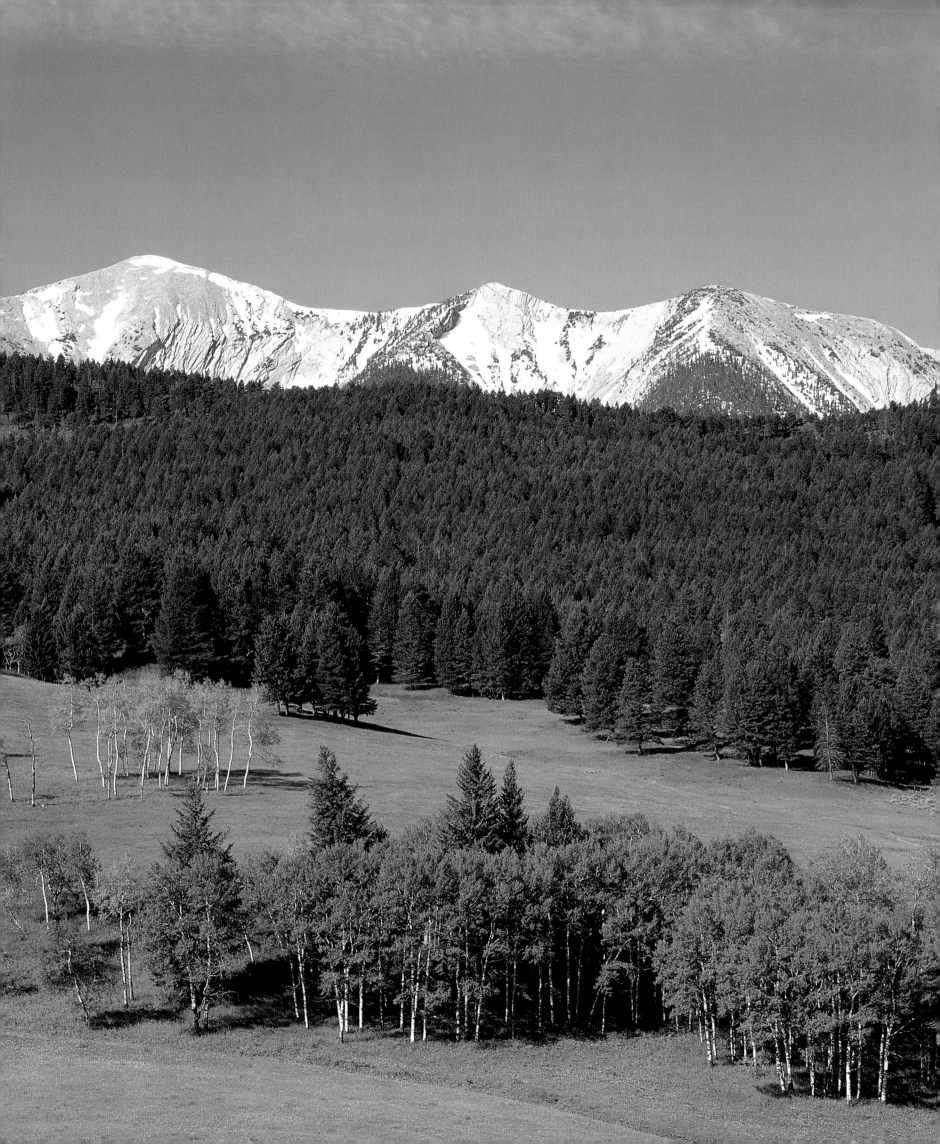

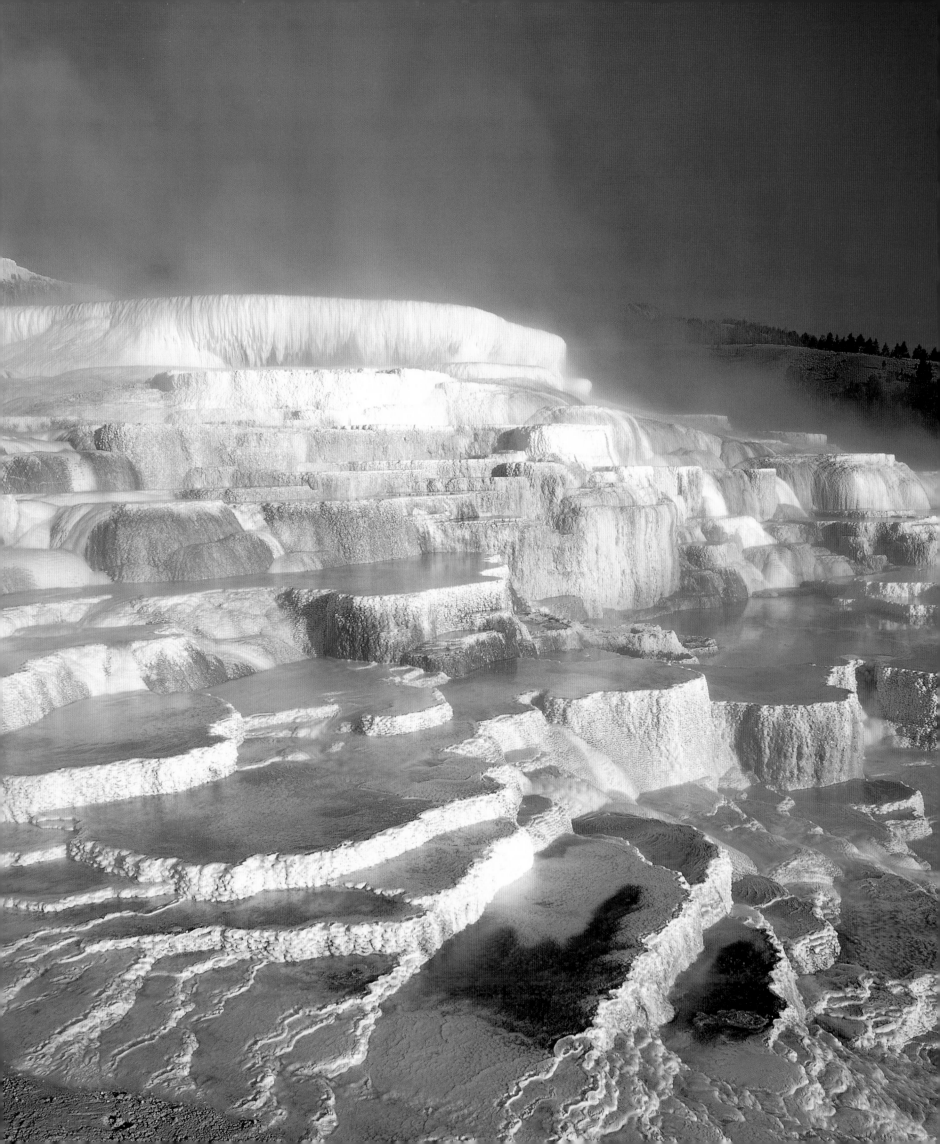

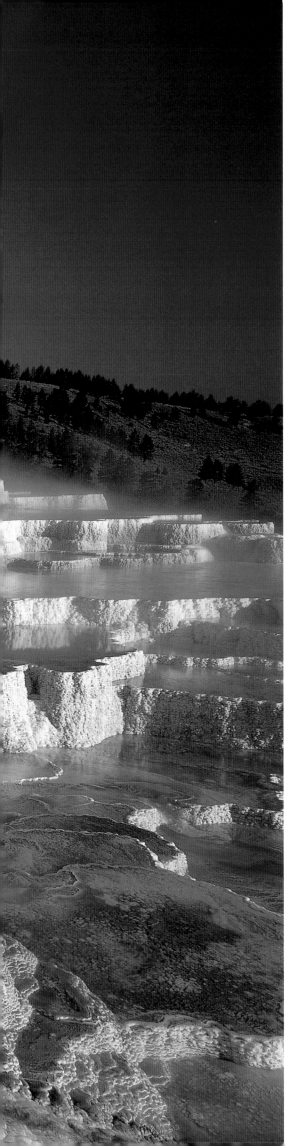

Left: Minerva Terrace, at Yellowstone National Park's Mammoth Hot Springs, was formed by hot water carrying rich loads of calcium carbonate that dissolved the surrounding limestone and hardened into travertine, the material that forms these beautiful terraces. CHUCK HANEY

Below: Beargrass blossoms open in clusters; this close-up shows the detail of a single flower within its cluster. CHUCK HANEY

Right: Farmers and ranchers raise hay and other crops on the rich bottomlands adjacent to the Missouri River. Meanders and islands characterize the river as it flows through the prairie landscape near Fort Benton. JOHN LAMBING

Below: Warm Springs Creek cascades over a ledge near Garrison, then joins the Clark Fork River. JOHN LAMBING

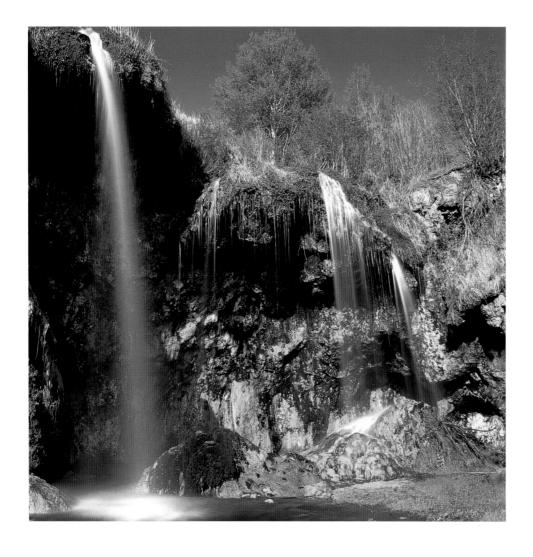

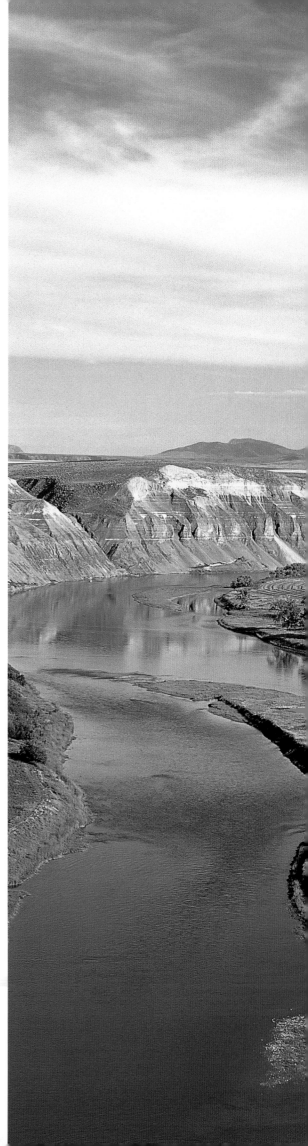

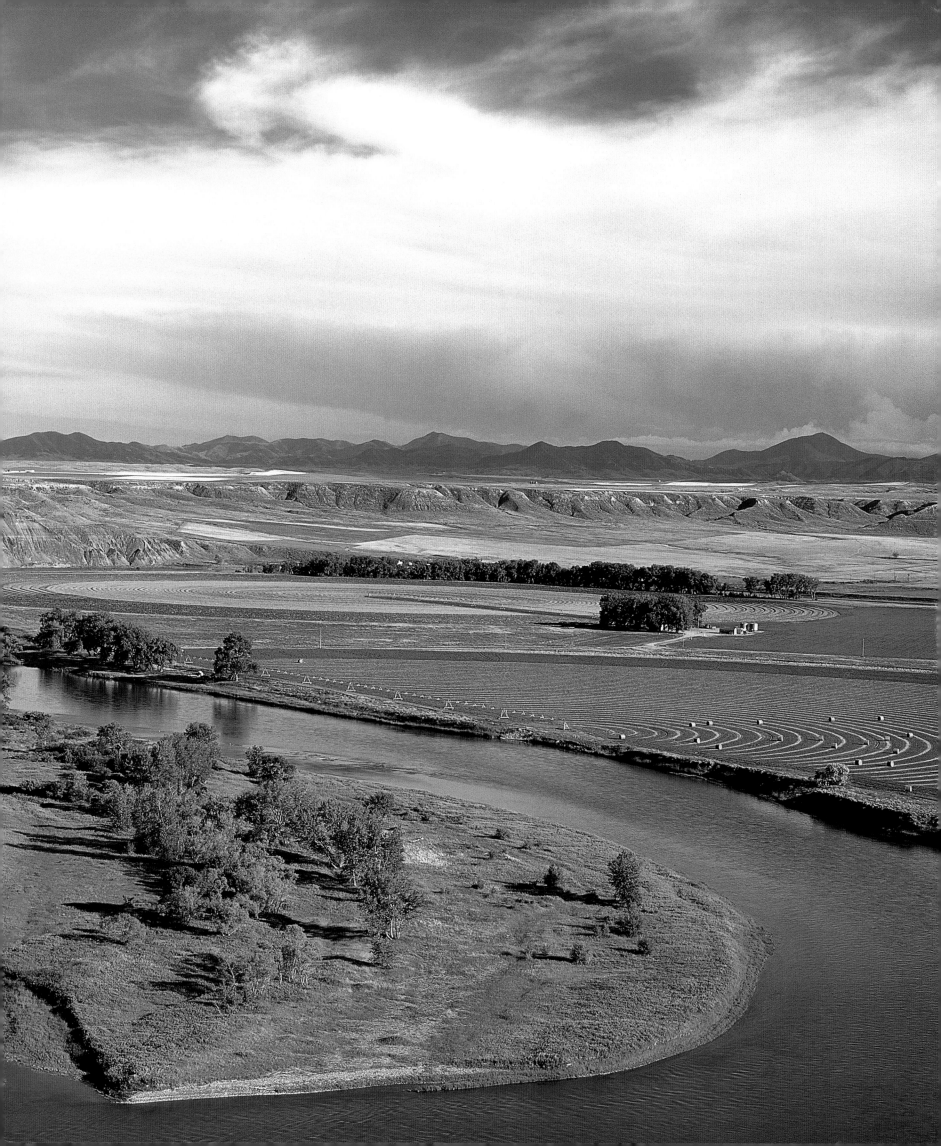

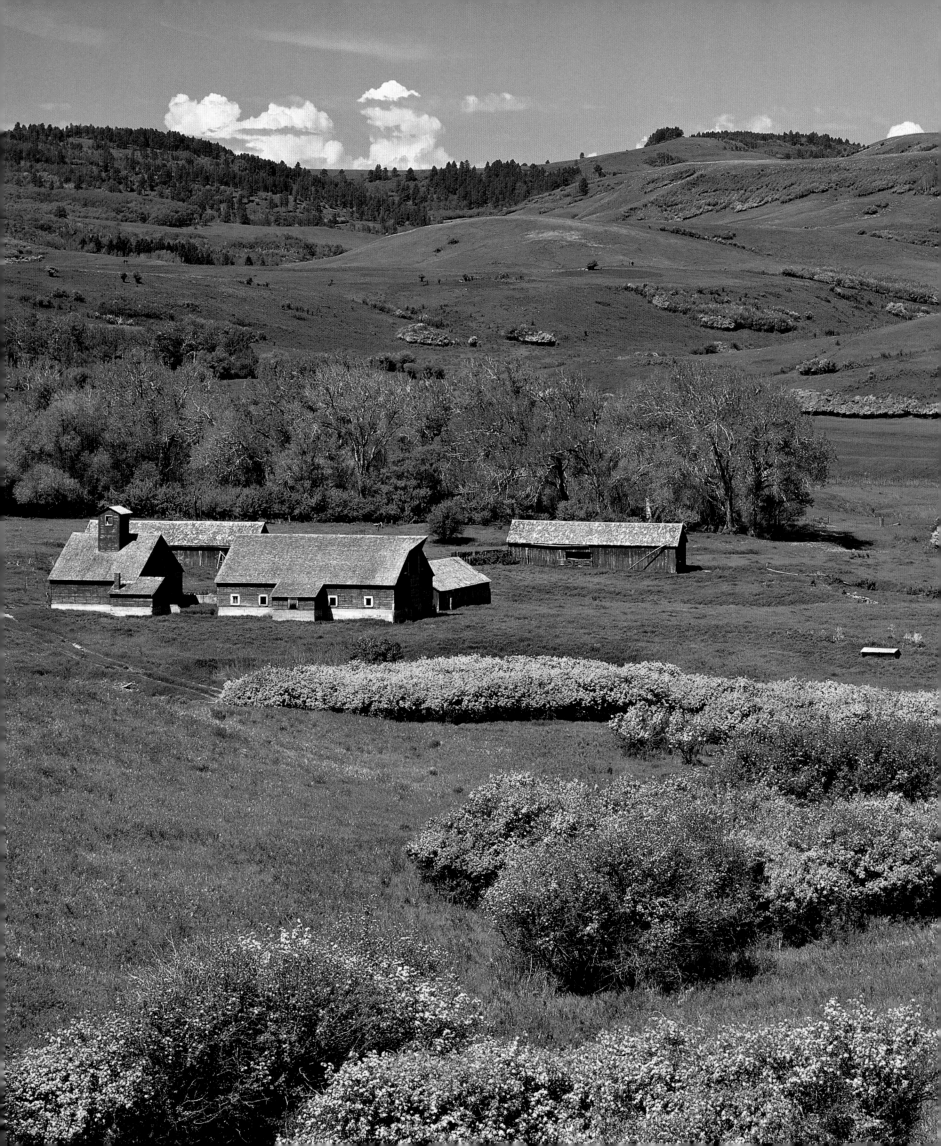

Left: Barns and loafing sheds dot the rural landscape along Big Spring Creek near Lewistown. JOHN LAMBING

Below: A ring-necked pheasant cock watches for predators. A century ago this game bird species was imported from Asia, and the birds have adapted to conditions in many parts of Montana. CHUCK HANEY

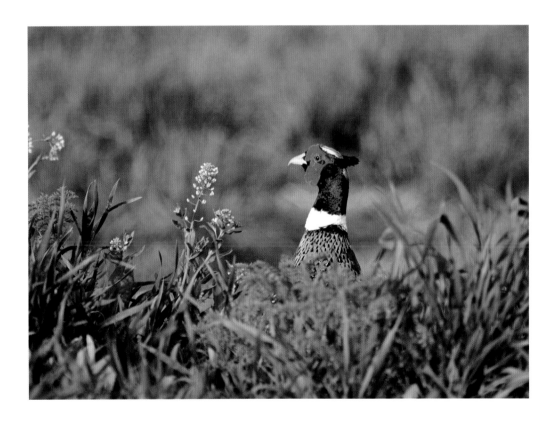

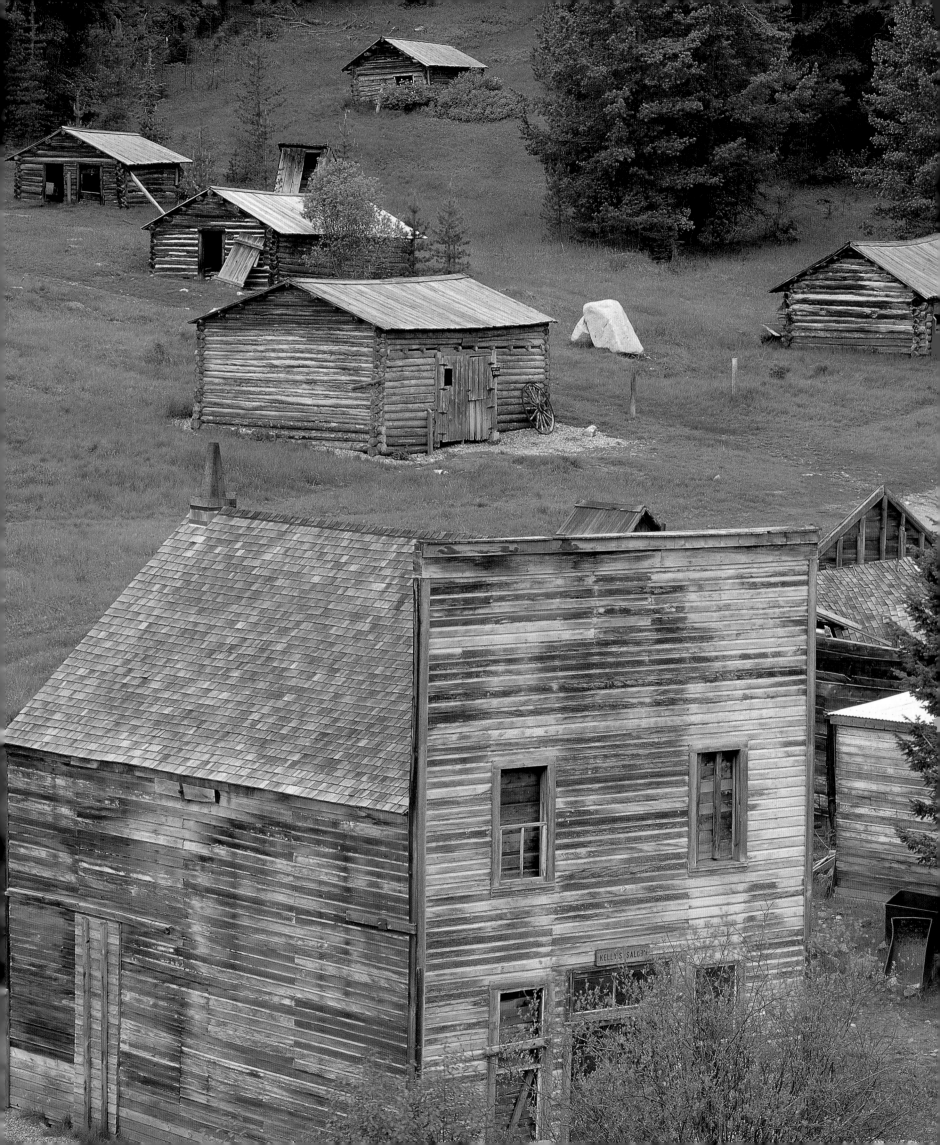

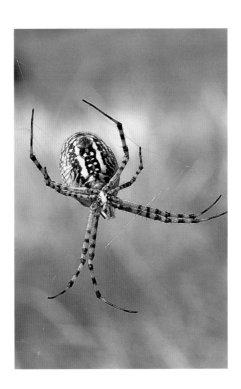

Left: Orb-weaver spiders can construct a web in less than an hour. Their web pattern is a central hub with radiating spokes. JOHN LAMBING

Far left: Garnet ghost town still contains log structures and intriguing relics of the gold rush era in Montana. JOHN LAMBING

Below: Many Indian tribes consider white buffalo to be sacred animals. Here, someone has painted a white buffalo calf on a cliff on Rocky Boy's Reservation. JOHN LAMBING

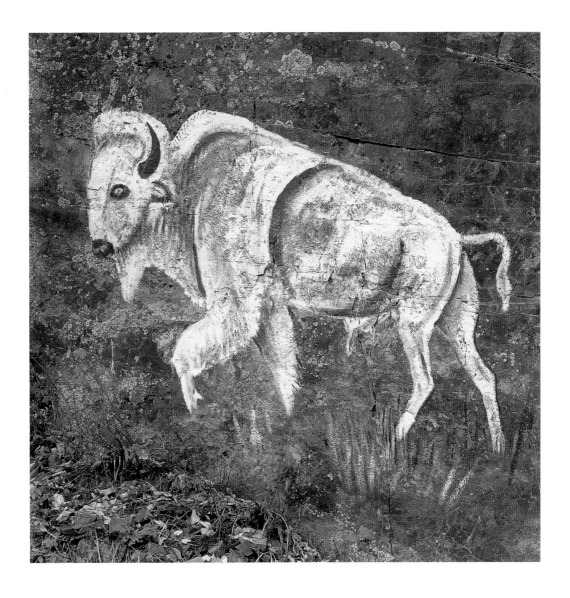

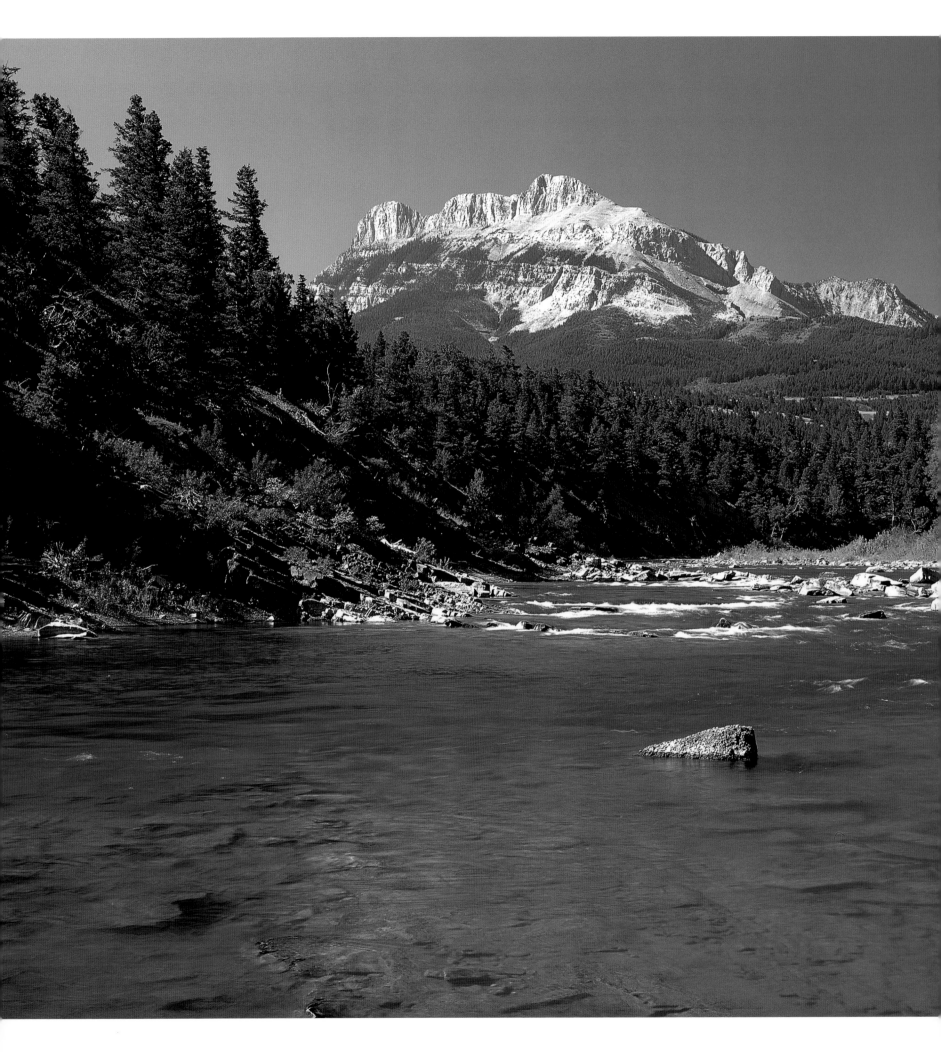

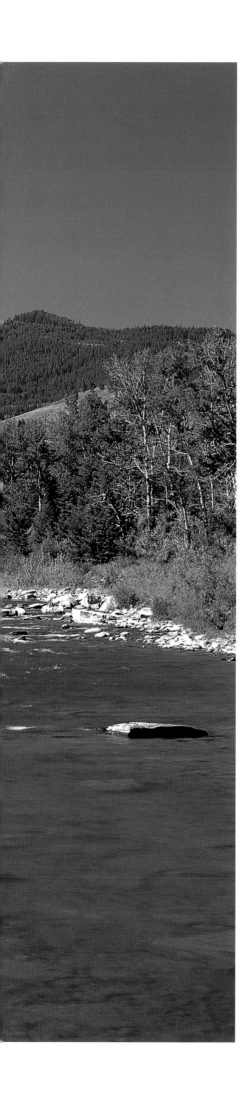

Left: The Rocky Mountain Front's Sawtooth Ridge rears up to 7,907 feet, forming a rugged backdrop to the Sun River. JOHN LAMBING

Below: Visible from the Going-to-the-Sun Road in Glacier National Park, Haystack Creek cascades down the ledges on the west side of Logan Pass. JOHN LAMBING

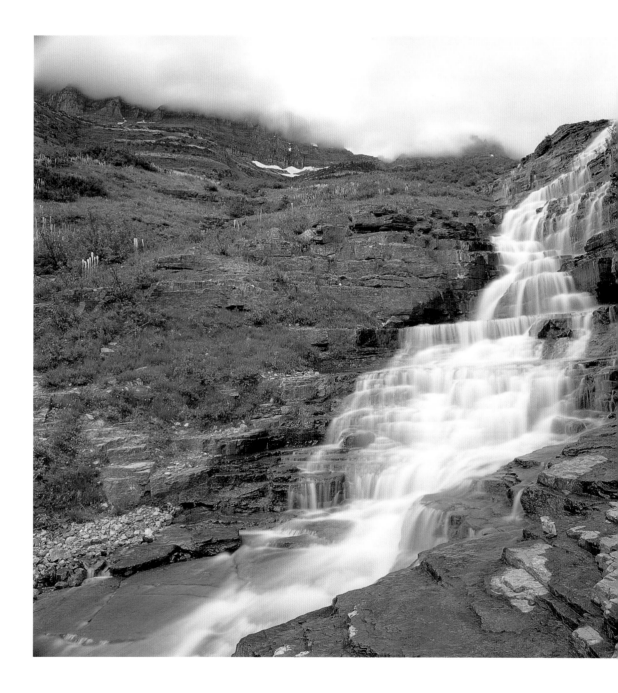

Right: Glacier National Park's Going-to-the-Sun Road took eleven years to build; it opened to the first tourist traffic in 1932. Named for the nearby mountain peak, the road was dedicated in 1933. The fifty-mile route is designated a National Historic Landmark for its remarkable engineering and construction feats. CHUCK HANEY

Below: Pronghorn antelope thrive in the wild prairie grasslands of Rosebud County. CHUCK HANEY

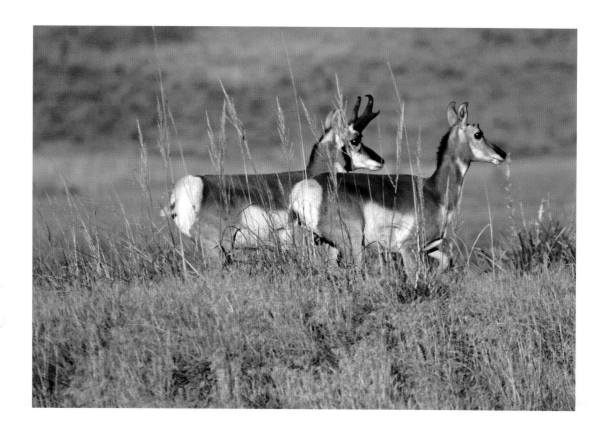

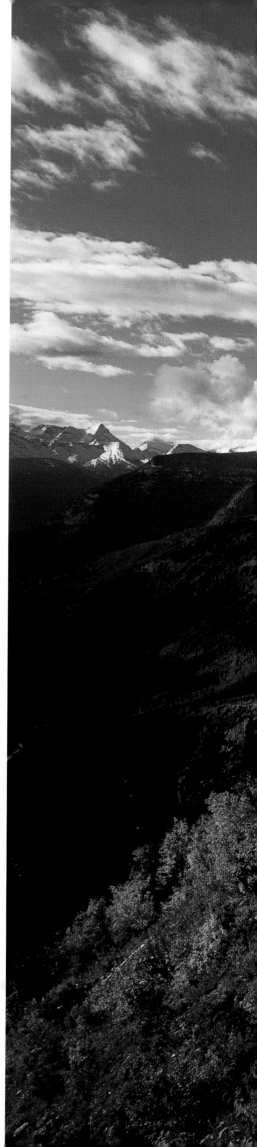

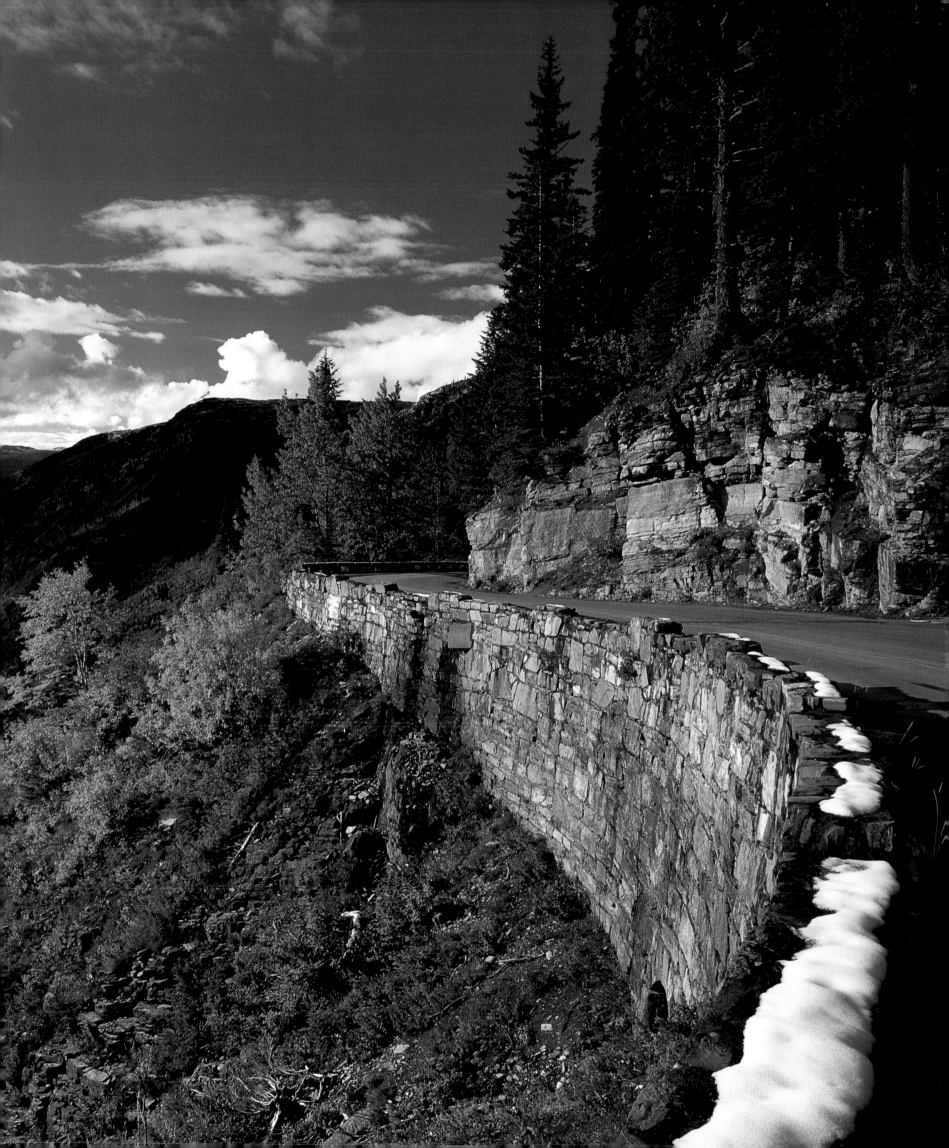

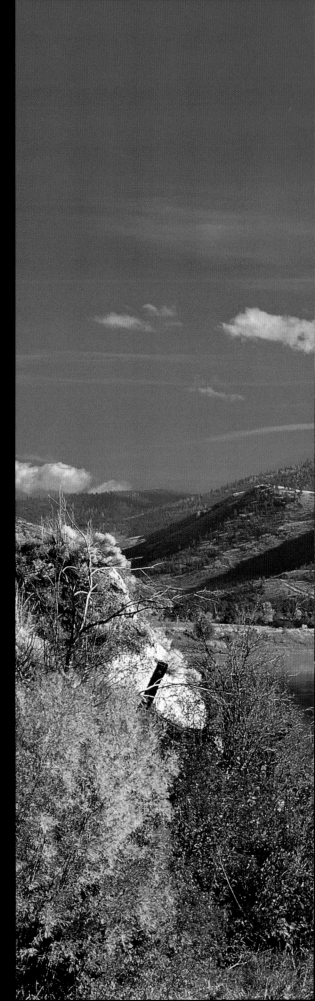

Right: The Flathead River flows through some of Montana's most beautiful countryside. The golden trees on the slopes in the distance are larch, also called tamarack. It is Montana's only conifer that turns color and drops its needles in winter. JOHN LAMBING

Below: Reynolds Creek cuts a beautiful path through Glacier National Park. CHUCK HANEY

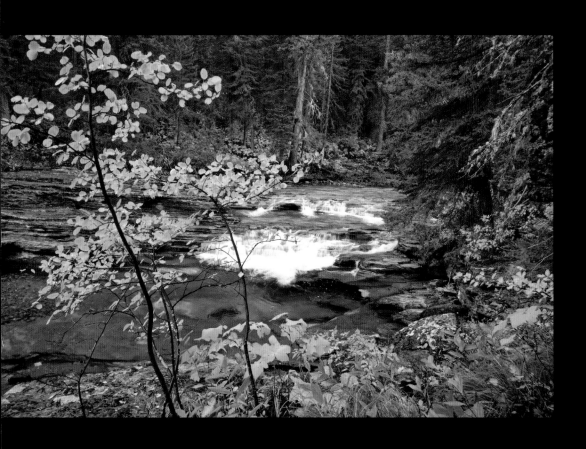

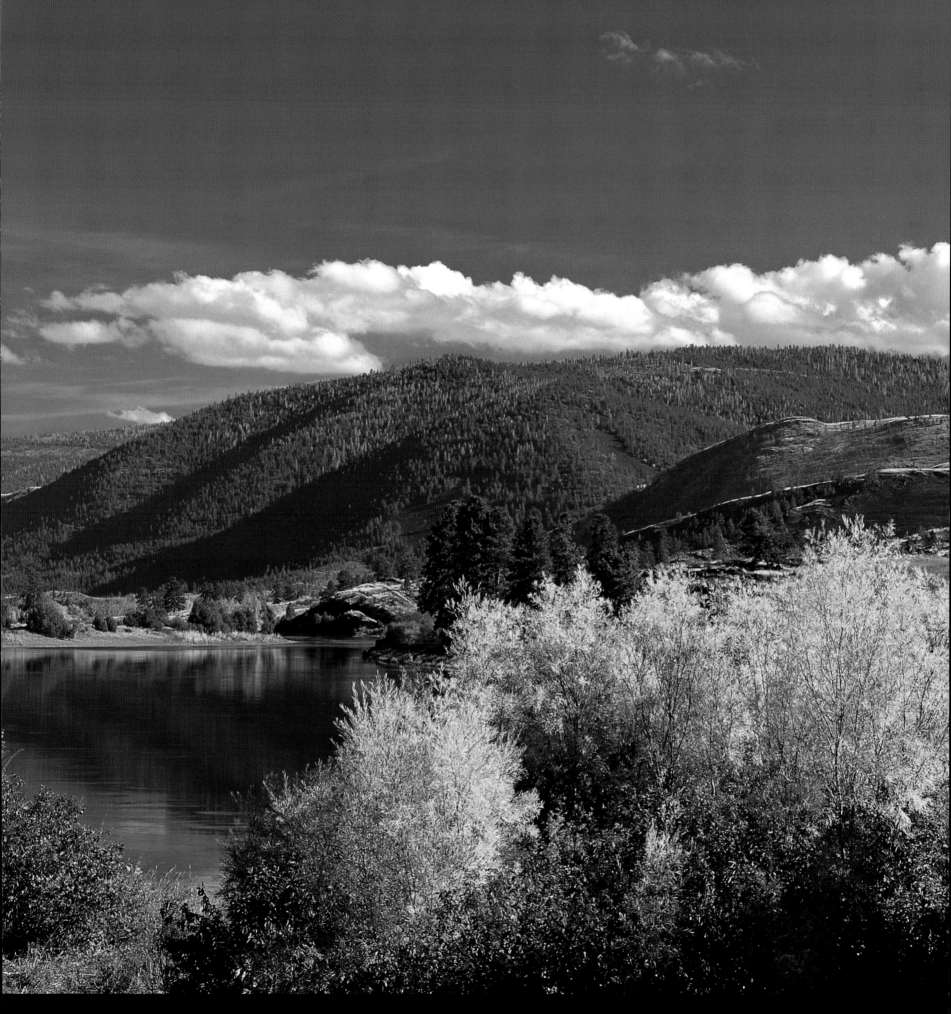

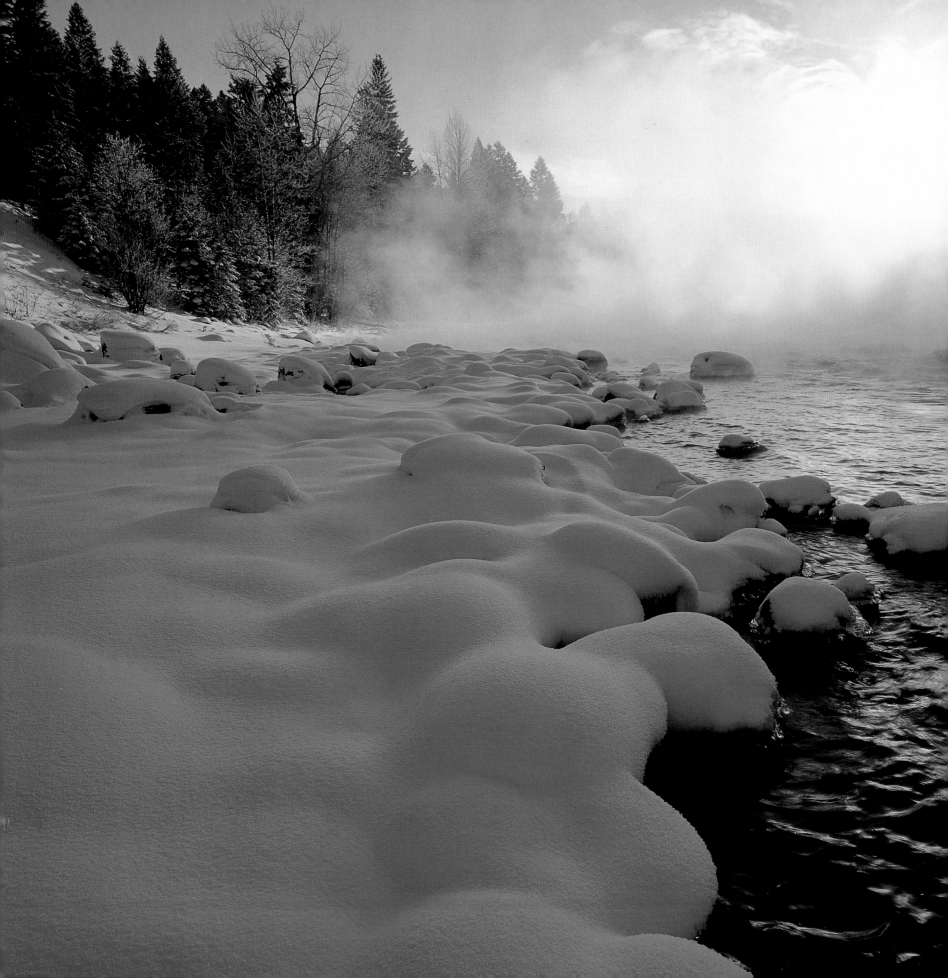

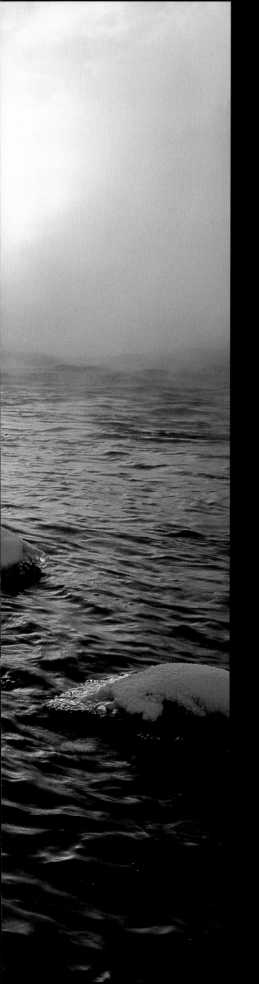

Left: Air temperature of -20 degrees F caused this thick fog to rise from the warmer water of the South Fork Flathead River. CHUCK HANEY

Following page: Bear Creek cascades over large boulders during spring runoff on Marias Pass. CHUCK HANEY

Below: The Continental Divide runs atop the Livingston Range, high above the larch-covered slopes that enclose Bowman Lake. CHUCK HANEY

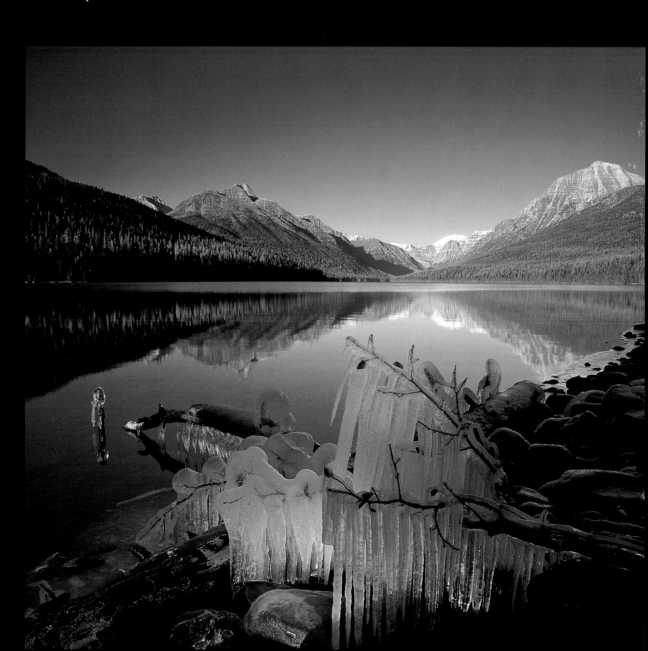

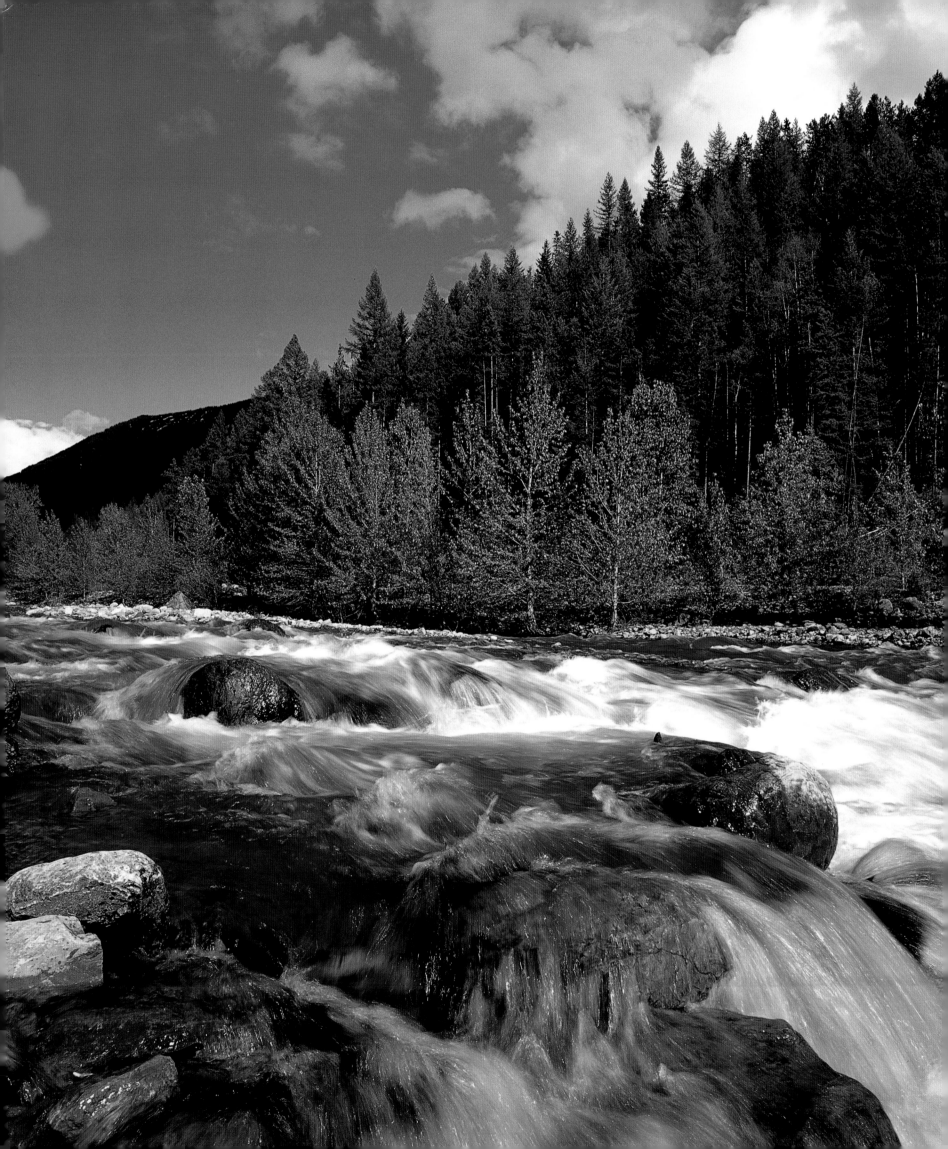